« To meet the challenge that art offers to reflective thought. »

Art
and human intelligence

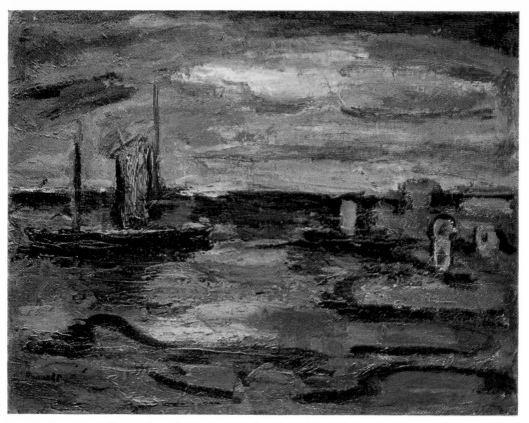

1. *Georges Rouault*, Afterglow in Galilee. *The Phillips Collection, Washington, D.C.*

« Physics seeks to exhaust the manipulability of things, art to make interest in them inexhaustible. »

VICTORINO TEJERA

HOWARD UNIVERSITY

Art
and human intelligence

New York

APPLETON - CENTURY - CROFTS

DIVISION OF MEREDITH PUBLISHING COMPANY

Acknowledgments

For an excerpt from "Ars Poetica" by Archibald MacLeish, from THE COL-
LECTED POEMS OF ARCHIBALD MacLEISH. Boston, Houghton Mifflin, 1952.

For excerpts from ART AS EXPERIENCE by John Dewey. Copyright 1934 by
G. P. Putnam's Sons, New York.

For an excerpt from COUNTER-STATEMENT, second edition, by Kenneth
Burke. Los Altos, Calif., Hermes Publications, 1953.

For an excerpt from LITERARY AND PHILOSOPHICAL ESSAYS by Jean-Paul
Sartre, translated by A. Michelson. New York, Criterion Books, 1955.

For an excerpt from "The Mind" by Rita Barton, in ART, ARTISTS, AND
THINKERS, J. M. Todd, editor. Harlow, England, Longmans, Green & Co. Limited,
1958.

For excerpts from NEUROTIC DISTORTION OF THE CREATIVE PROCESS
by Lawrence S. Kubie. Lawrence, University of Kansas Press, 1958.

For excerpts from "The Outlook for Aesthetics" by Stephen C. Pepper. Gambier,
Ohio, *The Kenyon Review*, Vol. 8, No. 2, 1946.

For excerpts from "Pragmatism and the Tragic Sense of Life" by Sidney Hook,
in "Proceedings and Addresses of the American Philosophical Association," *1959–
1960*, Volume XXXIII, The Antioch Press, 1960.

For excerpts from THE REBEL by Albert Camus. New York, Alfred A. Knopf,
Inc., 1956.

For an excerpt from THE SPIRIT OF THE FORMS by Elie Faure. New York,
Harper & Row, Publishers, Incorporated, 1930.

For excerpts from WHAT IS LITERATURE? by Jean-Paul Sartre, translated by
Bernard Frechtman. New York, Philosophical Library, 1949. By permission of Lit-
erary Masterworks, Inc., New York.

To the memory of my father

PREFACE

This book is addressed to the upperclass-
man, the graduate student, and the educated pub-
lic. It hopes to give instructors in aesthetics and
related fields substantive matter for reflection and
discussion. It can, in this connection, be used in
conjunction with some of the numerous books
of readings in aesthetics now available. At the
same time it seeks to provide what the latter do
not, namely, a more or less *coherent* intellectual
framework for further study and discussion of
the topics covered. Such study should be carried
forward, as this book is, with continuous ref-
erence to human experience.

I have sought to redress a bias in tradi-
tional aesthetics which led it more and more to
base itself on assumptions which were neither
those of the artist as such, nor those of the cre-
ative personality. I have in fact sought to show
that to be human is to be creative. In developing
a philosophy which accommodates, and pro-
motes sympathy for, the premises of artistic

production and creative action, I found it unexpectedly possible to exhibit with equal sympathy the close kinship that binds together the human activities which we distinguish as art, technology, science, and conduct. It is hoped that the reader will, in consequence, see that the contempt in which aesthetics as such has been held is quite unwarranted. A coenoscopic observer would probably say that it is just because the craving for aesthetic satisfaction is so deeply rooted as to be unnoticed, that it is just because the need for creative modification of our condition is so unremitting, and that it is because the urge to rehearse or communicate what we value is so nearly irrepressible that we fail to see ourselves for the reconstructors—and conservators by reconstruction—that we inevitably are. I hope here to have contributed the sketch of a perspective which favors observation of the traits which will justify and fill out conceptions of man as a creative animal, which is to say, conceptions of man as an intelligent organism who achieves or realizes his worth in the very measure to which he is a creatively intelligent, or witting, agent and recorder of change.

There are perhaps two major tests of any aesthetics. A first test is available in the extent to which it promotes enjoyment, appreciation, and understanding of art. A second is provided by the degree to which it brings clarity and relevance to the terms in which we discuss and practice art. On such tests, and for much the same reasons that every generation creates its own art, any philosophy of art is fated for correction. I can only hope that the reader interested in art and the philosophy of man will find this essay a fraction as stimulating as it is corrigible.

I take this opportunity to thank the many individuals and institutions whose courtesies and assistance have made this book possible. Where it is so great that it cannot remain implicit I must mention my indebtedness to my former teachers John Herman Randall, Jr. and Justus Buchler, to the artist Ellen Compton, and to Howard University.

<div align="right">V. T.</div>

Howard University

Numbers in the margin refer to figure numbers.

CONTENTS

Contents

x

Contents

Contents

« To meet the challenge that art offers
to reflective thought. » J. Dewey

Art
and human intelligence

PART ONE

Methodological introduction

The nature of aesthetics, or the trouble with theory

The non-Theorist is something incredible and astounding to modern man.

Nietzsche

To all who have undertaken it, teaching is an exciting experience, yet "education," as Emerson said many years ago, is too often a dull subject; so "aesthetics," which is about some of the most exciting things humanity has done, needs redeeming from the dreariness that has invaded great parts of it. Perhaps the most important reason for this is that "aesthetics" has hardly yet understood itself, what it is supposed to be, or is supposed to be doing. Where a great many works begin with the question "what is art?" we will, therefore, begin with the question "what is aesthetics?"

I hardly need to say that, in part, we shall find out what "aesthetics" is by doing some, that is to say by philosophizing about art. Reasons will emerge shortly for speaking of the philosophy of art rather than of "aesthetics." In philoso-

3

phizing about art we shall, of course, have to ask among other things, "what is art?" But the question about the nature of the inquiry into art is logically prior to the question about art, since the answer to the first can beg the second. Also, once we have understood what we are doing when trying to answer the question "what is art?" we shall the better be able to answer it.

In granting priority to the job of defining "aesthetics," however, I am making some other assumptions. I am, that is, supposing that definition, and the problems it involves, to be a responsibility of philosophy. I am also supposing that it is up to the philosophy of art, rather than art itself, to *state* what art is. Art exhibits what it is, and does what it does, but it does not actually state what it is or does. Art is often reflexive, but it is seldom *verbally* reflexive in the full sense of commenting upon itself. The cases in which it is will of course become sources for our thinking about art. But the only discipline that is *necessarily* reflexive is philosophy, and upon it will devolve the challenge and rewards of attempting a statement of the nature and function of art.

What is aesthetics?

It must now be noticed that the form of words habitually used to frame this main question may well be misleading or partial. Why should the definition of art take on the form of an answer to the question "what is x?" Why shouldn't it equally well correspond to a philosophical inquiry into "what does art do?" or "what is the function of art?" or again "why do we call art the processes, the powers, the qualities, and the things which we do call art?"

"What is x?" is taxonomic and calls, characteristically, for a classification of x. It becomes a fair question whether an approach borrowed from biology and zoology is the most apt for the study of art. Some of the time, moreover, "what is x?" assumes that x is a *thing*, or that x's are things sharing a single common attribute or distinctive set of properties (the "essence" or the "usage"), reference to which will define the class of x's. This tendency is based on the supposition that "kinds" as such exist in reality, or, that the world is in fact divided along the lines of conjoined sets of characteristics.

4

This approach also treats the world itself as a thing-with-attributes. Applied to art, then, this interrogative form begs the question of whether art is a thing-with-attributes; art might turn out to be something else. At other times, however, it appears to be agreed that the classification developed is merely a matter of convenience without any compelling logical meaning, that definition is purely nominal and an arbitrary convention about the usage of a word. But think what a clamor of confusion would arise in the arts, among unscrupulous dealers, promoter-critics, would-be artists, and self-appointed jurors, if the definition of art were merely nominal and only a matter of no-one-knows-whose practical convenience!

On this approach it would become imperative, and there is no *a priori* reason why it should not be possible, to find an objective basis for classification. The discovery of progress or change in techniques of creation, simultaneously with the plotting of changes of interest which motivates their use as a function of human needs, in conjunction with an exhaustive understanding of the latter would—theoretically—institute an objective basis. But in the absence of the requisite combination and fullness of technical, cultural, and anthropological knowledge this remains a long-term program. And there is reason to believe that there will, in any case, always be disagreement on candidates for classification as art. On the basis of the observation that new and genuine art always confounds the established understanding of what art is and always takes at least a generation to be classified as art, we should be wary of the taxonomic approach.

Is aesthetics a theoretical study?

Worse, any agreement would be the result of *theoretical* and purely logical disputations that would surely be nugatory in the end. And that precisely is the philosophical rub: that this interrogative ("what is art") is taken as a theoretical question. The point, in connection with the arts, is that should these turn out to be primarily matters of practice, say, or of the exercise of a kind of understanding other than theoretical, then a theory of art, as theory, would possess no adequate checks on, or control over, its relevance to the practice or experience about which it was theorizing. So we are brought back to the previous

question: what sort of study, then, is the study of art, what does it do, and how does it happen? I would venture that in answering this question our best help will come from roughly three different sources, namely, the history of "aesthetics," classifications of the sciences, and consideration of the subject matter itself of the philosophy of art. In the order of discovery as distinct from the logical order, this subject matter comes first, of course; there would be no study of art if there were no art to study.

Not all knowledge is theoretical

Classifications of the sciences in our time appear, on the whole, to be a matter of parceling out different areas which it is assumed are to be investigated in much the same way. We seem to have lost the sense that different sciences might not be the same in the amount of system or degree of explicitness of which they are capable, or that they might in fact differ in kind from other sciences. This is due to the speculative bias of Western civilization which, since before Aristotle, has preferred and developed the sciences which he called theoretical and which today are called deductive. Aristotle himself, however, did distinguish—as we do not—different kinds of science. For him, all intellectual activities (*pasa dianoia*) divided into three kinds, theoretical knowledge or science (*theoretikc episteme*), practical (*praktike*) knowledge or science, and productive (*poietike*) or poetical knowledge or science (*Metaphysics* A. 1025b25). I have translated Aristotle's term *episteme* as "science" or "knowledge"; so the point must be made that the last two kinds of knowledge are not, for Aristotle, "sciences" in the sense of "theories." But they are knowledges, though not theoretical knowledges.

As Joachim [1] pointed out, the modern philosopher generally thinks of ethics as the *theory* of conduct or right action. And he thinks of "aesthetics" as the *theory* of artistic production or creation. In Aristotle's analysis, however, this would only have made them *subdivisions* of the first kind of science, of theoretical or speculative knowledge, whereas in fact Aristotle's finding was of three *separate*

[1] Harold H. Joachim, *Aristotle, The Nicomachean Ethics, A Commentary* (New York: Oxford University Press, 1951), Introduction.

kinds of knowledge. The strange thing is that he would seem to have separated them too sharply, since this separation, in combination with the Greek notion of the superiority of, and happiness to be found in, contemplation or detached reflection (*theoreo, skeptomai*), has been largely responsible for the subsequent bias of most Western thought towards what a thing is, rather than towards what a thing does, or how it comes to be.

It is interesting that when in the Renaissance inquiry turned its attention from what and why a thing is to how a thing works, this improvement was in fact still a theoretical refinement. Outside of the renewed emphasis on observation it was a question of replacing syllogistic *deduction* with mathematical *deduction,* so that interest was really in how to predict mathematically the behavior of a thing. The notion of a practical or productive science had so much been neglected in learned circles (there were exceptions, however, like Pomponazzi of Padua), that the revolt against scholastic theorizing was actually a return to the bosom of the archmathematician Pythagoras and to the archcontemplator Plato. The irony is, as the reader knows, that Aristotle had already classified, as the subdivisions of theoretical science or speculative philosophy (*philosophia theoretikai*), *mathematics* and *physics* along with theology! (*Metaphysics* E.1.1026a).

In contrast to these Aristotle had understood that poetics is a technique or art of poetry, not a theory of it. In the sphere of production at least, as in the sphere of action, Aristotle was this much of a pragmatist that he understood knowledge to be inseparable from the power (*dynamis*) to make (*poiein*) and to do (*prattein*). The moral of the story, so far, is that in the sphere of art what is wanted is not a theoretical knowledge of art but some sort of intimacy with the subject matter which, while it may not always lead to original production, will properly lead to the enjoyment and understanding of art.

"Theory" is a limiting concept

Perhaps the distinction intended can be clarified as follows. A theoretical science may informally be defined as one in which understanding the theory results in immediate mastery of the science, approximately as in pure mathematics or symbolic logic. Even in these sciences, however,

actual mastery comes only with problem-solving or practice; and many a presumptive theorem, empirically "discovered," remains unproven. The truth will out that, in the end, the sciences are so many arts of investigation, analysis, or construction. It may be doubted that *purely* theoretical knowledge is knowledge about anything at all. This becomes especially clear if we take pure mathematics as our model of a theoretical science. There is such a thing, of course, as knowledge *of* mathematics, but knowledge of mathematics is only knowledge *about* the deductive development of symbolic systems. All this, to be sure, can only be said on the old assumption, due to the theoreticist prejudice I am attacking, that there is actually such a thing separable in reality as theoretical knowledge. The truth of the matter seems to be, rather, that it is a never-realized limiting concept, implicit in the deductive phases of the sciences, which tends to get hypostatized as attention becomes absorbed by the logical structure of the sciences.

On the other hand, at the (lower, less formal) level on which theory consists of generalizations about the subject matter of the discipline which go beyond the discipline itself, theory can provide a kind of understanding of art. That is to say, the philosophy of art can create a more general perspective within which to contextualize the arts and by means of which they can be related to activities and products that are not art. We may refer again to the example of Aristotle's *Poetics* and its place in his philosophy as a whole to show that, on the one hand, theory can be relevant but that, on the other, the study of poetic drama is a non-theoretical discipline. In the present work we ourselves would always reserve the right to make as many such interdisciplinary, or metaphysical, generalizations about art as are felt to be relevant. The point remains that in such statements we will be talking theory not art, we will be doing some metaphysics or first philosophy rather than aesthetics.

Aesthetics as the poetics of art

And here we must clarify what we mean by "aesthetics" since I will be using the term in a sense somewhat different from the "traditional." I would wish the term to stand in the same relation to art as poetics (the art or technique of poetry, or talk about poetry making and

reading) stands to poetry and its enjoyment; in the same relation as talk of composing and listening stands to music, as talk of painting and seeing stands to paintings, and *not* the relationship in which the theories of poetry, musicology, and "aesthetics" in the old sense stand, respectively, to poetry, music, and what used to be called the "fine arts."

This old sense of "aesthetics" is very sharply given by Bosanquet in the first sentence of the preface to his history of aesthetics. "Aesthetic theory is a branch of philosophy, and exists for the sake of knowledge and not as a guide to practice." [2] This is an extraordinary statement; almost everything is wrong with it. It is as misconceived as if a literary agent were also to write a 500-page book on literature as a branch of business and offer the theory of his business as the theory of literature and as a kind of knowledge which was yet not a guide to practice (the practice of *what*, one wonders). The bafflement comes from the false alternative, or exaggerated dualism, between knowledge and practice. There is no scientific knowledge that is not somehow practical and no scientific practice that is not in some degree knowledgeable. Bosanquet and the tradition he worked in seemed to think, further, that all knowledge is always theoretical; but in this they are not alone to blame, as I have pointed out. Here the whole Western intellectual tradition is at fault.

Another basic difficulty with the traditional concept "aesthetics" is that, as it has usually been defined, it is both too broad and too narrow. If it is the theory of *beauty* it must study, more than the arts, the nature and the human nature where beauty also has a locus. But it will, at the same time, neglect all the qualities other than beauty which the arts exhibit. If it is the theory of *art*, it will have still to relate art to other activities which we do not call art but which will throw light on it, as, for example, science and craft. In the past it has, nonetheless, tended to neglect the aesthetic, or better, the creative substrate that pervades human existence.

It is no wonder that some philosophers have been in the position to claim, with justice, that there is no such thing as "aesthetics." With equal justice, others have been able to claim that "aesthetics" is the most basic of all studies because it is about the most basic facts of human behavior. Needless to say, in the latter case, the study would

[2] Bernard Bosanquet, *A History of Aesthetic* (New York: Meridian Books, Inc., 1957), p. ix.

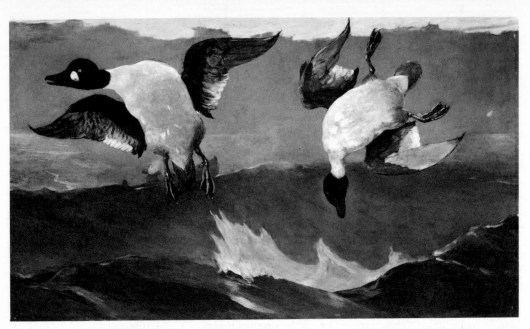

2. *Winslow Homer*, Right and Left. *National Gallery of Art, Washington, D.C. Gift of the Avalon Foundation, 1951.*

« To discuss it in terms of physics
is to misunderstand it. »

have lost as much specificity as it failed to attain in the former. So that, on the understanding that "aesthetics" is a theory, there is indeed no such separate study as aesthetics.

The philosophy of art is both foundational and technical

Since there is, nonetheless, a subject matter to be in some way studied, it would seem preferable to speak of the philosophy of art. For the ways in which philosophy considers a subject matter are, characteristically, diverse. At the frontiers of a subject it is, for instance, likely to be technical and indistinguishable from the discipline it is trying to clarify. Or, alternatively, it will be speculative in extrapolation. About the foundations of a subject it is likely to be theoretical in another way, for example, systematically. Or again, it can be analytical of generic key concepts in a discipline or of characteristic terminology.

Philosophy likes to point to both human and interdisciplinary applications of specialized activities or new knowledges. It is likely, in particular, to be technical in another way, namely, in providing acquaintance with the basis of any human activity, in distinction from the theoretical grounds for this activity.

The state of the question forces us to grant that the philosophy of art must inquire after the assumptions on the basis of which works get created: and that to understand or enjoy art on the basis of any other assumptions, as those of physics or psychoanalysis, is to misunderstand and not appreciate it as art. It will also be insisted today that the philosophy of art relate to the theory of criticism though it will remain distinguished from it, as will appear subsequently. The

« 2 »
« 3 »

« To discuss it in terms of psychoanalysis is to misunderstand it. »

3. Hokusai, Self-Portrait of Hokusai as an Old Man. *Musée Guimet, Paris.*

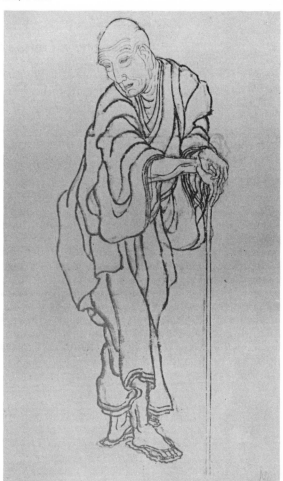

subject matter of the theory of criticism is critical statements; but the subject matter of the philosophy of art is, like that of criticism itself, art. However, when theory of criticism challenges critical statements and their grounds, it becomes, at a given point, again indistinguishable from the philosophy of art; for it is challenging these statements either in the light of their logic or of its view of art, and this view will have to be made explicit.

We must, then, try to become intimate with art on the basis of *its* assumptions, those inherent in its mode of creation, not seek to "understand" it on the basis of assumptions which serve to organize other subject matters.[3] This has been the mistake of most aesthetics in the past. Of course, there is a sense in which the kind of intimacy or knowledge of acquaintance which I am envisaging will remain "theoretical" as long as it does not issue in material works of art. But such knowledge will at least not be misleading, it will not be anti-artistic or impertinent. And it will, again in its way, be practical: for it will profoundly affect the conduct and the accomplishments of those who have such knowledge.

Philosophy as avoidance of the reductive fallacy

Let us then, for the time being, be content with the term "philosophy of art." Among other things this term will symbolize both our emancipation from the compulsion to be only "theoretical," as well as our freedom from partisan or otherwise unexamined commitment to any single given method or to any single given set of categories such as psycho-

[3] Cf. Willem de Kooning: "That space of science—the space of the physicists —I am truly bored with by now." *The New American Painting* (New York: Museum of Modern Art, 1959), p. 52. The mathematical *concept* which serves to organize the results of astrophysical inquiry, like the conventional "space" of perspective geometry, has indeed failed of explanatory value with regard to modern painting. The former concept, so far as it helped pry us loose from attachment to the latter, did act to promote sympathy for twentieth century painting. But it is obvious that artistic design cannot be developed or explained mathematically. "It will take a long time," Dewey once said, "to wean intellectuals from the notion that human subject matter can be scientifically treated by reduction to the terms of physical science." *Journal of the History of Ideas*, Vol. XX, no. 4, 1959, p. 576.

logical, archaeological, or those of a single school of philosophy. On the positive side the term will stand for our willingness to understand philosophy pluralistically, to recognize further that its approach may range all the way from literal to metaphorical, from the theoretical to the technical, from being detached to being involved; and that whatever approach it takes it must avoid, so far as is possible to intelligence, the over-all self-contrariety of being reductive. In the special sciences analysis is justifiedly reductive, because it is so for a special purpose. When philosophy engages in logical analysis it is being logically or formally or lexically reductive, but philosophical inquiry is much more than logical analysis. In non-Positivist usage there is no consecrated or accepted synonym for the adjective "philosophical" in the expression "philosophical analysis." But "contextualist," or "symbiotic," or even "non-reductive" itself would be good candidates where the intention is in the first place to clarify, in the second to give perspective or establish contexts, and in the third to restore to wholeness both the parts of abstracted subject matter being considered and the fragmented experience, or lives, into which they enter.

The subject matter of
the philosophy of art

The philosophy of art studies are both in terms
of art, and in terms of other things: but the crux
of the matter is, what does it study? As in any
inquiry, the phenomena to be investigated should,
in a preliminary way at least, be isolated or deter-
mined. The catch here, it will be noticed, is that
this determination turns out to be—and perhaps
always will be—problematical and logically
prior. The reason for this is that determination
of the field of the philosophy of art is a function
of what we judge to be artistic, to be good art, or
criticize as bad art, or not art. I mean that our
judgments, or criticism of art, and our definition
of the field of the philosophy of art are interde-
pendent. The fact that only a few art critics have
noticed this interdependence and that not many
more have worried about the basis of their criti-
cism, does not invalidate the necessary connec-
tion. There have been good empirical critics
without philosophy, but the reader of criticism
soon notices that the observations and insights of

15

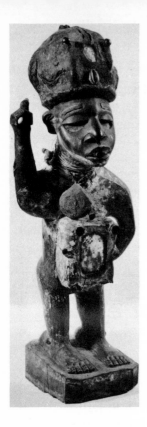

« A different set of artistic facts. »

4. Bakongo Looking Glass Fetish. *Oudheidkundige Musea; Etnografisch Museum, Antwerpen. Courtesy of the Burgomaster and the Board of Aldermen of the City of Antwerp.*

this minority are capable of *a posteriori* organization around a certain implicit "philosophy," or consistent outlook, which they reflect.

Furthermore, an understanding of the dynamic nature of cultural life suggests that philosophies of art can no longer avoid taking as one of their starting points the relativity and the changes in artistic values which exist from culture to culture and epoch to epoch. We must also realize that divergent aesthetics have differed because they have been developed on the basis of either a different set of artistic facts, or on the basis of different arts. What we notice and what we fail to note in ordinary life depends upon our interest and our conditioning; so it is in our intellectual life, though—one would hope—to a lesser degree. Extant philosophies of art probably complement more frequently than they preclude each other. The insights of this one supply the oversights of the other. The scope of some goes no further than Western art. The works which so beautifully verify other aesthetic hypotheses all turn out to fall within a given historical period or belong to a definable school or tradition. The aesthetics of the

« 4 »

16

music lover differs from that of the art student, and both from the aesthetics of the man of letters. Some of the standing generalizations in the field are based on considerations about the creative process, while others are rooted in the contemplative habits of the gallery goer. There are aesthetics that have been interested primarily in the rational and intellectual phases of art, and aesthetics whose concern has been mainly with the emotional and volitional phases of it. The point of departure has sometimes been the origins of art, at others its social or psychological "purpose." The majority of aesthetics have been written for the public at large, including the academic world, but few have addressed themselves directly to artists and makers.

There are also aesthetics whose origin is *systematic*, namely, those which have been deduced from already developed philosophical systems or positions. These are not necessarily false, though Procrustean; and they sometimes have the suggestiveness of a good caricature. The fact of the matter is that these aesthetics have been concerned to extend the terminology of a given system to a set of facts, the facts of art, which probably weighed very little in the initial development of the system. Such philosophies of art seem to be saying, "this is what art looks like to me from this vantage point." But what they should actually be saying is, "subsequent separate and unprejudiced observation of artistic facts has confirmed—or has caused me to modify—my philosophy of the other facts." There are, however, philosophies which have started with the creative life of man. Carried through, some of these have ended by being, like Santayana's, poetic visions of man's fate articulated with consummate verbal art. The history of aesthetics is, in a word, essentially a history of explanations of different fields or different phases of the arts. Stated in another way, different aesthetics have dealt with different factors in the creative process or, if one likes, different aspects of the creative situation.

The aesthetic judgment

The state of the question, as the reader must by now suspect, makes it necessary to unravel, from all that has been offered as aesthetics, what actually qualifies as such. For instance, when Prall put it that aesthetics

"is a general summary of particular aesthetic judgments," [1] he achieved consistency at the price of being too narrow. It is to be feared that such a definition would have the consequence of restricting aesthetics or the philosophy of art to the theory of criticism. Our subject matter would have become a series of critical propositions rather than the facts of art. As a matter of fact, extremes of discrepancy among men's aesthetic judgments make direct inductions or generalizations from them impossible. It remains, nonetheless, a problem proper to the philosophy of art to provide foundations for critical and artistic judgment. We must also list Prall's insight into the "judgmental" nature of all aesthetic responses, his posing of the problem of "symbolistic" art, and his identification of expressiveness as the differentia of the so-called fine arts as subjects with which any philosophy of art should be able to deal, and on which it may be tested.

Beauty and its meanings

What are some of the other things that the subject matter of the philosophy of art or aesthetics has been taken to be? The list made up by Richards, Ogden, and Wood of the sixteen distinct senses of "beauty" which they identified is worth referring to here.[2] They classify the aesthetics that imply these sixteen senses into three groups: (1) formal theories, (2) revelatory theories, and (3) psychological theories. But now notice that the process or facts to which these clusters may be anchored are, respectively, (1) abstraction, (2) mimesis, expression, or communication, and (3) stimulation. More than this, the types of art with which these theories correlate will be those, precisely, in which one of these processes predominates over the others. Outside of all this, however, the telling point is the assumption behind the authors' brief but brilliant book. The assumption is that aesthetics is the theory of beauty, that beauty is the subject matter into which the philosophy of art must inquire. And this at the same time that the book shows an almost universal and deeply sensitive sympathy toward ex-

[1] David W. Prall, *Aesthetic Judgment* (New York: Thomas Y. Crowell Company, 1929), p. 352.
[2] C. K. Ogden, I. A. Richards, and J. Wood, *The Foundations of Aesthetics*, 2nd ed. (New York: International Publishers, Inc., 1925), pp. 20-21.

amples of art from the whole world over. Waiving for the moment the hypothesis advanced as the true one (namely, that the characteristic and criterion of the aesthetic process is "synaesthesia," a state of the organism in which all the senses are enlivened to cooperate in harmonious tension), it is remarkable that the direction of the inquiry, the field of aesthetics, has been antecedently defined without the conscious deliberation of the investigators. The questions they should have put to themselves were whether the analysis of beauty does not carry one beyond the philosophy of art, into the philosophy of nature; and whether the analysis of beauty succeeds in exhausting the field of aesthetics which has always had room for the tragic, the ironic, the grotesque, and so on. Both works of art and the experience of which they are constitutive exhibit additional distinctive characteristics which need to be investigated.

Going further, if beauty is a trait pervading all existence then the study of it becomes a part of metaphysics, the science which passes in review the generic characteristics of existence as such. Of course, we must refrain from jumping to the conclusion that aesthetic quality is irreducible. In this connection, however, it will be the job of metaphysics to assign to aesthetic quality the degree of generality it does warrant—as it will fall to one's philosophy of man to determine the degree to which art, as a possible ingredient of all human activities, pervades such activities. Lastly, the reader may want to remember that the definition of aesthetics as the study of beauty had, in the past, the deplorable effect of justifying in theory the escapist, affected, and in the end sterile practice of the European aesthetes of the turn of the century. There is no doubt, however, that the nature of beauty is *one* of the problems of the philosophy of art.

The peculiar and operative assumptions of art

So far it would appear, in summary, that the philosophy of art inquires after the assumptions on the basis of which works of art get created; and that to understand or enjoy them on the basis of any other assumptions, as for example those of physics or those of psychoanalysis, is to misunderstand and not appreciate art. Next, we found that the phi-

losophy of art includes, but must be distinguished from, the theory of criticism. It includes it in that it investigates the basis of critical statements; but it differs from the theory of criticism, whose subject matter is critical statements, in having art, like criticism itself, for its subject matter. The philosophy of art will, futhermore, seek to identify the qualities that works of art exhibit and the powers that go into their making and enjoyment as human activities. It remains to note that the philosophy of art will also concern itself with the ulterior implications of human artistic aptitudes and that, in short, it will be concerned both with the creative act as an element in the experience of art and with creativity as a part of life.

The aesthetic attitude and the sense of beauty

Just as the divergences of critical judgments cause initial trouble in the understanding of criticism, so the chaos, subjectivity, and diversity of aesthetic experiences inhibit and impede, for some thinkers, the definition and very intelligibility of art as experience. As I understand the situation, however, it is the same dilemma that confronts common sense: the dualistic common sense which has for centuries egocentrically divided the world into subject and object, and which, in aesthetics, over-opposes the experience on one side to the "finished" work which precipitates it on the other. How, indeed, can we tell that what is being observed is art by investigating the observer, if observers say such conflicting and unrelatable things both *in* and *of* their responses? And why is it, on the other hand, that when we turn to the object itself and try to enumerate the set of characteristics which identify it as a product of art, we succeed only in excluding—with our insufficient list—more kinds of art than we are prepared, or would be allowed, to sacrifice?

Some authors do not recognize the aesthetic experience as having a structure, or rhythm, or phases of its own. They do not believe it is analyzable. But I doubt that anyone who has had an experience of art has not also felt it as *an* experience with discriminable parts and as an experience with form. He need not have reflected upon this, mind you, but he will have felt it so. It is quite curious,

20

therefore, to find authors who resolve the dilemma mentioned above by asserting that there is either a separate aesthetic sense or a special aesthetic attitude in terms of which beauty may be accounted for. «5» This positing of an aesthetic faculty seems, in retrospect, more like a logical maneuver than the result of observation. Observation would have shown that the aesthetic attitude and aesthetic sense are, precisely, phases of aesthetic experience. And it is to be noticed, again, that the explanatory value of this sense of beauty depends upon the assumption that the proper object of this faculty is beauty, and that beauty is the defining characteristic of the art process. This may turn out to be true, but it would have to be proved, not presupposed. In any investigation it is better at the outset to entertain several alternative hypotheses rather than one. When it is a question of human matters as

« The equivocity
of beauty. »

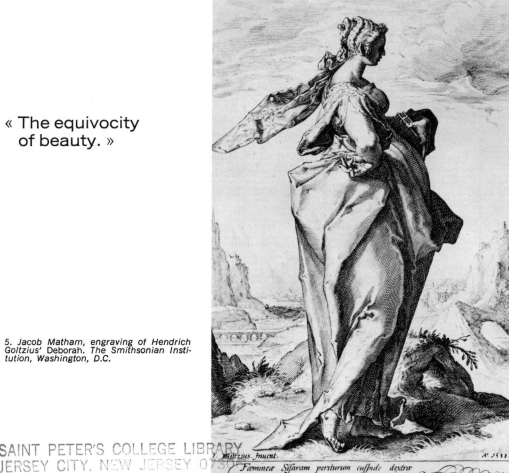

5. Jacob Matham, engraving of Hendrich Goltzius' Deborah. The Smithsonian Institution, Washington, D.C.

complex as the ever-extraordinary facts of art, the natural supposition will be that art involves more than one distinctive characteristic. Is it not, in any case, a begging of the question to (1) assume that beauty is what defines works of art, (2) say that the main job of aesthetics is to define the work of art, and (3) discover, in the end, that the property which works of art, taken as a class of objects, have in common is beauty?

Aesthetic quality

Recent philosophy, in its concern with aesthetic quality as something complex (S. C. Pepper,[3] J. H. Randall [4]) or as something basic to the existential matrix of artistic activity (Dewey [5]), has provided an interesting lead in more fruitful directions. We must not assume, however, that because "aesthetic quality" is a key term in the contextualist approach, it is therefore deductively primitive or irreducible in fact. For Dewey the quality that pervades situations or unifies works of art is—operatively—prior and pre-reflective, but this does not make that quality, which is the resultant of interactions, simple, though it is often *felt* as simple. We will take up again later this whole subject of what gives works of art their unity (and whether all of them have unity) as a central problem for the philosophy of art. But notice that it is a problem which causes both Randall and Dewey to go beyond aesthetics into first philosophy. Pepper, though, limits himself to a technical use in which aesthetic quality is made a function of the factors "conflict" and "novelty" in the work. His sense of the context, in art, does not seem, incidentally, to be quite the same as Randall's and Dewey's.

What requires notice in this chapter is the way Pepper found of avoiding the vicious circle referred to above (at the end of the preceding section). He recognized that

[3] See Stephen C. Pepper, *Aesthetic Quality* (New York: Charles Scribner's Sons, 1937).
[4] John H. Randall, *Nature and Historical Experience* (New York: Columbia University Press, 1958).
[5] John Dewey, *Experience and Nature* (LaSalle, Ill.: Open Court Publishing Co., 1925), and *Art as Experience* (New York: Minton, Balch & Company, 1934).

22

The classics furnish the safest well recognized group of facts for roughly locating in a preliminary way the field of our inquiry. To say, however, that the facts which we are studying are the sort of facts of which classic works afford outstanding examples, is not to beg the question in aesthetics, is not to determine antecedently the results of our inquiry. . . . It determines nothing at all beyond a preliminary rough demarcation of the field within which aesthetic enquiry is to begin.[6]

This kind of mute and slightly hesitant pointing to where we can begin may, indeed, be accepted in the spirit of corrigibility in which it is offered. Methodologically, it also implies that we begin with an inquiry into the factors which have caused the masterpieces to survive. I mean of course the aesthetic factors, not the historical or circumstantial factors in their survival. As Pepper said later,

". . . among men's activities and production are things which men evidently consider worthwhile, or significant, or good, and which do not get their significance from their truth, their practical effectiveness, their moral justification, their social prestige, or even their reality or matter-of-factness. . . . Whatever the things are that have this unclaimed significance, these are the subject matter of "aesthetics." [7]

Artistic "activities" and "production," these are terms which we will be clarifying later in this book. Right now we need only remind ourselves of the danger run by the observer who limits himself to just the recognized masterpieces. What happens is that a repertoire of what could be called Olympian art eventually is enthroned on the strength of our repeated references to it for our standards of greatness. Sometimes a further outcome is the enslaving and sterile habit of comparison which is thus acquired, and which ends in something which in Spanish is known as "formulism."

The aesthetic object and the possibility of art

Whether he believes it or not the reader must know that there are authors who think that there is no such thing as a philosophy of art, and that

[6] S. C. Pepper, *op. cit.*, p. 15.
[7] Stephen C. Pepper, "The Outlook for Aesthetics," *Kenyon Review*, Vol. VIII, no. 2 (1946), p. 180.

if there were it would still not be worth the while. The classic state-
ment of this view was made by F. L. Lucas in his book on tragedy:

Into vague generalizations about "Art" this is in any case no place to go. At
best very little can be said that is worth saying, about things as different as a
cathedral and a sonnet, a statue and a symphony.[8]

This sort of thinking corresponds to the desire to limit one's responsi-
bility to the understanding of a single art without bothering about the
other arts. It cannot be denied that the arts may be approached one
by one; but without reflecting on each of the arts and afterward,
about all of them together, we cannot become philosophers of art. It
also happens that a knowledge of other arts improves our knowledge
of the single art we may be considering. The irony is that Lucas's
words are, in fact, a very dramatic way of initiating the main ques-
tions in the philosophy of art.

 There *is* a type of philosophy which claims, in answer to Lu-
cas's denial, that what can be said about art in its different forms is
said about something of an ideal nature called "the aesthetic object."
This artificial entity appears to reside in works of art, where it is
spotted by abstraction, by logical not artistic abstraction as it turns
out. The technical way of saying this is that the aesthetic object is a
logical construct deduced from the study of the ontological conditions
of the possibility of the object, or if you like, of the possibility of art
works entering into and engaging perception in the way they do. This
may be valuable as epistemology, but the concept it arrives at is hardly
more than a colorless and immaterial duplication of the idea of a work
of art or a reification of the notion of "the aesthetic," required by the
logic of a certain point of view. This is the point of view which, hav-
ing developed the problem of knowledge [9] into an antinomy—that is,
left it without solution—proceeds, in aesthetics, to deal in the same
antinomic way with the related problem of the "perception" of works
of art which is, after all, only the problem of our production, enjoy-
ment, and understanding of them. It is, besides, hard to believe that
what the aesthetic process seeks, that what works of art embody, or
the aesthetic experience achieves, is a *logical* entity. And it would not
be distinctive of works of art. "The aesthetic object" looks, at best,

[8] F. L. Lucas, *Tragedy in Relation to Aristotle's Poetics* (London: Hogarth
Press, 1927).
[9] In the sense of the problem of our dealings with the objects of science.

like the precipitate of the application of dialectic to art: it is a dialectical, not an aesthetic, object.

The experience of art and the making of art

The working hypothesis that art is both a kind of experience and a kind of making addresses itself most directly to the inextricably related problems of the ends of art and the creation of art. It re-introduces the idea that art is a power possessed by the artist as well as an activity the outcome of which is *also* called art. The consequence of this is that aesthetics becomes the discrimination of the phases or components of this activity—much, for example, as Aristotle analyzed the tragic art into the art of dialogue and the art of the lyric, the art of plot development, the art of exhibiting thought and character, the art of presenting an action to be viewed in a setting permeated by the music of the voices. Another consequence is that aesthetics thus becomes a part only of the philosophy of art, and that the latter will be understood to be a non-reductive attempt to relate art to other human activities.

Does an artist's art constitute an experience for him in a way different from that in which it constitutes an experience for someone

« Controlling or compelling attention? »

6. *Kenneth Noland,* Amusement Blues. *Andre Emmerich Gallery, Inc., New York. Collection: Alfred Ordover.*

«6»

else? How does the aesthetic experience work: by controlling or compelling attention, or by provoking or expressing emotion? What is emotion, and is it ever, in the arts, unmixed with intelligence? What is creativity? What *sort* of making is art? These are all questions that the philosophy of art must answer. It will also seek to answer questions about the nature of artistic meanings, about the relation between common experience and artistic experience, about the connection between ordinary making and creative production.

Finally, it must seek to discover what—over and above the many purposes the several arts have—the overall human function of art is, or has been, or is likely to be. An advantage of this approach will be, I hope, a more immediate recognition of the continuity between the philosophy of man and the philosophy of art and the interdependence of their hypotheses and insights. A context begs to be created within which the question, what is the significance for man of the phenomena of creativity?, may be answered. It is to be hoped, too, that we will have found a way in all this, to obviate two of the most inhibitive dualisms of our time: namely, the dualism which has almost irrevocably divorced contemplation from creation, and that which has both sundered the artist from the rest of the community and the creative elements it manages to retain, and alienated the individual and very human purposes of the first from the social and very human purposes of the second.

PART TWO

Expression

Medium and meaning in art

A work of art is something made and, hence, there is a sense in which art, as Aristotle said, is a kind of making: the working out of the work of art. As such, it is an experimental and productive, or constructive, activity which has for its outcome the record of an exploration of experience. The exploration is for the sake of both the record and the experience. The medium used to record or create the experience is the source of the aesthetic felicities which, achieved, make the creation or the recording a work of art. The experience which the medium seeks to exhibit, to capture or stabilize for participation and observation, must be genuinely the artist's, the artist being defined as one who is master of his medium. It is the genuineness of the experience and the felicities of its working out that ensure the enjoyment and the sharing of the work of art by others. The apprehension by others of the values instituted, discovered, celebrated, or formalized by art is, characteristically, itself creative. It is to

29

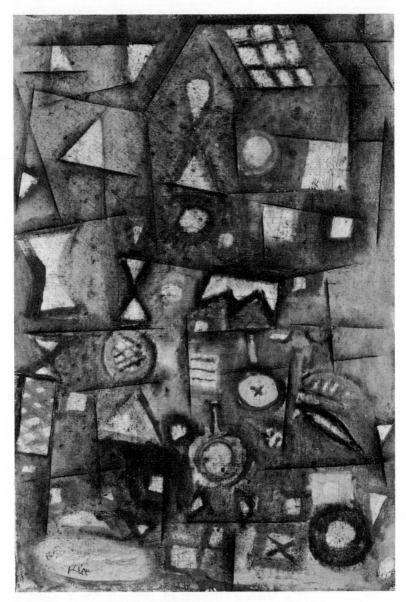

7. *Paul Klee*, Garden Still Life. *The Phillips Collection, Washington, D.C.*

« Painting can be ''literary.'' »

be noted that the creation and contrivance of the thing made seems to advance or to be controlled by the emergence, or invention, or discovery of both an aesthetically right form—a form which works, as we say today—and by a consideration of the possibilities of the medium as capable of exhibiting or binding just those qualities whose realization and organization is the artist's task.

The medium

Materials by themselves, as Dewey has pointed out,[1] do not constitute a medium. It is when materials are used as an organ of expression that they constitute a medium. It is to be noticed both that the chosen medium expresses the insights or experiences of the artist and that the materials may be said to have found a medium that expresses *their* value—imaginative and sensuous—in human experience. The specific and characteristic tendencies of the different arts are consecrated by the media they individually employ and in which, as it is usually put, they are "embodied." But it is equally true that given arts have, in time, developed certain particular but by no means fixed characteristic tendencies only because they employ given media.

Thus the qualities of, or in, experience that we call "poetic" or "literary" may also be found in painting (for example the work of Paul Klee), just as "painterly" qualities may be found in literature (such as the lurid in Ammianus Marcellinus, the panoramic in Tolstoy). Music can in certain examples be said to be "dramatic," while poetic discourse is now and then primarily "musical." Tragedy, among the Greeks, *was* musical, but it can also be said to be, and has been, "visual," or primarily spectacle. It is of the nature of the art of ballet to be both rhythmical, or musical, and visual. On the other hand, painting during the Renaissance sought to be "sculptural," by creating the illusion of three dimensions, and of course failed. Where it remained great painting nonetheless it was because though the *idea* then in fashion was to *violate* the medium, it was still in fact only *exploited*. It was another case of the stated theory differing from the actual practice of a new kind of design. As an artist Michelangelo, for

« 7 »

[1] John Dewey, *Art as Experience* (New York: Minton, Balch & Company, 1934), p. 60 ff.

31

instance, knew better than to let literary allusion or optical illusion spoil the total design of a work. Similarly, it would be a mistake to judge collages as if their medium were not a different medium from that of painting. Obviously music cannot be made out of building materials, but architecture has more than once been said to be "musical." Almost as obviously, "architectonic" is a quality of experience that examples from all the arts, including music, express. It is also a quality discoverable in "nature." It would seem entirely possible therefore for any art to express any quality—even if, for historical reasons, the initial revelation or development of a given quality was confined to a single given art. The explanation of the predominance of certain arts at certain times and of the predominance of certain qualities within them is a historical one, and to be sought in the circumstances of the time and place in which they flourished.

The particular arts have the power, or more exactly, are the powers which men have, of taking materials that are to hand and converting them by a process of selection and combination into media able to carry meanings. But any medium that conveys meanings may be said to be functioning—in an extended sense of the term—linguistically. Thus the medium of every different art is a different language; but it is also to be noted that the sense in which these media are languages is analogous to the sense in which language is the medium of literature. The long-standing fashion of speaking of the arts as "languages" has represented a valuable suggestion; but it is more accurate to speak of the arts as "literatures." With this, however, I do not mean to imply that literature is the prototype among the arts; nor do I intend to neglect that property of these "literatures" which makes them intelligible to peoples speaking different languages. This way of looking at the medium has been eloquently stated by Fauré in *The Spirit of the Forms:*

Plastic language is even more of a language than one might suppose. It is a manner of speaking because it is a manner of thinking. It is even probable that it adjusts more strictly than verbal language its manner of speaking to its manner of thinking. It can express ideas and the relations of ideas which the sculptor or painter would be altogether powerless to translate into words. It is even desirable for him not to know how to do it, for he would cease to be a sculptor or a painter and become a writer and would lose, in the meanderings of discourse, the simplicity, the coherence, and the vigor

of his thought. The grandeur of a spirit is not bound up with its faculties of discourse, but with its greater or less power of expressing, in whatever language, that which it conceives.[2]

Just as a man's relation to his language is both assimilative and manipulative, so is the artist's to his materials. The artist "understands" his materials and has an affinity for and dotes on them. You might say that though adopted, he understands their possibilities as if they were his own offspring. He is willing to be surprised by them—if they can carry it off; but he has his own plans for them. His executive talent exploits them without violating their natures, but like a wise sovereign he is aware that any revolution that they force upon him must be accepted—stemming as it probably does from previous, if unwitting, abuse. He concedes that a neglected need has been revealed that was too intimate for his unaided or habitual perception. The artist labors to see, and enjoys seeing, what his materials can be made to *do*, what they can be made *into*, what they can be made to express.

«8»

Expression

It is to be noticed, however, that what the artist expresses he also creates: otherwise he could *only* express an already given natural or personal beauty, a beauty that was anywhere *but* in his medium and which would therefore not need transposing into that medium. If expression is a process generative of art it must be (1) because it discovers qualities or beauties in the world not otherwise accessible to observation, or available to enjoyment, (2) because it discovers qualities in the materials, or (3) because it invents the situation, or the forms, in which these qualities are consummated by the artist or for the perceiver. On any of these alternatives expression in the arts comes down to being, initially at least, either a sort of invention or a sort of discovery.

[2] Elie Faure, *The Spirit of the Forms* (New York: Harper & Brothers, 1930), pp. 227-228.

33

Cognitive meaning

To understand this we had better first get clear about the difference between this and the more common but here misleading usage of the term. That is the sense of "expression" which equates it with "the statement of a meaning." But this is the more common or "primary" meaning only because of that intellectualistic bias in our culture which unwarrantedly assumes that theorizing—of the kind undertaken by our so-called "pure" sciences—is the most important of our distinctively human activities. And it is to be observed that meaning in this sense is restricted to what is called "cognitive" meaning. To this, however, it is to be objected that there are other kinds of meaning such as "affective" meaning, or "conative" meaning of equal importance. "Cognitive" meaning in fact is, on most occasions, subservient or secondary to these other kinds of meaning. The actual state of affairs is, clearly, that feeling (as Peirce and others have pointed out) can occur without knowing, while every instance of knowing involves some kind of feeling. But it is also to be observed, in the second place, in connection with this sense of "expression," that by "statement" is usually meant "statement in propositional form." And this raises two questions: first, the whole question of statements or expressions in ethics or poetry whose logic is non-propositional and, secondly, the question of whether cognitive meanings themselves can be stated only in propositions—for there are "analytic" philosophers who would maintain that some meanings can be conveyed or *shown forth* that cannot actually be *stated* in so many words, and there are some poets who would maintain that complex expressions can carry meanings not reducible to the sum of the meanings of the parts.

Now, on these matters common sense tends today to be nominalistic, that is it tends to the view that language consists of mere sounds that happen to have been attached, by convention, *to* things or associated *with* sensations, perceptions, or thoughts—all of which are also thought by common sense to occur prior to speech. Language is then conceived to "express" meanings in much the same way that a

tube conducts air or an orange-squeezer presses out the juice. This, of course, overlooks the transforming effect which the act of speech has upon the things it takes up, and—equally grave—it fails to understand the function of signs in making reflection and anticipation possible, in creating the modes of recollection and prediction. As for *what* is expressed, this view believes that statements can be distinguished into referential (declarative), or cognitive, on one hand and emotive, or poetic, on the other, and that only the former are meaningful, that is, only the former state meanings. To the latter the status of pseudo-statements is imputed; for they are held not to state cognitive meanings. They are, in this view, generally held to express either personal preferences or suggestive nonsense respectively.

Sometimes, though, they are said to express emotive meanings, the latter being conceived as another kind of meaning than cognitive or referential. That is, it is sometimes agreed that feelings and emotions have references also, or even (as I. A. Richards maintained) are actually a more subtle way of referring to things and characters. Notice that this assumes (mistakenly) that meanings are always ways of *referring* to things. But meanings are just as much, or rather, ways of taking things or of thinking of them; namely, the meanings of things are what you take them for. Now it is just these other kinds, and notions of, meaning that we wish to understand, in the expectation that whatever clarity we can get about them will improve our grasp of the nature of expression in art. Peirce, for instance, maintained that emotions have a cognitive element, that is to say, that emotions are really predications about objects (5.247 and 1.250). It is, then, only an unexamined assumption that emotive language has no meaning. It is equally an assumption that the language of poetry is adequately described when it is conceived as primarily emotive. We need only remember, for doubt about this to arise, how I. A. Richards, one of the devoted students of these matters, progressed from the position that "poetry is the supreme form of emotive language," to the view that "poetry is the completest form of utterance." [3]

[3] In, respectively, *Principles of Literary Criticism* (Harcourt, Brace & World, Inc., New York, 1924) and *Coleridge on the Imagination* (K. Paul, Trench, Trubner, and Co., London, 1934).

Emotions and self-expression

Common sense today, however, is not only sci-
entistic, it is romantic and, in connection with
the arts, holds a view about expression that is as
partial as the one just outlined. This is the theory of art as the expres-
sion of emotion or, more crudely, of art as self-expression. And this
view is but the other side of the positivist coin without which, indeed,
the latter could not have gained currency. Here, as in the case of
cognitive meaning, something conceived as already existing is *trans-
mitted, conveyed,* or *aroused*—except that now it is emotion. One
gets the impression that the underlying analogy is of this emotion
being poured into the work, sometimes upon the audience, and some-
times just poured out by the artist. But there is not only inaccuracy
in this metaphor, it is also ambiguous.

The doctrine involved is inaccurate because expression is not
possible without a medium. Meansless expression is meaningless. An
act of sheer discharge that lacks a medium will not function commu-
nicatively. But the exhibition of excitement, the expression of emo-
tions, of welcome or repugnance for instance, all use the parts and
motions of the body as media or signs. This is what we know as the
language of gestures, once a certain range of expectations has accrued
to the latter in the light of the intentions with which they have been
charged or which they have been understood to signify. And, unless
qualified, the doctrine is ambiguous because there are occasions when
a third party may detect seeming signs of psychological states when
no expression or communication was intended. There is a further am-
biguity which this view must face, and that is whether it is merely his
experience of things, the impressions they make on him, that the artist
tries to express or whether it is some character or quality or relation
of the world itself that he is trying to show forth. This is a particu-
larly interesting question with regard to music; or in connection with
the way painters talk when they say that they have only put down
what they see. Notice the ambiguity in this, by the way!

Our own emotions are felt by us directly as bodily states. The

emotions of others are known only inferentially.[4] But people's utter-
ances of them, whether by gesture or in a suggestively organized
work of art, are understood only by an act of identification with the
subject of the utterance. Without the participation of others an "emo-
tionally charged expression" is meaningless, as in the case of incom-
municate schizophrenics. And it is probably impossible, even when
alone (unless one *is* a schizophrenic with his own impenetrable sym-
bolism) to rage without also expressing rage, to grieve without ex-
pressing grief, to be elated or anxious without elation or anxiety. For
even then the gestures accompanying the discharge of these passions
are potentially expressive, being socially conditioned and acquired.
We must realize that if human life is basically or pervasively social,
then it follows that all our acts are expressive (though not all are
intended to be). "Life itself," as Peirce said in a letter to Lady Welby,
"should be recognised as Expression." And, giving effect to much the
same perspective, the semanticist herself had said "language is only
the extreme of expression." [5]

Art and the analogy of language

It has by now become axiomatic that art is ex-
pressive—what needs to be cleared up is the sense
in which it is. But if art is expressive it is because,
like language, it expresses either the meanings of things, or the inten-
tions of human beings, or the ulterior consequences or contexts of
things and acts. Language and art, if you like, are kinds of expression;
just as anything can become the subject of language so can anything
become the subject of art. We need to remember, however, that in
its turn expression is a human adaptation with all that *that* implies.[6]
Thus, in connection with the arts, the question "what is the meaning

«9»

[4] "That a thing is agreeable appears to direct observation as a character of an
object, and it is only by inference that it is referred to the mind." C. S. Peirce,
Collected Papers, Vol. I (Cambridge, Mass.: Harvard University Press, 1931),
paragraph 250. It needs to be added that it is partly inferential and partly a mat-
ter of observation that the agreeableness of things is socially conditioned.
[5] See Philip Wiener, *Values in a Universe of Chance*. Selected Writings of
Charles S. Peirce (Stanford, Calif.: Stanford University Press, 1958), p. 415,
where both remarks may be found.
[6] See below Parts II, III and IV.

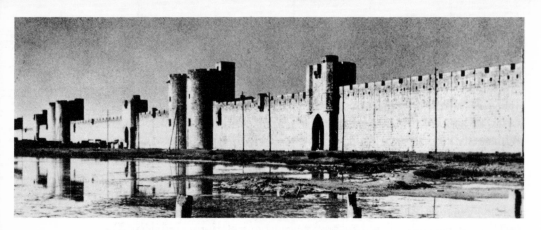

9. The Ramparts of Aigues Mortes. *From* Romanesque Europe, *published by The Macmillan Company, New York.*

« Meanings, intentions, consequences, contexts are expressed by art. »

of this work?" does employ the term *meaning* meaningfully, and is a legitimate question—in spite of some recent short-sighted suggestions to the contrary.

If the reader will consider the question just quoted, he will recognize that there is no lack of reference in the term meaning as used there. In the first place the reference may derive from a protest against the challenge of the work of art itself compounded by the shock of the unfamiliar. Secondly, the question may be a call for further specification of the vague impression or feeling of significance created by the work. The percipient will often have been actually enjoying the work while not quite yet knowing what to think about it or, as we say, what to make of it. He may not immediately know what it is doing to him, or what he may do with it, that is, how he may fit it in with the attitudes he at the moment holds. But now, isn't meaning that which anything has when we see a use for it, when we see it as a means or connective, when we see it functioning in association with other things? It is also possible that the perceiver is asking a question about the place of the work of art either in the history of art or in the context of the present, a question about what it adds to or changes in both, about what it is making us realize. Finally, it may be that people ask this question about *particular* works because they have yet to understand it as it applies to art in general. Every single true work of art also raises the fundamental or general question. "What is the meaning of *this* work of art?" will thus often mean

"what is the meaning of art?" But it must be pointed out that, conversely, even when one has some sort of answer to the general question, one can still ask the particular one by way of testing—or extending—the former.

If we consider the related questions, "what *is* this?" or "what is art?" it becomes obvious that these are *theoretical* questions. They are the kind of question, namely, the whole reason for which lies in our spectator or contemplative habits of relating to the world—or rather, of detaching ourselves from it. To put it in another way, these are the questions that we put to *things*, on the assumption that there are things-in-themselves. Perhaps, however, they are not the right questions to raise about those processes in which we are involved and which we do not wish to arrest. It is only under this aspect that the question "what is the meaning of this work?" may be off target, the fruitful question being rather "how am I to enjoy this work?" or perhaps "what satisfactions, perceptions, or insights does this work offer, or purport to offer?" But the prohibition against asking "what is the artist trying to convey here?" has certainly been overdone. For one thing, it is a question not far from being synonymous with the one just preceding it above; and if the former is valid then so is the latter. For another, we have read too much into MacLeish's lines, "A poem must not mean but be." [7] This issue will be further clarified in the sequel; all we need to say here is that because a work of art is something made or constructed, it is no disrespect to it to understand that it is also something meaningful. The question that must be faced is, again, the one about the validity of the analogy between art and language on which we are relying.

We are aware, as pointed out earlier, that the arts exhibit, but do not state, what art is. The question next besets us, can what art is be stated? The answer will depend upon the answer to another question, can what anything is be stated? If anything can, then, up to a point, everything can. But not everything may be worth the trouble of putting into words, for example, the fluid dynamics and the physiology of muscular and nervous activity in the art of swimming. It may happen, to put it another way, that the frame of reference or classificatory systems available, within which such-and-such is explained by being classified ("it is so-and-so"), are not at all relevant.

« 10 »

[7] Archibald MacLeish, "Ars Poetica," in *Collected Poems* (Boston, Houghton Mifflin, 1952).

39

Another and related question extrudes itself. Are there other ways of stating what things are than in words, for instance, by pointing, or presenting, or suggesting (subgesturing)? But these of course are ways of exhibiting. The issue becomes one of how we will use our words. We do well to limit "statement" to "statement in words." But we do not limit "expression of meaning" to "statement of meaning," for our whole position is just that meanings may be expressed by other means than words.

But the philosophy of art must use words. Poetry, the reader will say in the spirit of what he has read so far, exhibits what literary art is, but can language state it? Would it have to be non-literary language to do so? As we realize that language cannot stand outside language, we see that the difference between literary art and cognitive language is partly the difference between expression and statement. So that people who have the habit of calling for a statement whenever they are confronted by an expression are habitually missing the point. The further they go toward being "declarative" the further are they getting from the meaning being *expressed*. The only help in this case is to return to an unobtrusively creative use of language that

« Because an art work is
a construction, it is not
therefore not meaningful. »

10. *Haitian Ritual Art,* Vodou Ceremony. *Drawing by Vergniand Pierre-Noel.*

will bring into play the implicit lights of the literalist and restore to him something like what it was that was being expressed. And this is the way of it in connection with the other arts besides literature.

Observation of linguistic, communicative, and artistic activities shows that the various kinds of meaning are modalities of one another and can occur mixed. It may, in fact, turn out to be more difficult to find them occurring pure than mixed. But if this is so, does it mean that, as previously conceived, aesthetics is the attempt to reduce "emotive" or, more correctly, "expressive" meanings to "cognitive" meanings? If, however, we are to understand art otherwise than by becoming artists, but nonetheless not misunderstand it, we must refrain from reducing it to something else, we must be non-reductive, that is philosophical about it. Of course the philosophy of art will appeal to the artist in all of us, for it is safe to assume that every man is creative about something; and in this way the extension of our understanding of expression will be based on experience. But the philosophy of art will, with equal certainty, sooner or later find itself relying upon expressive language in performing its task of advancing understanding of the arts.

So that it can, after all, be put this way: if language is an art then *writing* about all the arts is assuredly an attempt to account for all the arts by the use of one of them. However, there are two things that must be said to this. First, this is not the same as saying that we are reducing all the arts to the art of philosophy or literature, but that philosophy is in its way literary, and that when explanation consists of the verbal communication of a meaning then explanation is, on some of those occasions, poetical. For, secondly, it happens that we customarily get and call for explanations in the form of words (though explanation can be effected otherwise). Hence the philosophy of art. To shirk these points is, basically, to shirk art and some facts about man. Civilized man is the creative animal who lives by art rather than by instinct. And the picturing or, more generally and correctly, the symbolising of things by means of which he copes with and relates to the world is of the essence of art, if not perhaps the art of arts or the skill of skills.

The basic skill must in the end be said to be living; and civilized living, living by his arts, the art of arts. The arts became possible, however, only when instinctual skills were developed into arts by the mediation of the symbolic process. It is therefore a shocking thing to

41

realize how anti-artistic our civilization has become, with the loss of the awareness that the sciences and our technologies, that our conduct and our actions are, at bottom, arts. No wonder it is difficult to explain the arts, when it is forgotten that explanation is itself an art and when our theoreticist blind spot keeps us from seeing so many human activities as so many arts.

Dewey once suggested to a correspondent that "perhaps the main function" of language was "that of picking things out of what Whitehead called the welter and arranging them so that they have form or pattern exactly as a painter picks out certain things and arranges them to make a painting a work of art." [8] Now this is an explanation of language in terms of art; the analogy between them illuminates both. To decide which is the more fundamental activity we would have to decide first what we mean by fundamental. If we mean prior in the order of human development, there would seem to be no reliable way yet of assigning such priority as long as by art and by language we mean non-instinctual activities. But if we mean to ask which is the more generic activity, the linguistic or the artistic, and if explanation is to go from the less to the more general, then we will probably have to explain language in terms of art (like Dewey above). As things stand in our highly verbal culture, however, people more often understand or have a feeling for aspects of language than they understand or have a feeling for art. And art may thus usefully be talked about in terms of the more familiar functions of language; though in the end it may be that art activity is the best, or basic, paradigm for all human activity.

But to return to the original point about the possibility of the philosophy of art, the philosopher does, then, have a recourse. And this is, to talk about the arts in terms of each other—but without confusing them, to discuss them not only in terms of art but in terms of science and conduct, and in terms of their mediation by symbols. Finally, he must be prepared to discuss art and the arts in terms of the human enterprise and of their relation to human intelligence.

[8] As quoted in "Texts and Motifs," *Daedalus*, Vol. 88, No. 3 (Summer, 1959).

Making and experiencing

Mimesis

The doctrine that art is expression is much younger than the doctrine that art is mimetic. Historically, it was formulated in contrast both to the narrowness resulting from the post-Hellenistic equation of "mimetic" with "imitative," and in opposition to the abuses of the Renaissance emphasis on representation as the principal criterion of success in painting and sculpture. I have already pointed to some of the difficulties in which the expression hypothesis is currently involved and suggested that they are connected with the inadequacies of a scientistic theory of meaning, and a "romantic" and one-sided or consumer's view of art. This does not mean that art is not expressive or that Romanticism was not a great and liberating movement. It only means that the expressive phases of art have been inaccurately described or not grasped by a scientistic vocabulary operating on the basis

of assumptions about the physical [1] world made for specifically different purposes than those of art. Similarly in my critique of the view that art is imitation I do not intend to deny that some of the world's works of art have been representational, or that in general art in some of its phases is in its own way referential,[2] and when not referential still meaningful.

The view that works of art are imitations or copies, though traditionally ascribed to Aristotle, is not—in this stark form—the view that he formulated in the *Poetics*. Aristotle's understanding was, on the contrary, that a poem (actually a poetic drama) is something made: "thing made" being, in point of fact, the translation of *poiēma*, the Greek word for "poem." In keeping with this, *poíēsis*, his word for "poetry," denotes a process or activity, a making and not—as both the unwary commentator and copy theorist allow us to think—a collection of poems or a quality evinced by poems. But poetry was also, for Aristotle, one among several kinds of *intellectual* activity (*pasa diánoia, Metaph.* E.1.1025b). Poetry was the kind of knowledgeable activity which had a product for its end (*télos*), an activity which sought to come out with a poem by means of the varied techniques the development of which constituted the art. We have already seen what the implication of this is for poetics, namely, that the aim of the art of poetry must be the working-out-itself (*to érgon*) of the work of art. The question here is, did he think the thing made was an imitation, or the making an imitating?

The answer had better be in Aristotle's own words: and when he says "all these [forms of making] turn out to be 'imitatings,'" the affirmative answer given by Hellenistic and Renaissance tradition seems justified.[3] But this, of course, is only so if we translate *mimēseis* by "imitatings"! It would seem, however, that if by imitatings we mean copyings then, for various good reasons, this is an impossible translation.

[1] Ambiguously so called, the ambiguity cloaking an identification of the everyday "Practical" world with a literal interpretation of the concepts of physics which takes them to have a descriptive rather than a directive or operational function.

[2] The term referential should not unpremeditatedly be assumed to be synonymous with the term representational. Nor should representationism and realism be simply equated without qualification. Professedly a representationist himself, Michelangelo, for instance, criticized the Flemish painters for being too realistic.

[3] *pasai tygchánousi oúsai mimēseis.*

44

11. Ancient Greek Stage. The Theater at Epidaurus.

« The formalization of impressions. »

But what can mimesis mean if it doesn't mean imitatings? The arts will answer for us; as when, having seen and heard Swan Lake performed by Ulanova, we say that Tchaikowsky's ballet is mimetic—and we become aware of the vast difference between such creating of a formal impression and a copying or imitation. Thus Marsden Hartley's painting of Lincoln is mimetic but in no sense a copy. Thus, again, when we think about music and conclude, like the nineteenth century thinker Bain, that music—even Greek music—is "only in a slight degree imitative of originals in nature" [4] the point suggests itself that, if Aristotle is going by the facts in saying that music is mimetic, the being "mimetic" is equivalent to being "in a degree imitative."

« 11 »

If mimesis is a process which only suggests originals, however, this means that mimesis is a process of suggestion. The outcome of suggestion, however, is not a copy but (minimally) the planting of an idea in the mind, and (at the most) an "expression" of the idea. Be-

[4] Alexander Bain, *The Emotions and the Will* (New York: D. Appleton and Company, 1876), p. 255.

45

tween "putting-in-mind" and "expressing" there is a continuum which ranges from a merely germinative function to acts as completely originative or constructive as those which in the arts we call creative. Note that I am not committing the fallacy of extension here, but identifying an ambiguity. When we talk of "suggesting" its grammatical object is "what it suggests" (a suggestion suggests what it suggests). But "what is suggested" is ambiguous in reference. It can mean "that which we are put in mind *of*" or "that which is put in our minds." Taking them dynamically what we have is a suggesting and a suggestion, with the "original" assimilated to the suggestion, indistinguishable from it in fact, and actually worked out in it. On this understanding the suggestion and the suggested are the same. Mimesis, then, turns out to be either a kind or degree of expression, or a phase of expressive—suggestive or creative—activity. It is a presentation or production, not a representation or reproduction, that is, not a copying but an expressive making.

I have referred to some observed facts, and done a bit of linguistic analysis; we must now look at Aristotle's text. In the first three chapters of the *Poetics* he notes that the arts differ in their media or the means which they use, and he notes that they differ in the manner of their making (for example the method of epic is narrative while that of a drama is dialogue). He also notes that the arts will be **different** (*éstai hetéra*) by virtue of mimetic-making (*mimeisthai*) of different things (*toi hétera*) in this way (*touton tòn trópon*). I give the Greek so that it may be seen that there is no reference to different original "objects" in *toi hétera*, but only to the different things that are the *result* of mimetic making. A reading of the last paragraph of chapter one and of chapters two and three of Aristotle's *Poetics* which is unprejudiced by the assumption that art is imitation will not read objects outside of, and prior to, the mimetic process back into the text. To retort "but the mimetic process must be *of* something" is simply to reiterate the prejudice in another way, for the mimetic process, as I am trying to show, is *constitutive* of the work of art. It is the creation of an object of art, not the copying of a given "object," a word, it is important to note, which the Greeks did not have but which is found in too many translations.

The point can be made in another way. For the traditional interpretation to be correct the phrases "what is imitated" and "what is mimetically made" would have to be equivalent, or would have to

denote the same thing. But we have seen that this is possible only when mimesis is assimilated to creation or, at least, to expression. That Aristotle does not go into this assimilation explicitly enough is another matter; but neither is he explicit about assimilating making to copying, only his commentators have been. But the explanatory value of the latter assimilation is too limited; it leaves out everything which differentiates making, or creative transformation, from copying or reproducing something already given.

The whole trouble seems to go back to the phrase in the *Physics* (Bk. II, ch. 2, 194a) in which art (*technē*) is said, in English, to imitate (*mimeitai*) nature (*physin*). The all-important nuance which I wish to restore can be communicated, even if ungrammatically, as follows: art makes like nature. Or, we could say: art makes things *in the same way* which nature does, for art, like nature, is an activity or process effecting changes in things, the latter giving rise to their characteristic growth and shape, the former to the development of human works. And this is the analogy on which the passage is based.

Oscar Wilde's brilliant quip about its really being *nature that imitates art* was based on the fact that it is from artists that we learn to see nature, or picture it to ourselves. But it has hardly been noticed that there is just as much basis in Aristotle's *Physics* for Wilde's remark as there is for its converse. This may be supported by a quotation from Wicksteed and Cornford's translation:

In any operation of human art, where there is an end to be achieved, the earlier and successive stages of the operation are performed for the purpose of realizing that end. Now, when a thing is produced by Nature, the earlier stages in every case lead up to the final development in the same way as in the operation of art, and vice versa, provided that no impediment balks the process. The operation is directed by a purpose; we may, therefore, infer that the natural process was guided by a purpose to the end that is realized. Thus if a house were a natural product, the process would pass through the same stages that it in fact passes through when it is produced by art; and if natural products would also be produced by art, they would move along the same line that the natural process actually takes. We may therefore say that the earlier stages are for the purpose of leading to the later. . . . If, then, artificial processes are purposeful, so are natural processes too; for the relation of antecedent to consequent is identical in art and in Nature.[5]

[5] II, 8, 199a.

It is relevant here that in the *Parts of Animals* (Bk. I, ch. 1, 639b) Aristotle makes a distinction between the science *with which* nature works and the theoretical science *of* nature.[6] So that if the science with which nature works is productive, then here it is nature which is like art, or is being explained on the analogy of art. If *poiesis* "makes" then nature, *physis*, "physics." Aristotle makes the point, in this place, that the kind of necessity which is attributable to "everything that is formed by the processes of Nature" is the same as that which is attributable to the products of art. Aristotle's analogy, then, is between the making of human products and the development of natural organisms, for he found that, in both, *the parts are related to each other in the same way* by what he calls a conditional, or hypothetical, necessity.

Art, for Aristotle, is the operative cause of the poem or thing made—or, rather, the art in the poet is the cause. In Book six, chapter four of the *Nicomachean Ethics* he calls art (*téchnē*) "an established disposition (*héxis*), or trained capacity, to produce in accordance with true reasoning (*metà lógou alēthous poietiké*)." Art is a "rational productive state of mind," or as Grant translated it, "a productive state of mind rightly directed." These definitions regard the art in the poet; here now is how he defined it in regard to the materials: "art is a beginning of change in something else (*he téchnē archē [metabolēs] en állōi*)." Or again, "all arts (*téchnai*), that is productive knowledges (*poietikaì epistemai*) are powers (*dynámeis*): they are principles (*archaì*) of change in another thing or in the artist himself as other." (*Metaph.* Lambda. 3, 1070a7 and Theta. 2, 1046b3).

"All art," adds Aristotle in the *Ethics* (loc. cit.), "has to do with creation (*génesin*), and with contriving (*technázein*) and considering (*theorein*) how something may come into being (*génētaì*)—be created—which is capable of either being or not being, and whose cause (*archē*) is in the maker (*poiounti*) and not in the thing made (*allà mē en toi poiouménōi*)." Here, as Grant pointed out, "contriving" and "considering" are to be understood, not in contradistinction to "creating," but as expansions of this term. "For art is concerned neither with things that come to be by necessity (*anángkēs*), nor with things that come to be by nature (*katà phýsin*), since these have their origin in themselves . . . and, in a way," he continues, "chance (*týchē*) and art (*téchnē*) are concerned with the same things . . ."

[6] See the note to page 58 of Peck's edition.

Notice the dynamism of all this; but notice too the ambiguous attitude to the nature of the materials reflected in the first and last of the phrases quoted. There is no doubt, however, that Aristotle considers art the exercise of a power, and an activity. As he says in the *Poetics*, "the end for which we live is a certain kind of activity, not a quality" (Ch. 6, Bywater's translation).

It follows from all this that the species of poetry (*ton eidon autes*) which are mentioned in the first line of the *Poetics*, the analysis of which occupies most of the rest of the book, are not species in the sense of different classes or kinds of poems but in the sense of different species of the poetic power, or of the working knowledge of technique as just defined. In other words, Aristotle's is not a study of genres in the common sense but an analysis of variants of the poetic power or art.

The reflection that art is to be considered a power which the artist has developed in himself may not at first startle the individualists among us. But it should when the emphasis is placed on the relation of this power to, and its derivation from, the developing and available techniques of the art. There is a healthy impersonality, nonetheless, about the view that it is *the art* of the poet which is the operative cause « 12 » of the poem. The poem, on Aristotle's account, is produced not by the maker as man or individual but by the man as maker. As he says in the *Physics* (II. 3, 195a34), "it is accidental to the sculptor that he is Polyclitus." So he might have said it is the tragedy-making technique of Sophocles (his play*wrighting*) that matters, and the epic art (how he did it) of Homer that matters, not Sophocles or Homer themselves. And, indeed, we find not a word in the *Poetics* about either of them as personalities, Aristotle's great admiration for them notwithstanding. The implications of this for the analysis of style would seem to be worth exploring, but it is clear that Aristotle does not think of art as *self*-expression.

Because expression, in modern times, has come to be habitually and unthinkingly associated with emotion we must next ask what is the relation of emotion to mimetic making in Aristotle? Tragedy, for him, no more expresses *given* or stock emotions, as in the popular theory, than it purges them, as in the pseudo-medical explanation. It creates dramatic objects—actions and situations—which are suffused with emotion and then resolves, or abreacts, that emotion. Careful attention to Aristotle's words on *kátharsis* within their context will

49

show that he has reference to a dramatic process and not to a psychological end-result. The objects of this process are "pitiable and fearful events" (*páthē*, or *páthēma*), not people. It is the doings and undergoings transacted between capable people familially related which are to be purified of their horror and terror. The worst and the ugliest of things that can befall a man must be brought under artistic control before they can be fully faced, and once faced, reflected upon. To see that it is not the audience which must be purified we need only ask (1) why should it be purged of two such valid emotions as compassion for men and fear of the consequences, and (2) how can pity and fear themselves relieve us of pity and fear? What the audience is relieved of at a tragedy are, I should think, the suspense and anguish

« It is the art of the artist which is
the operative cause. »

12. State Staircase, Palazzo Madama, Turin. *From* Italian Villas and Palaces, *published by Thames & Hudson, London, and Harry N. Abrams, New York.*

generated by the play itself and which it itself assuages by the resolution of the action within the universe of discourse of the tragedy.

It also becomes clear that the "carrying to completion" (*peraínousa*) of the purification is a matter of plotting and language, that is, of the way the events are put together (*sýstasis pragmátōn*). As he says in chapter fourteen, "since it is the pleasure that comes from pity and fear by means of mimetic making that the poet should provide, it is clear that this must be built into the doings (*phanerón hōs touto en tois prágmasin empoiētéon*). It is striking how this passage illuminates the catharsis clause in the famous statement where tragedy is defined as the mimetic making of a doing (*éstin oun tragōidía mímēsis práxeōs . . .*). For the catharsis clause itself let us use Gerald Else's wording: "carrying to completion, through a course of events involving pity and fear, the purification of those painful or fatal acts which have that quality" (*di'eléou kaì phóbou peraínousa tēn tōn toioutōn pathēmátōn kátharsin*).

The artistry of the work done upon, or with, the murders, incests, arrogances presented constitutes the tragic quality of the play. Granted that there is something like an "emotional assault" upon the audience with a (knowingly) simultaneous re-orienting of its psyche toward the image of man's destiny exhibited, or projected, in the particular tragedy—the way in which the *pathemata* are composed is, precisely, the plotting. And the plotting is just the binding ("binding" in both the objective sense of tying together and the psychoanalytic sense of controlling subjectively) of the painful sequence into a meaningful unity. The emotion which pervades this unity can only be called the emotion of humanity, for it is our humanity that has been touched (not purged away) by the tragic presentation.

The *Poetics* we have neglects the language (*léxis*) and concentrates on the dramatic aspects of the mimesis, but for Aristotle the latter was also, though less emphatically, a linguistic process. Here is what I mean. Aristotle thought, as he says in book Zeta of the *Metaphysics*, that "of things that come to be, some come to be by nature, some by art, and some by chance." Now art, or technique, is not a cause of coming to be in the same sense as nature, since in fact it presupposes nature, and is only the cause of the coming to be of a new form in a certain matter which already existed as a natural material. So tragedy, unlike nature—the doctor who doctors himself—does not write itself. The tragic art causes the coming to be of the tragic form

51

in words and actions: it is the power to make things happen in such a way, and within such a perspective (created by the language in its intellectual dimension), that they acquire the tragic quality. The tragic art does this by envisaging a certain order of development for the events, it does it by the use of creative language and song (or music), and by the use of actors and staging (or "spectacle"). And the distinctive peculiarity of all this productive activity, of all this making, is that it is "mimetic," or expressive in the sense assigned.

Now Aristotle does state in chapter four that this creative activity has natural causes: ordinary imitations, or re-cognitions, are both pleasurable and a basic aspect of our intellectual nature, since we get experience and learn by means of them. Also we take a natural delight in melody and rhythm—which are constituents of tragic poetry and out of which it grew. Cursory and difficult as the passages are in which Aristotle talks about these things, it is clearly implicit that, as verse, mimesis is partly a linguistic process. As such it will, after all, have in itself an inherent principle of movement, namely, that of human language. Language is a growth, taken from his culture and assimilated by the poet. And insofar as it is a growth it has such an internal principle of movement as may be ascribed to natural things in Aristotle's philosophy. In our day, this principle has been dissolved into the adaptive and responsive functions of language. But insofar as the linguistic process creates tragedy, or is mimetic, it has an external principle of movement, namely, the power of the poet over the language. And this is worth saying because the interconnections between linguistic processes and the processes of art define an area, it seems to me, upon which poetics today may fruitfully concentrate. Success in exploring the poetic process will probably throw some much needed light on the creative process in the other arts.

Representation versus expression

The position, however, that we need to state at this point and want to consider on its own merits is the position that art is imitation—or, as we had better say now—representation. We have found, however, that Aristotle is not a good spokesman for this position. Let us then consider it as it has been held by others before or after.

As a matter of fact, it is difficult to find any straightforward exponents of representationism outside of Platonism, the painter theorists of the Renaissance, and Neoclassicism. In Plato's *Republic* (Book Ten) the view is voiced that art imitates particular things and that, therefore, its products are twice-removed from reality. This inference follows from the stand Plato takes that only the intelligible, his realm of Ideas, is real and that things in the sensible world are mere imperfect copies of their Ideas. On such a philosophy works of art become copies of copies. Followers of Plato who had some respect for art sought to mollify the affront to it in this theory by stating that works of art copy not things but what groups of things have in common, namely, their general natures or essences. From this it was sometimes inferred that art imitates the universal in things, hence is of an ideal nature and thus is actually concerned with improving upon Nature.

So Sir Joshua Reynolds, in the third of his *Discourses*,[7] asks the artist to "consider Nature in the abstract and represent in every one of his figures the character of its species." And the procedure he urged for achieving this is "a long habit of observing what any set of objects of the same kind have in common," for this will result in "an abstract idea of their forms more perfect than any one original." While on the whole he believes that "this great ideal perfection and beauty are not to be sought in the heavens but upon this earth," he allows himself in a peroration of the ninth Discourse to lapse—with an excess of that very "enthusiasm" he elsewhere fashionably deprecates—into an extreme statement of the old Platonic outrage of the mental upon the visible: "The beauty of which we are in quest is general and intellectual; it is an idea that subsists only in the mind; the sight never beheld it, nor has the hand expressed . . ." In the end we are left wondering about even his more customary Neoclassicism when we find the statement in the eleventh Discourse that "he that does not at all express particulars, expresses nothing."

His intention, of course, is that the artist select just those particulars out of things which are of widest occurrence. And here at last he is talking about something which artists in fact do, namely, select, and something with which they are in fact concerned, namely, the particular—if by particular we mean the singular and the concrete (Reynolds seems to have meant the latter). But what do selection and

[7] Sir Joshua Reynolds, *Discourses*, ed. by Austin Dobson (New York: Oxford University Press, 1907).

13. *Sir Joshua Reynolds, Mrs. Siddons as the Tragic Muse. Henry E. Huntington Library and Art Gallery, San Marino, California.*

« Representation proceeds by selection,
and typicality is suggested by
the particular. »

particularity have to do with representation and ideality, respectively? This modification of representationism amounts to a statement that imitation is not imitation but selection, and that universality, or typi- «13» cality, is to be suggested by the particular. In other words, it is a statement that art proceeds by abstraction or selection in the light of what concrete or particular subject matter is capable of suggesting (expressing) even when the avowed purpose is "representation." As Goya the realist said at the end of Reynold's century, in the preface to his *Caprichos*, "Painting, like poetry, selects in the universe whatever she deems most appropriate to her ends. . . . From this combination, ingeniously composed, results that happy imitation by virtue of which the artist earns the title of inventor and not of servile «14»

F. Goya: « The artist earns the title of inventor. »

14. Francisco Goya, Los Caprichos, plate 75: "No hay quien nos desate?" National Gallery of Art, Washington, D.C.; Rosenwald Collection.

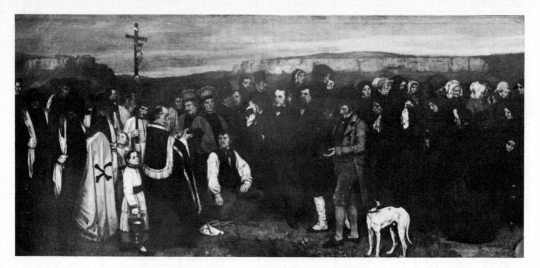

15. *Gustave Courbet,* Funeral at Ornans. *Cliché des Musées Nationaux, Musée du Louvre, Paris.*

Courbet: « Realism is at bottom a negation of the ideal. »

« 15 » copyist." [8] And as Courbet was to say in the next century, "realism is at bottom a negation of the ideal." Presumably because it did not go far enough realism itself is attacked, later, by Gauguin who wrote, in one of his letters to Monfried, "painting should seek suggestion more than description as does music." [9]

It is not just that realism—which is mistakenly supposed to illustrate or justify the view that art is representation—negates idealistic versions of representationism like Reynolds'. The latter doctrine has really only to be stated to be seen to be futile or circular. For it is based on the assumption that art represents ideals or types beyond or behind natural objects and enables us to perceive these otherwise supersensible realities. But if the reality can only be known by means of the work of art, it follows that aside from the work of art we cannot ever know what it is supposed to be a representation of. It also follows that we cannot ever judge one work to be better than another on the ground that it reproduces an unperceivable reality more beautifully than the other: for we would have to know, independently of both works, what it was that they have reproduced. If we cannot know what is being reproduced except by knowing the reproduction we can know neither that the reproduction is a reproduction at all, nor how

[8] Quoted in *Artists on Art*, 2nd ed. by R. Goldwater and M. Treves (New York: Pantheon Books, Inc., 1947), pp. 202-203.
[9] Gauguin's *Letters*, Edit. by Joly-Segalen, (Paris: Librairie Plon, 1950).

56

accurate a reproduction it is. Thus, even if the idealist version of the imitation theory were true it could not be verified or known to be true.

But could not art be considered as the imitation of knowable realities, as the reproduction in a given medium of things existing in nature of another medium? "Art" that could thus be conceived, however, would at first sight not seem to be art at all but merely reporting or—literally—translation. It would not only have no distinctive interest but would, in most cases, be unnecessary. The facts that are relevant to this issue, as one of fundamental theory, are the facts of art, of art history and its remotest beginnings in cave paintings and bone carvings, of primitive art [10] and of children's "art," of naive and folk art. The basic issue is whether the more pervasive and comprehensive category in terms of which art operates, or may be understood or responded to, is abstraction or representation. Our solution will be worked out in the sequel; in the next section, as part of the fair statement of the issue, we will formulate and comment upon the equally popular but rival view that art consists in the expression of emotion.

Emotion and expression

This attitude toward art has been well described by Herbert Read as believing that "art . . . gives outward release to some inner pressure, some internal necessity. That pressure is generated by emotion, feeling, or sensation, and the work of art becomes a vent or safety-valve through which the intolerable psychic distress is restored to equilibrium." [11] This wording is given first because of its imputation of a therapeutic function to art (art the reliever), and its recognition of a compulsive element in the creative process, both matters of interest which we will consider. While this wording also falls short of stating what it is that art expresses, most statements of this position leave no doubt that it is emotion, or passion, or feeling, or sentiments, or states of mind. In

« 16 »

[10] Gauguin is again of interest here: "Primitive art comes from the mind and *uses* nature. The so-called refined art comes from sensuality and serves nature." Quoted by R. Huyhe, *Gauguin* (New York: Crown Publishers, Inc., 1959), p. 74. The second sentence is already a value judgment, but the first seems more factual and verifiable.

[11] Herbert Read, *The Meaning of Art* (Baltimore, Md.: Penguin Books, 1959), p. 163.

16. *Edvard Munch,* The Cry. *Lithograph. National Gallery of Art, Washington, D.C., Rosenwald Collection.*

« ''Art gives outward release to some inner pressure'' (H. Read). ''For there to be expression there must have been compression in some sense'' (J. Dewey). But to psychoanalyze this work would be to miss its synaesthetic effects and design qualities. »

pursuing our study of the process of expression, we will at this stage only be concerned with that version of the expressionist view which may be called the emotionalist doctrine of expression.

Expressionism was, from the first, a revolt against the interpretation of art as the representation of an *antecedently* given external object. Art was conceived, in terms that rapidly became psychologistic, as an activity in which the feelings or insights of the artist—what he had been gifted with or had nurtured *inside* himself—came to be exteriorized for the edification of a wider public. As Goethe said to Eckermann, any effective tendency must come from the inside out, from the soul to the world. Expression is now thought of as a subjective act which takes place in an environmental vacuum, and tends to be discussed not only in abstraction from factors of the surrounding context but worse, in abstraction from the medium without which (as this book maintains) expression could not exist. This popular version of the doctrine that art is expression is, in a parallel way, just as crude as its representationist rival; for it, too, thinks that the things to be expressed exist preformed and antecedently—though now in the person, or subject, of the artist.

There are, of course, more thoughtful accounts of the expressionist view. Since Eugène Véron's *L' Esthétique* (1882), which was a hypothetical, genetic account of the development of art out of language, the most consecutive exposition is without a doubt contained in Collingwood's *Principles of Art*.[12] The only point it makes that we will take up here bears on the last assumption mentioned in the preceding paragraph. Collingwood makes no doubt that what the artist does is express emotion: he is particulary concerned to show, however, that a man who, in contrast, sets out to *arouse* emotion is not an artist but at best a craftsman, persuader, or entertainer. Then, having made this distinction, he develops the following thesis about expression: "Until a man has expressed his emotion, he does not yet know what emotion it is. The act of expressing it is therefore an exploration of his own emotions. He is trying to find out what these emotions are."[13] As the poet Wallace Stevens said, "poetry is of what does not exist without the words."

This is an important insight and Collingwood is quite right

« 17 »

[12] R. G. Collingwood, *Principles of Art* (New York: Oxford University Press, 1938).
[13] *Ibid.*, p. 111.

« 18 »

to insist on it. Expression is not of anything already given, but always of something created (see below). It may be contrasted with common sense statement; for if statement is the conveying of already elaborated objects of knowledge, then expression is not like statement at all. For expression is creative, constitutive precisely of new objects of enjoyment and perception. Antecedently to it only given materials, thematic and physical, not objects, exist; and it is the fate of these materials—as it would be of any object that got itself caught up among them—to be transformed into something else, namely, formal works-of-art. But if, Dewey points out in his *Logic*,[14] we go behind the commonplaces of conventional statement or behind the currently accepted objects of verified scientific hypotheses and find that the

[14] John Dewey, *Logic, The Theory of Inquiry* (New York: Henry Holt & Company, Inc., 1938).

« Expression is a subjective act. "Until a man has expressed his emotion, he does not yet know what emotion it is." (Collingwood) »

17. Adolph Gottlieb, The Seer. The Phillips Collection, Washington, D.C.

« Expression is also an objective act. »

former are arbitrary precipitates as the latter are amendable, then statement in the investigative sciences is like expression: for it is concerned with the formulation of things that could have been put otherwise, or reformulated, and with the creation or invention of new objects of knowledge that are *relative* to the specific and ongoing purposes of science.

Experience and invention

But now, is it indeed emotion, as both Collingwood and the popular view maintain, that art expresses? There is no doubt that emotion accompanies the creation and appreciation of art; but what human activity is not accompanied by it? And if emotion occurs as a concomitant of all human activities then it would certainly not serve to differentiate

expressive or creative activity from other activity. Even so we would still like to be clear about what "emotion" refers to. And understanding becomes imperative if we consider the latent corollaries or alternatives to Collingwood's view. Does he mean that emotion is the *content* of artistic expression or works of art? There is also a puzzle if he means that art defines emotion in the sense of creating a consciousness of it; just as there is if he means that a previously non-existent emotion is given form or rhythmic structure by previously existing forms. For, having been given antecedently, these forms would be external to the work of art, and cannot be what is expressed by it. Collingwood cannot mean either that these forms act to *arouse* emotion, for on his own view this would not be artistic but excitement or entertainment by means of craft formula.

It is clear that Dewey was right when he pointed out, referring to the individualization of works of art, that "the notion that expression is a direct emission of an emotion complete in itself entails logically that individualization is specious and external." [15] For, if the emotion is already determinate, then the particular formal vehicle used to convey it is not only adventitious but a matter of indifference. This criticism also gets at the weakness in the idea of "the objective correlative" as a doctrine about how poetry is made; for, according to this idea, the poet *starts* with an emotion and after casting about finds objective data, things, or situations which he believes can be used to embody it. Thus the question which arises at this point is, indeed, one which Dewey has raised and answered, namely, what exactly is the role of emotion in the experience and the making of works of art?

Like Aristotle, Dewey did not think that emotion constitutes a distinct subject matter for aesthetic study—as it would, for instance, if Collingwood's formula for art as "the expression of emotion" were true. Emotion is not the content of the work of art: were it so, the more emotion manifested, the greater would the work be judged. It is obviously not the case that the more emotion there is "in" a work, the more effective it is as expression.[16] Emotion is not exhibited but *used* by art. In Dewey and in fact, it is the work done by, or under emotion, that is the process of expression which is a subject for aesthetic inquiry. Thus the whole of chapter four of Dewey's book is a rejection of the notion that expression is merely a process

. « 19 »

15 John Dewey, *Art as Experience*, p. 67.
16 *Ibid.*, p. 69.

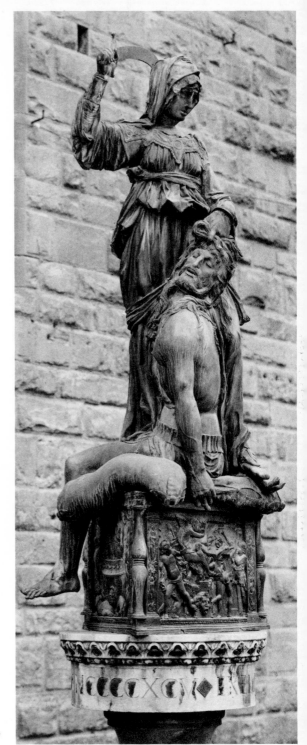

« It is not the case that the more emotion there is in a work the greater it is. »

19. Donatello, Judith and Holofernes. *Piazza della Signoria, Firenze.*

20. Interior, Palazzo Ducale, Urbino. *From* Italian Villas and Palaces, *published by Thames and Hudson, London, and Harry N. Abrams, New York.*

« Emotion must be expended indirectly upon things. »

64

of discharging personal emotion. But because this rejection, for polemical reasons, requires a surprising amount of negative discussion of the topic of emotion itself we must not be misled into taking Dewey as an emotionalist.

Emotion, in Dewey, as in recent psychology generally, is simply any activation or agitation of the human organism. This has to be made clear because, in annotating everything that emotion is not, Dewey forgets to tell us in so many words what it is. But it also has to be remarked that in Dewey, interested as he was in the continuities among observable processes, emotion is something more than just physiological. It seems to be the stage in the process by which sheer response, or energy, becomes feeling, and feeling foreshadows full awareness. So he considers that emotional discharge is perhaps a necessary but certainly not a sufficient condition of expression. He insists, however, that as a discharge, emotion to become available to expression must be expended *indirectly* upon things (objective materials). Further, emotion or energy is not all that is evoked in the contact with, or manipulation of, objective and resistant materials. There is also a "qualitative . . . transformation of energy into thoughtful action. . . . Things in the environment become, "are seized upon" as "means, media" to some end in the light of their possibilities.[17] Artistic construction, and appreciation, are for Dewey "as much a case of genuine thought as that expressed in scientific and philosophical matters." [18] There has to be, in creation, "administration of subjective conditions"; hence emotion is always *about* something objective, or *to* or *from* it.

« 20 »

Emotion, in other words, is *from the first* and in increasing degrees intellectualized. Emotion is always implicated in a situation. Short of complete panic or blind thrashings and dischargings, excitement will utilize motor channels of action already worn by previous dealings with objects and will envelop such objects as it finds to the purpose with its own developing quality.[19]

The fallacy which is being exposed here is "the notion that an emotion is complete in itself within, only when uttered having impact upon external material." [20] For example, team elation in a victory, or

[17] *Ibid.*, p. 60.
[18] *Ibid.*, p. 116.
[19] *Ibid.*, pp. 66-67.
[20] *Ibid.*, pp. 66-67.

65

sorrow upon the death of a friend, cannot be understood except as interpenetrations of selves with objective conditions:

> Save nominally, there is no such thing as *the* emotion of fear, hate, love. The unique, unduplicated character of experienced events and situations impregnates the emotion that is evoked. Were it the function of speech to reproduce that to which it refers, we could never speak of fear, but only of fear-of-this-particular-oncoming-automobile, with all its specifications of time and place. . . . A life time would be too short to reproduce in words a single emotion. . . . poet and novelist have an immense advantage over even an expert psychologist in dealing with an emotion. For the former build up a concrete situation and permit *it* to evoke emotional response. Instead of a description of an emotion in intellectual and symbolic terms, the artist "does the deed that breeds" the emotion.[21]

There are, then, no singular or atomic emotions-in-themselves; emotion is always individuated or differentiated by reference to its objects.

The question which now arises, however, is whether emotion is causally operative in the process of artistic production, and whether some other factors are not also operative. In Yvor Winters' poetics, for instance, the feelings in a poem are *motivated* by concepts; he says that any rational statement will govern the general possibilities of feeling derivable from it, and that the task of the poet is to adjust feeling to motive *with precision.* "He has to select words containing not only the right relationships within themselves, but the right relationships to each other." [22] Winters' position is—textually—both that the motive for the poem is its rational meaning, and that a work of poetic art is a *statement about* an experience in which special pains have been taken with the expression of feeling.[23]

This view is in strong apparent contrast to that of Dewey, who preferred to say that the poem *is* an experience but who, however, also explained judgment as a kind of adjustment (see below, chapter eight). Dewey maintains, as a result of his observation, that emotion is pointedly operative; that, for instance, "the determination of the *mot juste* . . . is accomplished by emotion." [24] Because we accept Dewey's emphasis on quality we find no difficulties in the view that

«21»

[21] *Ibid.,* p. 67.
[22] Yvor Winters, *In Defense of Reason* (Denver, Colo.: Alan Swallow, Publisher, 1947), p. 367.
[23] *Ibid.,* pp. 363, 491.
[24] J. Dewey, *op. cit.,* p. 70.

21. *Willem de Kooning,* Door to the River. *Collection of the Whitney Museum of American Art, New York. Gift of the Friends of the Whitney Museum of American Art.*

« The task is to adjust the feeling to the motive with precision. »

« 22 » it is emotion that works to effect continuity of movement and single-ness of effect amid variety in art works. But it is not as easy to agree that, by itself, emotion is also *selective* of material and *directive* of its order and arrangement, unless we are allowed to stipulate that the kind of emotion within which works of art are generated is necessarily highly processed, and already reflective—else it would not be able to discern latent appropriatenesses and associations.

If this qualifier applies, however, then the position is not so different from Winters'; for Winters is also aware that emotion and reason are simultaneously and inextricably operative in any statement or expression. His intellectualism—except for his belief that poetry is statement—then becomes as indistinguishable from Dewey's empha-sis upon the role of intelligence in the task of creative selection as emo-tionalized intelligence is from intellectualized emotion.

For there to be expression, according to Dewey, the primitive and raw material of experience needs to be reworked. By expres-sion, however, he means the double process, the interaction, by which

« Emotion works to effect continuity of movement and singleness of effect; but it is also reflective in being directive of arrangement and selective of materials. »

22. Henry Moore, Family Group. *The Phillips Collection, Washington, D.C.*

the artist, with (1) his store of already worked experience and (2) his exploratory or constructive intent, transforms materials into a work of art. Dewey notes with respect to the physical materials that everyone knows that they must undergo change, but that it is not so generally recognized that a similar transformation takes place on the side of "inner" materials, images, observations, memories. And he insists that "the work is artistic" only "in the degree in which the two functions of transformation are effected by a single operation." [25] In expression « 23 »

> everything depends upon the way in which material is used when it operates as a medium . . . it takes environing and resisting objects as well as internal emotion and impulsion to constitute an expression. . . . The act of expression that constitutes a work of art is a construction in time, not an instantaneous emission . . . the expression of the self in and through a medium, constituting a work of art is itself a prolonged interaction of something issuing from the self with objective conditions, a process in which *both* . . . acquire a form and order they did not at first possess. . . .[26]

The better to note the characteristic anti-dualistic emphasis which Dewey puts on the observation that expression is a double transformation, it is worth quoting another passage:

> whether a musician, a painter, or architect works out his original emotional idea in terms of auditory or visual imagery or in the actual medium as he works is of relatively minor importance. For the imagery is of the objective medium undergoing development. The physical media may be ordered in imagination or in concrete material. Only by progressive organization of "inner" and "outer" material in organic connection with each other can anything be produced that is not a learned document or an illustration of something familiar.[27]

The emphasis on the continuity between inner and outer implies that the personal pole of the process of expression may not be isolated from the expressiveness of objective materials. It is also typical of Dewey, as it was of Peirce, that he insists on the objective reference of the feelings operative in expression. Human or psychic energy is called up and thrown into commotion by some need or some condition of the environment, and would without an expressive act of some

[25] *Ibid.*, p. 75.
[26] *Ibid.*, pp. 63-65.
[27] *Ibid.*, p. 75.

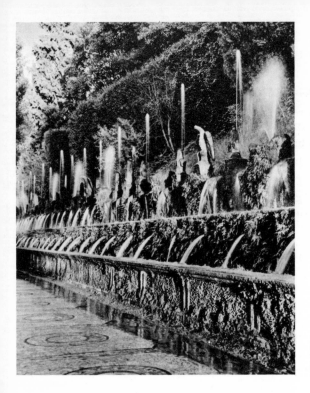

« In the expressive act energy is put to work on objective materials. Some meanings are as inherent in experience as those of a flower garden. »

24. The Terrace of the Hundred Fountains. *Villa d'Este, Urbino. From* Italian Gardens, *published by Thames & Hudson, London, and Harry N. Abrams, New York.*

« 24 »

kind brim over. But in the expressive act energy is put to work on objective materials; it is a little as if the sea itself or the flood were put to use in building the very dams and breakwaters which make them usable:

Unless there is com-pression nothing is ex-pressed. The turmoil marks the place where inner impulse and contact with environment, in fact or in idea, meet and create a ferment. . . . Hence it is not mere excitement that is expressed, but *excitement-about-something.*[28] [My italics]

The thing expressed, Dewey says, is wrung from the producer by the pressure exercised by objective things upon the natural impulses and tendencies. For example, raging is distinct from expressing rage in a set of sharp well honed phrases. The human being has to become aware of the intent implicit in his impulsion; only then are the attitudes of the self informed with meaning. As already noted, when energy is generated so are meanings, at the same time, called up from past experience:

[28] *Ibid.,* p. 66.

70

The quality of what is seen and heard varies with past experience. The scope of a work of art is measured by the number and variety of elements coming from past experience that are organically absorbed into the perception had here and now.[29]

Expression, then, will in general consist of the fusing of emotive and ideational "materials" with more sensuous and physical materials, of the suffusing of a medium with developed quality, feeling, or allusiveness. In art (as in science, for that matter, according to Dewey) "there is emotionalized thinking, and there are feelings whose substance consists of appreciated meanings or ideas." [30] So that, in general, the real *work* of art is the building up of an integral experience out of the interactions of the human psychosocial organism with environmental conditions and energies.

Dewey is particularly sensitive to the distinctive nature of significance in the arts:

Thinking directly in terms of colors, tones, images is a different operation technically from thinking in words. . . . If all meanings could be adequately expressed by words, the arts of painting and music would not exist. There are values and meanings that can be expressed only by immediately visible and audible qualities, and to ask what they mean in the sense of something that can be put into words is to deny their distinctive existence.[31]

In the kind of quotidian practical meaning which involves purely external reference, the sign or symbol points to or stands for something other than itself. In this case, Dewey's doctrine is that meaning does not belong to the sign of its own right but belongs to it by convention; the contrary is the case in art. Art forces us to observe:

But there are other meanings that present themselves directly as possessions of objects which are experienced. Here there is no need for a code or convention of interpretation; the meaning is as inherent in immediate experience as is that of a flower garden.[32]

Dewey's views on art and expression will not be understood if we do not appreciate the fact that, like Peirce, he believed feeling to be both proto-cognitive and proto-poetic, as we might put it. Thus his view

[29] *Ibid.*, p. 123.
[30] *Ibid.*, p. 73.
[31] *Ibid.*, pp. 73-74.
[32] *Ibid.*, p. 83.

that expression is a clarification of turbid emotion is intelligible by reference to his account of the process as one in which emotion is polarized about selected materials which are reformed or informed, transformed, in the light of the artist's expressive intent, and which are used to exhibit what he has to express. If I may pun without being misleading, the artist by feeling about things in certain ways makes something out of them. Though, of course, the validity of what he makes of them is not to be judged according to scientific standards for the reason that the context of the significance he is developing in them is not scientific. If any standards are to be applied they must be those of purely felt sequentiality and aptness, and ultimately of the kind of consummatoriness that the experience affords. And this is so because the context in art is a search for the kind of satisfaction which supervenes, without further action, upon realized meanings.

If emotion, attitude, suggestion, and interpretation are the personal contribution of the artist, what he expends upon his materials and what they draw out of him in given contexts, then expression is «25» *inventive*. But insofar as the created significance is shared by others, there is communication. So that expression is also a *social* process and functions as discovery. The artist has indeed "made something intelligible" in the two important senses of these words.

For Dewey and for pragmatism, qualities are *brought out* from nature in the same sense, say, that gasoline is derived, or produced, by human industry from raw materials. Dewey no more *imputes* qualities to nature than gasoline is imputed to crude oil. Nor is gasoline any the less *discovered* in crude oil because it has to be manufactured or extracted from it. Just as, in inquiry, qualities belong not to the "objects" inquired into (what Dewey calls the "subject matter" in his *Logic*), but to the objective of inquiry, that is to the "objects of knowledge" which are the consummation of inquiry—so, in the process of art, it is the outcome of expression, i.e. the work of art, which exhibits the qualities felt to be immediate or moving. The way J. H. Randall puts it in Chapter 10 of *Nature and Historic Experiences* makes Dewey's meaning clearer, namely, that one of the things works of art do is to "immediatize" experience as well as order it. Works of art, Randall says, "qualify" the human pole of the aesthetic transaction with "immediacy."

But just because the experience of art is shared and immediatized it puts the participants of it into a special relation with their surround-

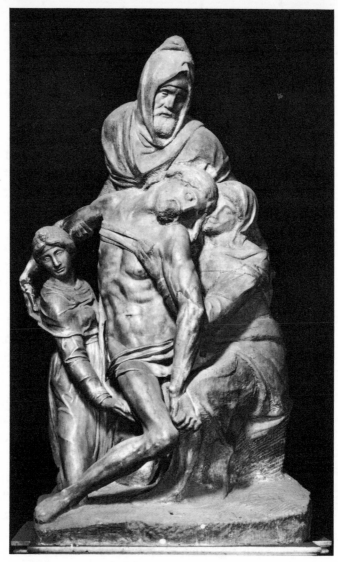

25. *Michelangelo Buonaroti, Late Pietà. Palazzo Rondanini, Rome.*

« Expression is inventive, and a social process
which functions as discovery. »

ings. The creative or selective transformation of the material drawn into experience both enhances the vitality and consciousness of the interaction which is human living and reveals unsuspected possibilities and continuities in it:

The moments when the creature is both most alive and most composed and concentrated are those of fullest intercourse with the environment in which sensuous material and relations are most completely merged.[33]

Now it is this merging of the ideational with the emotional, of the sensuous with the relational, the motor with the sensory, that constitutes the expressiveness of objects. But the expressiveness of objects is generally overlooked in quotidian and practical contexts. Routine "apathy and torpor conceal this expressiveness by building a shell about them" first, and then lull us into believing that the form we take them to have in our practical intercourse with them is fixed and necessary:

« 26 » The conception that objects have fixed and unalterable values is precisely the prejudice from which art emancipates us. The intrinsic qualities of things come out with startling vigor and freshness just because conventional associations are removed [34]. . . . Art throws off the covers that hide the expressiveness of experienced things; it quickens us from the slackness of routine and enables us to forget ourselves by finding ourselves in the delight of experiencing the world about us in its varied qualitative form.[35]

Dewey, like Aristotle, rightly opposes *art*, which they both consider a productive activity, to *contemplation*. Whereas Aristotle deemed contemplation a high point in the theoretical or scientific life, for Dewey it is merely aesthetic in the original, etymological sense of "aesthetic," and affective only.[36] Art, for both of them—as it is for every artist—is an affair of practice, a point which too many aestheticians forget. But this is not the contrast in which modern thinkers are as much interested as they are in Dewey's opposition of expression, as terminal or completive activity and consummatory interaction, to *statement*, which is directive, as in modern experimental science, and transitive.

Statement, according to Dewey, only leads to an experience.

[33] *Ibid.*, p. 103.
[34] *Ibid.*, p. 95.
[35] *Ibid.*, p. 104.
[36] John Dewey, *Experience and Nature*, p. 356.

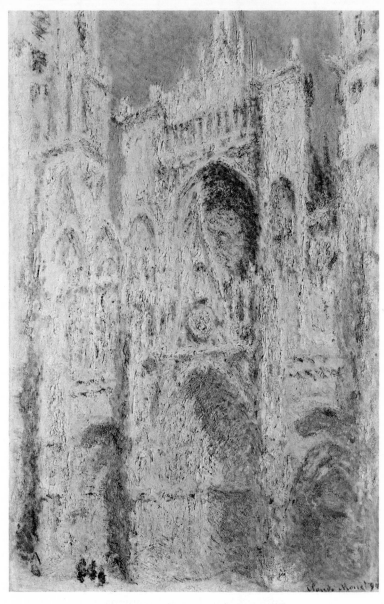

26. *Claude Monet*, Rouen Cathedral, West Facade, Sunlight. *National Gallery of Art, Washington, D.C.; Chester Dale Collection.*

« That objects have fixed and unalterable qualities
 is a prejudice which blocks expression
 of their qualities. »

75

Expression, however, constitutes an experience, is one. Accordingly he observes that poems or paintings do not operate in the dimension of scientific or directive statement but in the dimension of experience itself. The poet deals directly with the qualities of situations in such a way as to express their meaning, and to release in us a response informed only by these meanings and otherwise unfettered. The scientist deals with things at one remove, through the instrumentality of symbols that stand for qualities or properties indirectly, but which are not themselves immediately significant. Scientific symbols do not themselves possess the qualities they stand for. Scientific symbols do not express meanings, they simply state them, and are of the nature of directions couched in such a way as to protect the agent from interference by the emotional factor in achieving the control which he seeks, for scientific purposes, over objective conditions. While there is emotionalized thinking in both science and art, as noted earlier, in science the technique consists in the use of symbols that neutralize emotion.

In poetry, on the contrary, in artistic thinking or construction, the symbols used or invented are such as will express the emotion in which the productive activity is involved.

Prose is set forth in propositions. The logic of poetry is superpropositional even when it uses what are, grammatically speaking, propositions. The latter have intent; art is an immediate realization of intent.[37]

The logic of poetry, as Dewey propounds it in *Experience and Nature*,[38] is animistic. Words act upon things indirectly, as signs. But since words also express the significant consequences of things, i.e. the traits for the sake of which they are used, it is not surprising that words are also used to act directly upon things in order to bring about a release or exhibition of their latent powers. Things are invoked or events conjured as if they were amenable to human purposes; they are called upon animistically. Now the extraordinary thing about poetic communication is—that they are made to answer. And this is the consequence of a direct transfer of properties of the social situation of communication between persons to an immediate relationship of things to a person. The expressiveness of things is developed for the sake of the immediate—not unmediated, but not instrumental—satisfactions

[37] J. Dewey, *Art as Experience*, p. 85.
[38] J. Dewey, *Experience and Nature*, p. 181 ff.

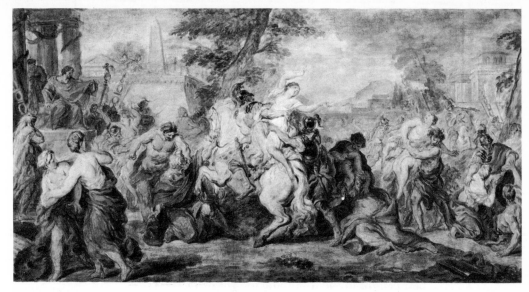

28. *Peter Paul Rubens,* The Rape of the Sabine Women. *National Gallery of Art, Washington, D.C.;* Widener Collection.

« The organization of energies into a cumulative whole is of the essence of art. »

things or events may yield. Not only is an intent participated in by the reader but an experience is enacted by him, either as poet or in the footsteps of the poet.

Now expression is for Dewey, as mimesis was for Aristotle, a process directed towards a certain end, but the end is not something fully foreseen and preconceived—as any artist we may wish to consult will tell us. The correlation has often been remarked that the greater the art exhibited the greater is the unexpectedness—and memorability—of the thing worked out.[39] It should be noted, however, that art has not just the effect on us of discovery but is itself a process of discovery. The work of art does not exist until it is made; and this is true even when the artist is in possession of the power to make it before he actually does so. But it will also be true of the artist that every work of art he makes is, in some way, a development of his powers.

« 27 »

[39] Even in the case of the performing arts. See, for instance, Mary Drage, "The Dancer," in *The Arts, Artists, and Thinkers,* ed. by J. Todd. (New York: The Macmillan Company, 1958). The composer or author in performing arts necessarily is giving an opportunity to somebody else to contribute creatively to the realization of "his" artistic product.

77

Expression is not of objects of knowledge; these are instrumental and conventional, and the objects of scientific statement: though, as we have noted, the first formal and well-formulated assertion of a scientific hypothesis may have, as discovery, much in common with an artistic expression. The expressive object is an object of, and for, creative experience, the enactment of an integral response in a given medium formally worked. It is the outcome of a constructive process in which the qualities of the environment or of any objective material are immediatized, and in which therefore the significance of these qualities requires, as already stated, no code or convention of interpretation to be apprehended. The similarities as well as the differences between the objects of science and the objects of art are, perhaps, best caught in the following insight of Dewey's:

> We are aware that thinking consists in ordering a variety of meanings so that they move to a conclusion that all support and in which all are summed up and conserved. What we perhaps are less cognizant of is that this organization of energies to move cumulatively to a terminal whole in which the values of all means and media are incorporated is the essence of art.[40]

[40] J. Dewey, *Art as Experience*, p. 172.

« 28 »

78

PART THREE

Art

Psychoanalysis, Gestaltism, and art

The experience of each age requires a new con-
fession, and the world seems always waiting
for its poet.

<div align="right">Emerson</div>

Art as a cultural symptom

We have become accustomed, within the evolu-
tionary and pragmatist perspective, to admit that
there is a sense in which everything we do is
"adaptive." Similarly, we have conceded to the
psychoanalysts their insight that there is also a
sense in which everything we do is "compensa-
tory." There is another usage, however, only
slightly less general, which we admit in our talk
about art that is much vaguer, and more ambigu-
ous. Talk about art commonly takes for granted
that in some sense all our works are "sympto-
matic." Then, beyond this, works of art are

assumed to be specially, or somehow more, symptomatic not only of our "states of mind" but also of our historical circumstances—more symptomatic than our journalism, say, or our sciences.

If there is a basis in fact for these beliefs, it is this, that the work of art affords a means of participation and not just communication. Thus what it "tells us about," if anything, is more deeply realized than when conveyed through non-artistic media.

Nonetheless, there would seem to be at least a surface difference between a mode in which things are perpetuated for feeling and consciousness and a mode in which the pattern is treated as evidence, or as documentary, of historical or psychological states of affairs. If there should turn out to be no difference, if the power of art as a perpetual source of delight should turn out to be related, at a more basic level, to its enmeshment with human history and the human psyche, then it must be our concern to uncover this relationship.

Another reason that is sometimes implicitly invoked in discussions of art as a social symptom is that, as a matter of fact, there is more pioneering among artists than in other groups devoted to intellectual activities.[1] Is there actually less pioneering, however, among scientists than among artists? Both, as we define the artist and the scientist, are concerned with discovery and creation. Is it, perhaps, the fact that the artist, characteristically a nonconformist, has more to say about the times in criticism of them than less reflective people who seek to be of their times and find status in them? There is a grain of truth in this explanation in that, more readily than in other callings, the critical powers of the genuine artist, habituated to the uncompromising rejection of the ersatz, will be applied with equal forthrightness to the acceptance and rejection of the values and customary modes of action "offered" by the culture. But when the artist *says* anything directly about the latter he does so, of course, outside of his art; or, if he is a literary artist, he may do so within his work but by implication only. As we have seen, he does not, like the routine social historian, deal in statements but in expressions.

[1] Cf. Kenneth Burke: "The artist, in dealing with ethical revaluations . . . had to make those conflicts explicit which the scientist could leave implicit. He got his effects by throwing into relief those very issues which the scientist could treat by circumlocution, implication, and the mystical protection of a technical vocabulary. Thus, whereas science for the most part was permitted to progress in peace, the artistic equivalents of this science produced a succession of scandals." *Counter-statement*, 2nd ed. (Hermes Publications, Los Altos, California, 1953), p. 65.

Still, we find art historians and thinkers persisting, from the nineteenth century to the present, in supposing that art—or some one of the arts—is the most explicit embodiment or reflection of the "spirit of the age." It seems to me, however, that when we put our questions about the age to art, as to the oracle, what we get is still—as of old—a richly ambiguous reply. This intellectual response of thinkers and historians to art, from Hegel to Wolfflin and S. Giedion, from Hazlitt to A. N. Whitehead, is significant and touching as a faith, but it must also be examined as an assumption.

As an assumption, it seems to involve the proposition that art has the effect of, or works as, a kind of confession. As a working hypothesis of historiography this one has been justified by fruitful results. For the moment, however, we must consider it for the sake of what it implies as to the cultural historian's understanding of art.

« 29 »

Today, this supposition about the confessional nature of art would be called Freudian. But in its shadow lurks another prejudice, and this prejudice is a "realistic" one. It is certainly a realistic, and a psychologistic, prejudice that leads a sophisticated critic to say, for example, that "The art that does not show us enough of ourselves and of the kind of life we live . . . does not release enough of our feeling." [2] I suppose that the intention was not to exclude Japanese painting, or African sculpture, or any of the arts and movements that do not conform to this realistic test, but that is the effect of it. Perhaps this position could be defended, however, by maintaining that such arts tell us things about "ourselves" that transcend superficial regional differences. Note, interestingly, that this defense implies that art tells us things about the human condition at some more basic level. We must inquire, later, whether this is not what some of the existentialists are maintaining, and whether it does not constitute an unwitting abandonment of realism.

It is true, as Harold Rosenberg has pointed out, that the situation of the modern artist is such that if he is not working at the frontiers of his art his work will, most likely, be either indistinguishable from that of his contemporaries in what it contributes to the art or it will be neo-academic.[3] What happens within this competitive cultural situation is that new gains by a particular artist in "self-revelation," or

[2] Clement Greenberg, "The Present Prospects of American Painting and Sculpture," *Horizon*, No. 93-94 (October 1947), p. 25.
[3] Harold Rosenberg, *The Tradition of the New* (New York: Horizon Press, Inc., 1959).

personal competence, are offered as or mistaken for genuine technical innovations. And this situation can exist wherever the public and the criticism, or better, the understanding of an art by its society fails to keep up with original achievement in it.

The psychologistic criticism of the last five decades is, in fact, all of a piece with our self-centeredness. But it is more specifically to be blamed than the latter not entirely unnatural tendency in its encouragement of false pioneering under the guise of advances or discoveries. I call this false pioneering because the assumption upon which it proceeds is that it is the subject matter, in this case the psyche, which of itself is interesting. And this old fallacy of subject matter [4] is not attenuated by the fact that today the human ego absorbs so much of our attention—on the contrary, this only compounds the error. Bad literature, for example, is excused on the plea of its confessional content. "These are things that nobody has expressed before," goes the cry, when what we should be able to say is, "Nobody has ever expressed things like this (in this way) before."

The basic questions which arise here are (1) the nature of the interconnections between symptoms and expressions; (2) the sense in which technique is, legitimately, discovery; and (3) whether the revelation, or experience—the concentrated realization—of the human condition in its truth is the job, or part of the job, of art? The third question will be dealt with in a later chapter; here we will consider the first two.

In connection with the first of these questions it must be pointed out that, for Freud, art is both a symptom of psychic states and a compensatory activity. It is more basically the latter since, though art is not neurotic, expression is supposed to be like the symptom in working on, or with, repressed material. But in being *substitutive*, within the economy of the human psyche, all neurotic symptoms are compensatory. They are, that is, not just a sign of, but also a substitute for, something else, namely, a repressed instinctual gratification.[5] If this is so, then what art may be presumed to do for the cultural historian is

[4] Cf. Larry Rivers: "only for the primitive and the semantically misinformed can enthusiasm for subject matter be the inspiration for painting." *Art News*, Vol. 60, No. 1 (March, 1961).

[5] See, for example, "The Poet and Day-Dreaming," or *Civilization and Its Discontents*, and *Inhibition, Symptom, and Anxiety*. But see also *Autobiography* and "Dostoyevsky and Parricide," for Freud's recognition that psychoanalysis cannot really account for art.

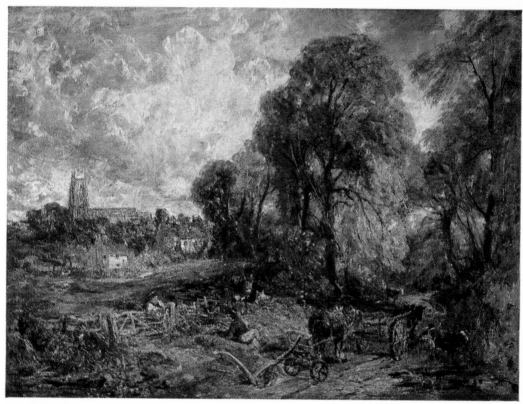

8. *John Constable*, Stoke-by-Nayland. *Courtesy of the Art Institute of Chicago, Chicago, Illinois.*

« As wise administrator of his materials, the artist is willing to be surprised by them. »

« 'Inner' materials, images, observations, memories are also transformed in creation: there is medium-bound thinking. »

23. Louis Michel Eilshemius, The Dream. The Phillips Collection, Washington, D.C.

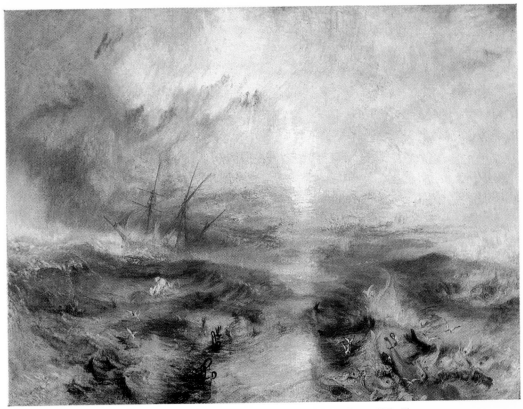

27. *William Turner*, The Slave Ship. *Courtesy, Museum of Fine Arts, Boston; Henry Lillie Pierce Fund.*

« Art not only has the effect on us of discovery, but is in itself a process of discovery. »

« Art works as a kind of confession
and technique as discovery. »

29. Jacob Kainen, The Search, 1952. Artist's collection.

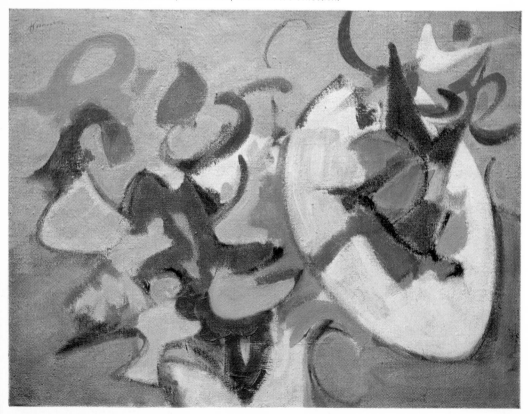

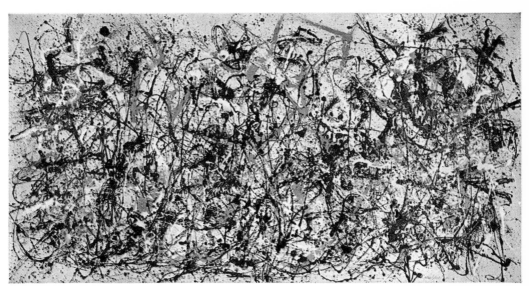

30. *Jackson Pollock*, Autumn Rhythm. *The Metropolitan Museum of Art; George A. Hearn Fund, 1957.*

« Pioneering expression. »

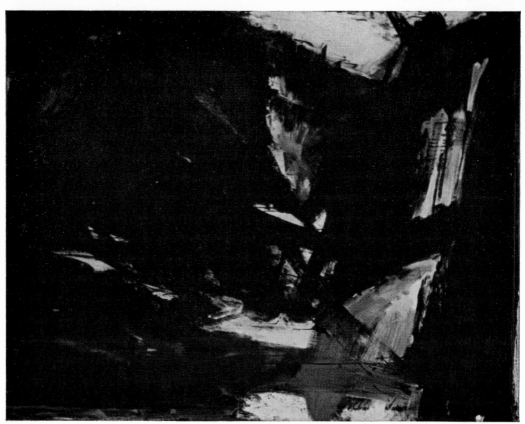

31. Franz Kline, Siegfried. *Museum of Art, Carnegie Institute, Pittsburgh, Pa.*

« Opaque and symbolic expression. »

« An internal revelation
from within of the human predicament. »

32. *Vincent Van Gogh*, The Potato Eaters. *Stedelijk Museum, Antwerp; collection V. W. Van Gogh.*

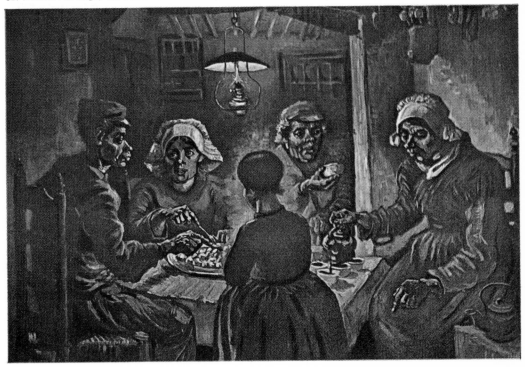

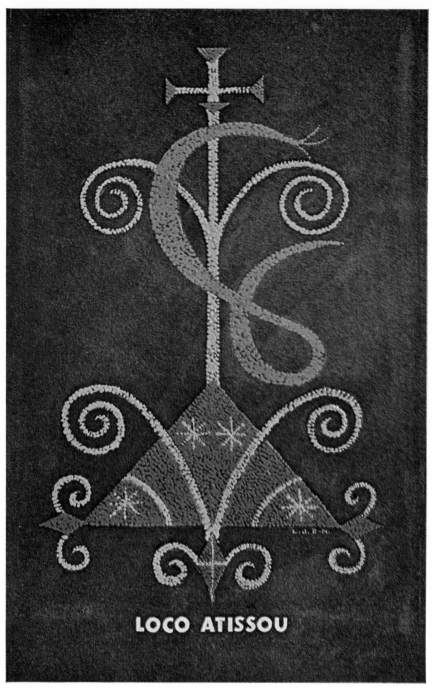

LOCO ATISSOU

41. Veve Vodou. Loco-Atissou. *By Louis Jean Pierre-Noel.*

« Why are the magical symbols
 made so beautifully?»

to allow him to infer what the "real" aims were which a culture was pursuing, what the activities were which it would have liked to indulge, but which it inhibited and sublimated—and of which, paradoxically, it left a cryptic but decipherable record in its art.

This, however, does not quite seem to correspond with what the cultural historian actually does with the works of art upon which he focuses his attention. It is more the kind of thing a clinical psychoanalyst might do. If the cultural historian did do it he would be generalizing—fallaciously—from the secret wishes of a particular set of artists to the secret wishes of their whole generation and overlapping ones.

On the other hand, a clinician who "psychoanalyzed" works of art would not, as a scientist, claim anything more than that the works used bring to light indirectly the conflicts and repressions of the particular men who made them. He might also make guesses about the social, or culturally contextual, causes of these repressions, but then he would be projecting a contemporary, or preconceived, standard of "normalcy" back upon the past in judging what was permissive and what had to be repressed. For in discussing cultural causes of psychological conflicts he would be going on the analogy of how such causes produce such effects in cultures which he has already known. His only alternative is to operate with an already firm notion of what the period was like—but that, precisely, is what the works of art are supposed to tell him! If he seeks to avoid this circularity and to be objective he would have to discover independently how cultural factors were, in fact, related to psychological (individual) effects in that culture. In initially excluding works of art from such an investigation, however, allowance would have to be made for the fact that the latter are themselves also causes of cultural effects. It is a question of a *reciprocal relation* in which selecting the data is almost bound to be misleading unless carefully hedged and contextualized. But beginning with the period and ending with the works of art is, in any case, doing the opposite of what the confessional theory of art implies ought to be done.

It is true, finally, that some artists, for example, some surrealists and expressionists, have conceived of their art as primarily a rendition of their emotional reactions to experience, a depiction—opaque in the action painters, symbolic among the surrealists—of a subjective reality constituted of feelings, impulsive rhythms, anamnestic evocations, and

« 31 »

85

so on. This conception is, however, inadequate to their actual practice which, as in all art, also involves the work of co-ordinating imagery, of correlating into a design or structure shapes or colors, tones or rhythms, motions, actions, or words, in such a way that they are felt to cohere, to be meaningful and, actually, as far as attention is concerned, absorbing and enjoyable on their own account.

If modern criticism has proved anything it is that to speak of subject matter as such, or "content," is not to be speaking of art at all but of the mere experiential materials of art. Art is conceived here, much as literature is by the New Critics, as just the total of all that differentiates pre-reflective experience or unformed content from the finished work. Thus conceived, art becomes, as in Aristotle, *practically* equivalent to technique; but it also is seen to include implicitly an intellectual dimension. It is true that a main part of the artist's subject matter is his experience. We must remember, however, that the set of means by which an artist attends to his subject matter and compels attention to it are precisely what we call "his" technique. The very discovery which an artist makes that he has a subject, or of a subject, is a function of his ability to explore. It is a function of his perceptive equipment and instruments and of his way of discriminating or abstracting his subjects out of the continuum of experience. The management of his discoveries, his eliciting of their meaning, in short, his judgment of their import and his power to establish this import in the conveying of it is, in fact, little else than his artistry.

Art and cultural self-understanding

In measuring an artist's timeliness, then, it is the perspective and control over a portion of experience which the artist brings into being in his work—and which develops what is enjoyable in the experience or the mastering of it—that is relevant. But on this understanding it is art, or technique, which provides the paradigm that therapy follows: except that in art the mastery achieved is "productive" where in therapy it is "practical." Symptoms, in any case, are only idiosyncratic from the point of view of communication. Works of art are more general in their import. As Rita Barton puts it:

Patients and artists are both making symbols. The artist is a professional craftsman, but he only achieves his end when he has created, by his special technique, a symbol which has some validity, and some therapeutic quality in a general way for mankind, and in a special way for the men and women of his own time. The patient, lacking all expertise, is unable to create a symbol of value for other people; but he can create the elementary outlines of a valid symbol, with a therapeutic quality, for himself. The artist is a person of heightened sensibility who accommodates this sensibility in a work of art. This is not 'pathological' and it achieves its own integration. But, as is well known, the greater the sensibility, the more finely is the artist balanced and the greater the tension, and the greater is . . . his ability to achieve the masterpiece.[6]

In connection with the health, and emotional substratum, of civilization, it now seems clear that Freud was as much afraid of an excess of repression as he was that sexual anarchy would damage cultural achievement. This was one of the interesting implications of *Civilization and its Discontents.* Another implication was that art is not only a substitutive activity but that, in being symptomatic of needs overriden by or in conflict with the predominant ideals of the culture, art could also become a valuable instrument of progress and self-understanding. This implication by no means entails the corollary, however, that art is self-expression (which seems to be the still-prevailing view among psychoanalysts). Nor does it entail the interesting proposition, now maintained by some interpreters of Freud, that art has the function of facilitating self-mastery as well.[7] That some arts do this is a fact which may be observed, not a deductive consequence of their symptomatic nature.

It is natural for the therapist to be interested, above all, in the possibilities of art as therapy; the question must be raised, however, whether this professionalistic attitude has increased, and how, or diminished, and by how much, our understanding of art. But it is clear already from what we have said in previous chapters that, so far as this claim assumes that emotion is what is expressed, this view is mistaken. So far, however, as this view maintains that it is something "repressed" that is expressed, aesthetics must inquire into the quality

[6] Rita Barton, "The Mind," *The Arts, Artists, and Thinkers,* edited by J. M. Todd (New York: The Macmillan Company, 1958), p. 233.
[7] See, e.g. P. Rieff, *Freud: The Mind of the Moralist* (New York: The Viking Press, 1959).

which materials have acquired when they have become repressed. And at this point it becomes possible to relate the psychoanalytic hypothesis about expression to Dewey's which we cited above. We must note at the outset, however, that the nature of the relation between creation and "catharsis" is only blurred by the egocentricity of the insistence, typical among psychoanalytic writers, that "the relevant catharsis" is "the one which the artist effects upon himself." [8] We here maintain, on the contrary, with Aristotle, Dewey, and the New Critics that the relevant catharsis is carried by the art *work*, the focusing job which brings chaotic materials into perceptible shape.

Dewey's insight [9] that the material of art has, somehow, to be compressed before it can be expressed needs expanding. Is the "compressing" a part of the elaborative process of working up and working out the aesthetic product? It has often been remarked that earned enjoyment is more thorough-going than easier satisfactions; and Dewey is only one among many who have noted the correlation between difficulties overcome and greatness of achievement. But what sort of resistance, exactly, is it that the creative process in art is called upon to push back? It cannot be intended that the difficulties to be met, or that the resistances to be overcome, should be artificial ones.

They will be those resistances that are *immanent* to the cultural or aesthetic situation or to the work of art as a *sharing* of informed experience. There will be the intellectual difficulties, or problems requiring to be solved, that arise from prejudices or misconceptions of the kind so hard to dispel just because it never occurs to us to question them, and because it has not been observed that some operative factors are actually "fictional" accretions to fact rather than facts. But intellectual, technical, and psychological difficulties will all be involved with one another. There will be the challenges to be made to the tradition defined as the accumulation of the valid techniques of the art: these may want modifying, reversing, or developing. There will be the psychological difficulties, including resistances, of communication generated by deep human reticences and by the tacit conspiracies of unverbalized but operative social compacts or modes of interaction. There will be the need (psycho-technical) not only to criticize the rationalizations of private and social censors, but the need (technical-semantic) to find effective ways of formulating per-

[8] Rieff, *op. cit.*
[9] See above, p. 70, and *Art as Experience*, p. 138.

88

ceptions of new modes of interaction of human with human or of human with natural. For art, like philosophy and psychoanalysis, is a critique of rationalizations.

In fact, without tensions internal to creation or appreciation which the work itself resolves there would be no structural development or rhythmic or formal fulfillment in the art object or its enjoyment. In this sense art is not just a making, it is also a remaking, or reconstruction of experience. There will always be art to be done because there will always be experiences that are fragmentary, unsatisfactory or in some way not unitary. Given the dynamics of human adaptation and of social change, the moment always comes when the art of the past no longer serves to inform current experience or the perceptions of the present. Perceptual confusions will tend to arise within and about new adaptative situations and these confusions call for new kinds or orderings.

The cultural phenomenon which we should isolate here, in order to answer the question raised earlier, is that these new situations requiring to be reduced to order are, in fact, often given an order, first in art and only later in conduct or ideology. It is on these occasions, and in this sense, that art is felt to be prophetic and, hence, a revelation: it has created a new perception of the world or discovered new patterns in some kinds of social and personal situations.

From this vantage point, both the application and the limits of the analogy between the psychoanalytic processes of binding and abreacting, and the creative techniques of art become clearer. In therapy the repressed thematic, or traumatic, material or experience is dredged up and worked over in order to be understood and made inoperative by being made conscious: it can then be dismissed. In art, on the contrary, the materials are reworked so as to perpetuate an experience—or more exactly—to celebrate an aesthetic precipitate of experience that we will enjoy returning to at intervals. In therapy the subject just recalls or reinstates past events; in art he observes, he invents, he completes and joins, he elicits and reworks forms. The psychoanalysts speak of free, or floating, libido "cathecting" an object. The object cathected has become fixated, and is said to be charged with emotion: so far the psychoanalyst could as well be describing the process by which an object, whose value is over-estimated, becomes a fetish. But this is far from being expression. When, however, psychic energy begins to *change* the nature of the "object" fixated, fixed upon,

or selected, then certainly it must be granted that one of the conditions for making it into a work of art (more than a fetish) is being met. A work of art does, like a fetish, seem to draw off emotion onto itself from the perceiver; but it does so by involving us suspensefully in a climactic universe of discourse within which the excitement or tension are rhythmically abated or resolved. The enjoyment of a work of art is therapeutic, but it succeeds in being so incidentally—not by reliving the presumed genetic causes of our particular troubles but, as in Greek tragedy, by creating what I have called perspectives of humanity, the net effect of which is to strengthen the will to live in face of the difficulties which universally beset the living human being.

Art and the preconscious

When Dewey attempted to provide a kind of measure of expressiveness by saying "the more a work . . . embodies what belongs to experiences common to many individuals, the more expressive it is," [10] he was not, I think, referring to the experiences that men are generally conscious of having in common. It is not simply that these would be the clichés of experience, but that in being already available they would be "unearned" perceptions.

As far as the perceiver is concerned, there seem to be at least two or three different kinds of effort involved in his "earning" of the creative perception. There is what for the moment can be called the unconscious contribution to its own identity and enjoyment that the work gets him to make. There is the thinking that supervenes upon and prolongs his felt response. And there is the testing or acceptance which proceeds by reference to his own experience and sense of what is possible or satisfying. The acceptance itself can be observed to call forth an adjustive performance requiring varying amounts of mnemonic and critical, or imaginative, effort.

Any object or set of stimuli will of course elicit, in the perceiver, unconscious activities that are among the conditions of its being perceived. Among these, we should be concerned here not so much with the complex physiological antecedents and accompaniments of perception but with those that are loosely called psychological. By

[10] J. Dewey, *Art as Experience*, p. 285.

the psychological unconscious is meant the forgotten or the repressed experiences (drives, doings, sufferings, tensions, impressions, etc.) which are activatable or operative under certain conditions and which under still other conditions can be brought into consciousness.

As far as the *structure* of works of art is concerned, the mode of operation of its unconscious determinants is obviously an important question, but it is a far from settled question—even with regard to the terms in which it is put. If, however, we decide to limit our discussion to the contribution that preconscious processes make to the creation and perception of form we not only avoid the hidden reification and contradictions of the term "unconscious," [11] but we find that some progress has been made in the understanding of their relation to art. And, what is more important, we find that they are processes which the artist and the perceiver can do something about, that they are in a degree controllable or capable of nurture and, therefore, relevant to practice, i.e. to aesthetics.

To speak of the unconscious determinants of anything, is it not to speak of presumed, but unknown, determinants? To speak of the unconscious determinants of someone's activity is to speak of factors unrecognized by him but not necessarily unknown to us, and therefore in principle not unknowable to him. The invoking of unconscious determinants of (creative) activity in the first sense would, therefore, be not an explanation but a confession of ignorance. In the second sense of unconscious, psychoanalytic theory seems to intend determinants over which the agent has no control. Unconscious, in other words, seems to mean compulsive—also a word used by psychoanalysts. Yet it is a cardinal tenet of psychoanalysis as therapy that the antecedents of our behavior patterns of which we can become conscious are, precisely, the antecedents which will cease to tyrannically govern our behavior. Once made conscious such antecedents could, of course, still be partially determinative of our activities; but the speci-

[11] There would seem to be a contradiction in so naming that which can be made conscious. The unconscious, as Freud himself stated, is a topographical, not dynamic concept. Useful for expository purposes, it is misleading from the viewpoint of system as well as practice. Interestingly, in the work of Kubie and Kris, the preconscious is assigned many functions that older theory gave to the unconscious. In *New Introductory Lectures* and *An Outline of Psychoanalysis* Freud said that the unconscious differs from the preconscious in the degree of difficulty with which its "contents" could be made conscious. In his "Introduction" to Varendonck's *The Psychology of Day Dreams* he asserts that there is no difference between preconscious and conscious mental processes.

91

fying of them would now be only a partial explanation of the activities they were previously invoked to account for.

Now, according to Ehrenzweig, the form-completing or gap-closing activities—the patterns of extrapolation or simplification—which have come to be called the Gestalt processes,[12] and which are more or less conscious and enjoyable, are themselves directed or determined in their action by the superego (which operates consciously as well as unconsciously). Also, however, according to psychoanalytic theory, the concomitant aesthetic feelings are *not determined by the objective properties of a good design* but, like the form-conferring or abstractive activity itself, these feelings are determined by the role they play in handling (Ehrenzweig says "struggling against") the depth perception activated by the art work.[13]

But what is this depth perception that a work of art activates? And what is it that is so dreadful about it, that is "struggled against" and requires so much handling or disguising?

Depth perception, so far as I understand it, is a formless perceiving that there *is* something, not *of* something. It is also a process of sheer awareness or undifferentiated responsiveness. It not only lacks a more or less definite goal, it is itself an utterly less differentiated attentiveness or activity than hearing, seeing, touching, digesting, excreting, fleeing, attacking, freezing, etc. As the non-definite object of the organism's as yet unorganized reaction the very worst is to be feared from it, namely, the destruction of the organism or some such extreme consequence. But the worst, the object of the fear of the worst, will, it seems to me, differ from organism to organism when these are human individuals or as soon as it begins to acquire any specificity: so that if for some it is not death, neither will it universally be a directly sex-associated object, but rather some kind and some degree of pain. As long as it is unidentified by the organism, which *must* react to it, however, the organism does not know *how* to react to it. In the meantime the organism has generated the energy with which to react, the eruption of such unbound energy being felt as anxiety. It is at this point that the form-conferring or abstractive

[12] A. Ehrenzweig, *The Psychoanalysis of Artistic Vision and Hearing* (New York: Julian Press, Inc., 1953).
[13] Jean-Paul Weber's psychoanalytic approach to poetry, however, sees the quality of the aesthetic response as a function of the power art has of restoring childhood impressions and excitements, i.e. those which accompanied the child's perceptual discovery of the world.

activities of the human organism come into play. The irritants, or excitants, the complex of stimuli, with which the organism has engaged must be identified or given form so that the appropriate response, readjustment, motion, or transaction can be organized.

If the above reconstruction, hypothetical as it is, is correct, however, then it must be conceded that the anxiety-provoking depth perception is not necessarily followed by the giving of a false identity to unconscious "contents" but, rather, by the informing of non-definite but operative possibilities. It is hard to believe not only that what everyone fears as the worst is the same for everyone, but that works of art also succeed in arousing this fear of the worst in everyone, thus causing every superego to initiate in its corresponding ego a form-giving process that disguises what is being perceived.

Now when this "masking" process occurs in dreams it is func- tionally characterized as an anxiety-controlling or stimulus-dampen- ing, sleep-prolonging dynamism. (Notice that the anxiety or the stimulus is already given and the dream mechanism *uses* it.) Formal- istically, dreaming is characterized as an imagistic, associational, con- densatory, superimpositive, displacing or diversionary dynamism. Here it would seem that the original stimulus, whether internal or exter- nal, in being given dream form can be said to have been "disguised" by the sleep-conserving reaction. It is an equally valid alternative for- mulation to say, however, in the case of internal stimuli, that dreaming is actually one way in which we give form to, or make perceptible to ourselves, our psychological conflicts. Were the conflicts imaged, or symbolized, any more clearly or transparently the mainly involun- tary preconscious thinking about them which is the dream would pass into conscious thought, or wakefulness, about them. Of course, it often happens that with wakefulness we repress, or completely suspend thought about, these conflicts. In any case, in this formulation there is no concealment in the preconscious dream activity, only incompleteness. Since this incompleteness can be pieced out by the techniques of analysis, it is better to say that dreams are *partially expressive* of, not a concealment of, our conflicts.

If it is true that even in the case of dreams the emphasis on concealment appears misconceived or questionable, it is still less credit- able that the form-giving or abstractive process which the art work sets in motion is aimed at concealment, or that a concealing process generates the aesthetic emotion.

What would an intellectually honest worker, bent on expression, want to conceal from himself and others in watchful-tolerant, critical-constructive, indulgent-ascetic, detached-involved wakefulness that is the creative state? That we are sex-motivated, hunger-driven beings subject to physical limitations and social coercion? Ehrenzweig is obviously thinking of the conventional member of the European bourgeoisie here, not of the creative artist. Is the truth that the artist is concealing from himself and his public, that he and they are really ("unconsciously") so many kinds of perverts? [14] Is this the truth that has to be disguised and the facing of which is so fearful? But these are truths that we learned from literature and drama before psychoanalysis was ever heard of. Surely they have been faced, in a multitude of examples, by literature, drama, and painting. In the glaring light of the testimony of so much literature, art, and drama, Ehrenzweig's claim pales into insignificance; it becomes supererogatory to say that the function of art is to covertly remind us that at bottom we are all polymorphous perverts and must be constantly rededicating ourselves to normality and sociability. Why not say that art protects us from the guilt-inducing superego by aesthetically contextualizing certain disvalues so that we may be able to face them, and then deal with them? This is, it seems to me, precisely the psychological function of the expressive structure of such art works as *Oedipus Rex*, the *Bacchae*, or *Agamemnon*. In this case, by the way, Greek tragedy becomes the paradigm for understanding the psychological function of other aesthetic structures.

If, however, the hypothesis that the form-giving or abstractive process expresses psychological conflicts is to avoid having consequences contrary to fact, it cannot be understood to imply that artists who have been psychoanalyzed thereafter cease to be expressive; for this is not the case. Similarly, it cannot be taken to imply that art is a means by which people, both analyzed and unanalyzed, are able subliminally to indulge tendencies or desires that are really perverse. Art works do not so much conceal or express the "true" nature of, or indulge, our id activity as give humanly bearable shape to facts and concerns to which the artist draws attention by choosing to expend psychic energy upon them in creative ways, for example by exhibiting or rehearsing

[14] Conceptual, or dialectical, difficulties arise here: if everybody is really perverse, then it is normal to be perverse.

or celebrating their very existence, by dramatizing or developing attitudes toward them, by eking out the enjoyable, or judging the reprovable, in them. Art, like anything else the artist does—including his failures—may incidentally reflect his compulsions and symbolize or be a clue to the objects upon which, on the assumptions of psychoanalysis, he is "fixated." This, however, is neither what distinguishes art works from other intellectual constructions nor what makes art works feel like revelations.

Works of art feel like revelations because they are, or rehearse, new ways of perceiving. A new awareness is bound to involve ("reveal") new objects of perception. But creative perception does not bring into focus, as the psychoanalytic view assumes, already given objects and situations that can be discovered by other means. When Freud first perceived the convulsions of an early hysterical patient as caricaturing the labor of childbirth, he was seeing creatively. He taught us, like any other great artist, how to look at a phenomenon. Looking creatively at what he saw he was able to relate his observation to others he was making on sexuality, childhood traumas, wit, the psychopathology of everyday life, and the uses and misuses of psychic energy.

The true matrix for this kind of creative synthesis is, however, as Kubie has demonstrated, the preconscious, not the unconscious. Just as the enemy of stereotypical reactions, like the artist, wishes to free our perceptual responses from preconceptions, so for Kubie

the more imperative need [in education] is to learn how not to let unconscious needs and conflicts and affects and defenses distort the work of the fully educated eye and ear and tongue and hand, lest these unconscious forces alter what we perceive in the act of apperceiving, and alter in the very act of communicating that which we have set out to communicate.[15]

When the unconscious system of motivations is predominant the relationship between forms and symbols and what they stand for is inaccessible (except perhaps to special psychoanalytic techniques)

[15] Lawrence S. Kubie, *Neurotic Distortion of the Creative Process* (Lawrence: University of Kansas Press, 1958), p. 105. This conclusion is unwittingly confirmed by Ehrenzweig's essay "The Hidden Order of Art" in the *British Journal of Aesthetics*, Vol. I, no. 3. This later study still fails to use the concept of the preconscious but it distributes what are clearly its functions between the conscious and the unconscious.

and therefore uncontrollable, rigidly unmodifiable and, hence, non-creative. It is then, in fact, that the creative process becomes the neurotic process to the more or less complete detriment of art.

Conscious symbols or purposes seek, of course, to bring order and intelligibility into our raw sensory impressions, but in so doing they also attenuate the vividness of the living experience. But, says Kubie,

in all art forms . . . particularly in the plastic arts and music where the symbolic process comes closer to the nonverbal symbolic tools of the dream, there is an effort to reactivate and revivify the sensory and emotionalized . . . components of past experience.[16]

This is because in art the symbolic process is fed from and guided by the analogic, hypermnesic, and associational dynamisms of the pre-conscious system.

Preconscious thinking occurs anywhere on the spectrum between the perspicuous form of symbolic activity in which we feel clearly aware of the relation between symbols and what they stand for, and the automatic, blind form of symbolic activity in which the relation between the symbols and what they stand for is lost to (repressed by) the agent. In preconscious activity the relation between symbols and references is less direct or rigid than in the conventional (coded) signs of conscious thought or the undecipherable distress signals of the runaway, disturbed unconscious. The relationship is figurative in all three sorts of activity but it is both more allegorical and plurivalent in the preconscious, as well as less subordinate to either external (utilitarian) purposes or guilty (conflicting) unconscious stimuli. The tendency to univocity and specific purpose firmly connects conscious symbolic activity to "reality," while the pathological anchoring of unconscious symbolic processes makes them unmodifiable except by therapy, if at all. Preconscious processes, on the other hand, are penetrable by sensory reports about the environment and anticipations about the future. They have access to information stored from the past from which they select both aesthetically, that is by analogy, homology, congruence, and contrast, and pragmatically, from other than purely aesthetic need. In recording multiple perceptions from all sensory modalities, in having automatic recall and multiple analogic linkages and overlappings, the preconscious also

[16] L. S. Kubie, *op. cit.*, p. 139.

has, according to Kubie, direct connections to the autonomic processes underlying affective states.

Kubie's thesis is that the creative person is someone who somehow has been canny, or lucky, enough to retain "his capacity to use his preconscious functions more freely than is true of others . . . potentially . . . equally gifted." [17] From our point of view, however, this serves more to define the productive rather than the creative personality. Nonetheless, he has shown convincingly that the productive (our word) process depends for its freedom upon the play of those preconscious functions which are precariously balanced between the utilitarian rigidities of conscious function and the pathological rigidities of unconscious function with its stereotypical and repetitive, or compulsive, symbolism. It seems to me, then, that given this freedom and given a good acquaintance with the history and tools of his art, the greater the preconscious freedom of the artist the greater will be his intellectual resources and expressive powers. Thus partially freed the artist's convergent energies can be devoted more effectively to the making of something newly, objectively, and universally interesting—something that is objective in its freedom from the culturally diverse but tiring overspecificity of externally given modes of satisfaction or connection, and universal in its freedom from unsharable [18] (undecipherable), too private, personal associations with, or representations or satisfactions of, recurring wants.

[17] Kubie, *op. cit.*, p. 48.

[18] The reader may think here that the psychoanalytic view of art holds that it is exciting whether undecipherable or not. But this forgets, first, that comprehensibility differs from art to art as it does from science to science and between the arts and the special sciences: understanding an occurrence sociologically is different from understanding it in chemical terms, and understanding an artistic event in aesthetic-kinetic terms is different from understanding it in aesthetic-acoustic terms. Secondly, the reader must not forget that comprehensibility is always a matter of degree in any communicative situation. In making the point that art excites before it is "understood" psychoanalysis is, after all, confirming the pragmatistic emphasis on the pre-reflective phase of any experiential situation—as long, that is, as it remembers that by pre-reflective we mean only not fully reflective, not non-reflective. Finally, it would seem that the invocation of a "hidden order" to account for the excitingness of art is superfluous—not just because we are told that this order is unspecifiable, or not an "order" at all, but a threatening chaos; but also because explanation is already available in terms of the perceptible order of the work and its preconscious and conscious connections.

Gestaltism and art

There is a kind of book on the appreciation of plastic art which seeks to reduce the latter to a finite set of elementary geometrical figures. This approach feels it can explicate the *design* of art works in terms of standard forms. It either frankly claims or tacitly implies that these standard forms are innate; and it bases on this innateness the explicatory power of the simple figures it likes to read into works that allow it. There is something reminiscent here of the "skeleton key" approach which works well enough in some branches of applied science or engineering, though it seems to work less well in books of popularization. That standard geometrical shapes can be *fitted into*, or plausibly superimposed upon, certain outlines in a visual work of art is, in fact, possible just because these shapes are being used like skeleton keys to fit many locks. Given any outline, no matter how complex and irregular, ways can always be found of "analyzing" it into "simpler" quasi-congruent curves and polygons.[19]

It is ironic that this approach should, in recent times, have drawn so much on Gestalt psychology in an attempt to acquire theoretical justification;[20] for Gestalt psychology was, in its origins, a movement against elementariness in perception. The geometrical approach came to Gestalt psychology, however, from the direction of a two-fold legitimate concern with, first, the contribution of the perceiver to the enjoyment of the work of art and with, secondly, how shapes and qualities emerge and behave in relation to each other as well as the perceiver.

Of course, the geometric approach is an elementariness of a kind of *wholes*, that is, of regular figures. But so do Gestalt psychologists sometimes lapse into treating their simple forms, their good Gestalts, as basic mental *elements*—somewhat in the manner that the old empiricists, whom they reject, treated their units or atoms of pure

[19] Gombrich has drawn attention to some very early works that do this, as Erhard Schoen's *Underweizung der Proporzion* (1538), & Albrecht Dürer's *Dresden Sketchbook* (1513). See E. H. Gombrich, *Art and Illusion* (New York: Pantheon Books, Inc., 1960).
[20] See Rudolf Arnheim, *Art and Visual Perception* (Berkeley: University of California Press, 1954).

sensation. The Gestaltists seemed to come closer, nonetheless, to the facts of perception in pointing out that atomic and pure sensations are a product of analysis and merely theoretical, not given in experience but only to a logical analysis which is secondary to the awareness of the configuration as a unitary whole. On the basis of the "phi-phenomenon" and some other experimental work, however, the claim that perceptual experience comes in wholes was expanded into the claim that these given wholes follow laws intrinsic, or "autochthonous, to the organism and that they are, at best, only "topologically" related to the "proximal stimulus pattern" from the object. Visible movement, or speaking more generally, phenomenological movement and wholeness are primary (unlearned and unachieved) sensory experiences not reducible to any more basic constituents or processes.

The nature of the configuration which the wholeness takes on is said to be always of the greatest possible simplicity and clearness: in the case of figures it is more specifically said to be of the maximum possible symmetry and regularity. Percepts, in other words, always tend toward "as good a figure" as the stimulus pattern permits—to the point where the weaker the stimulus the stronger the Gestalt, or tendency toward good form. From this, it would appear that we should get the "best" forms of all out of Cage's silences or Rauchenberg's blank canvases.

When applied to art the Gestaltist's equation of simplicity with goodness certainly does not work. The applied Gestaltists seem to have confused a recognized criterion for all good explanations with an effect obtained by some works of art. If what is being claimed is that the artist is in fact seeking to approximate the law of *Praegnanz* (and all the sub-laws which make for it, as for example, grouping by "similarity," grouping by "common fate," the principle of "closure," the principle of "good continuation)," [21] then we would seem to have an application which refutes the premise that good Gestalts are innate; for they cannot be innate if the artist has to work as hard as he does to achieve them. That the artist knowingly or intuitively relies on and uses the perceiver's disposition to respond in accordance with these laws is, however, a different and more plausible claim.

Now it seems to me that artists have always had the public's, or some public's, expectations or abilities and perceptual habits in mind—

[21] Ian Rawlins makes this claim in *Aesthetics and the Gestalt* (New York: Thomas Nelson & Sons, 1953).

sometimes to contravene and challenge them as much as to satisfy or use them. So in this sense the claim is not original. What is original about Gestaltism is the claim it makes about the kind of contribution the perceiver makes to what is perceived: he is made out as contributing symmetry, regularity, balance, movement, tension, geometricity, groupings, extrapolations, etc. Notice that what is being said is that he necessarily imposes these upon what is perceived, not that he expects them in it. It is also the case, however, that the applied Gestaltists take these characteristics as observable and felt phenomena, discussable in terms of *figural forces* outside the perceiver. This means that parts of a painting, for instance, appear as pushing, pulling, fusing with, echoing, repelling, attracting, modulating each other. The Gestaltists here seem to be rediscovering for us what every good artist has always known in one way or another, namely, that plastic, kinetic, acoustic, or verbal configurations have dynamic properties—and that is all to the good. But perhaps what they were really after is *why* configurations have dynamic properties or *how* figural forces have the effect or behave in the way they do. In the same spirit, perhaps what the applied Gestaltists are really trying to understand is how works of art come by their unity and coherence.

This is a central question in aesthetics. Have the Gestaltists answered it? Though the questions which the Gestaltists have asked about perception have led to the most interesting experimentation, it would seem that the *formulation* which they have given their answers and the *assumptions* which serve as premises for their formulations have made it impossible for these answers to be completely clear or truly empirical. What, for purposes of the practice and enjoyment of art, does the cortical field hypothesis after all explain? What are the Gestaltists' valuable observations that we always tend to see things in terms of figure and ground, or that perception is a process triggered by physiognomic cues—but observations and not yet explanations? Likewise, does the Gestaltist view of meaning really explain very much?

Line, for instance, is according to Köhler [22] an electromagnetic phenomenon arising in the cortex (not the retina). As a result of external sensory stimulation portions of the brain are activated in the manner of a charged body generating an electromagnetic field. The

[22] Wolfgang Köhler, *The Place of Value in a World of Fact* (New York: Meridian Books, Inc., 1959).

boundaries of such a field and the tensions between different centers of charge produce the perception of line. This is different from the "local sign" kinaesthetic or sensory motor theory of the perception of line according to which line is a kinaesthetic sensation: the perceiving organism silently recognizes the *gestural* meaning of lines as the obverse of the feeling, fundamental to the organism, of the linear quality of some muscular or bodily movement. Like the local sign hypothesis, however, the cortical field hypothesis about perception is an ultimate explanation only for those to whom psycho-physiological answers to questions about human action are ultimate. It affords no means of controlling or expediting the perceptual processes related to art, though it would seem to have implications for research and experimentation on the effects of direct stimulation of brain areas. Note that by treating perception as the end-product of stimulation processes the Gestaltists omit reference to skills which we may enjoy or acquire in character-izing or recognizing objects. Man does not, according to Koffka,[23] learn to perceive things more or less correctly. The "best," that is, the simplest and most regular pattern, is constitutionally imposed by us on things: we are on this account, innately and automatically, standard-izers.

Perceived meaning, then, is both assumed to be immediately given (at the psychological level) in the configurational experience, and it is also defined as the outcome of the simultaneous coming to equilibrium of the cortical field and the percept field: meaning is a property of the emergent whole as it neurologically attains its pre-destined organization, standard articulation, or goodness of figure.

Now, it is by virtue of this definition of meaning that Gestaltists are able to pass on to the aesthetic doctrine that "expression" is an inherent characteristic of perceptual patterns. Thus Arnheim claims that whatever we perceive has, before anything else, a physiognomic character because, as responded to by the survival-minded organism, any force active in its ambience is either hostile (dangerous) or friendly (beneficial). And according to this doctrine there is no pathetic fallacy here. The Gestaltists point out that expression is not limited to organisms possessing consciousness but may be found equally in things and events. They reason that expression in the human figure is just a special case of the more general phenomenon that shape, direc-

[23] See Kurt Koffka, *The Growth of the Mind* (New York: Harcourt, Brace & World, Inc., 1924).

tion, size, angularity, interval, speed, or textural properties are always translated into, or reacted to as, expressive qualities such as, respectively, frailty, purposefulness, fearfulness, sharpness, agreeableness, hurriedness, softness. Such reactions, however, are never unambiguous; and, applied to the general phenomenon observed, the demand for explanation still stands. Does it not happen only because the perceiver of these latter qualities (besides those of dangerousness and beneficence) is a human being whose reaction system has been funded with numbers of fused associations? Is it quite true as Arnheim claims, for example, that "there is a tinge of conquest and achievement to all rising"? In music increase in frequency of vibration is commonly, but not *inevitably*, associated with upwardness. And upwardness is not inevitably translated as achievement or conquest but often, according to context, as reaching or longing, flight, recession, or even falling away.

It is true that, for the human being, all existence is pervaded by such "motifs" as rising and falling, dominance and submission, consonance and dissonance, conflict, conformance, and so on. They may be found within our own psychic organization, as well as in our relation to other people, in the weather and in international politics, in the deliberate handlings of physical materials and in the accidental outcomes of natural processes. Because such motifs provide distinctive grounds for classifications they become the basis of metaphor (or novel "classifications") in general, not only of speech. Fire and locusts both consume what is in their path, and a man blazes a trail: in these metaphors we not only experience a little what fire, locust, and man are said to be doing, but both what we are told about them and the way they are related are, to a degree, matters of fact. So in visual work different shapes (whether abstracted from different things or not) can be made to share similar meanings, or gestural tendencies, the gestural tendencies themselves deriving their meaning or effectiveness from an underlying transfer of resonances from energy processes of the organism to the canvas. It will be granted, then, that visual and tonal configurations interest us, at this level of explanation, for much the same reasons as do metaphors.

Classifications or comparisons that are primarily perceptual and made for the enjoyment and enlightenment they can give in one context will, indeed, cut across classifications made primarily for purposes of the ulterior use of, and exploitive information about, things

required by another context. What this proves, however, is that neither the "physiognomic" nor the "technological" characters or classifications of things are more primary—except with reference to a specific context or purpose.

Likewise the expressiveness of objects may be experienced without a comparison of it to human psychic state; a felt pre-reflective comparison or fusion might equally well be made with other things. But such expressiveness is possible only because there is a psyche to react to or with it. The Gestaltist counterclaim is correct that these inventive or associational processes are no "pathetic fallacy," but only because there is no fallacy involved, not because there is no patheticism.[24] Surely there is patheticism in all metaphor, but some metaphors are better than others. Surely even the terms in which physics discusses matters are human terms, though dissociated from the emotional factor.

It is ironic that the implications for art of the law of *Praegnanz*, and of Gestaltism in general, should be either so meager or so unoriginal, or contradictory to their psychological presuppositions. The main reason for this is the innatism of the Gestalt approach; for this regularistic and physiognomic innatism not to short-circuit the creativity of the artist or make impossible any account of the development of his shaping skills it can only be taken, contrary to the Gestaltists' intentions, as an account of what the artist must fight against in order to be creative. If it is taken as an account of what the artist must, and is permitted to, deviate from then it loses its title, even by antithesis, to being a basis for a constructive aesthetics. It is the permissible deviations (as in the study of poetic meter) that would in that case have to be discussed. To crown this there is the further irony that, whether the inspiring attempt to prove experimentally that we perceive structural properties overwhelmingly and first of all was a success or failure it makes no difference, after all, to the practice and enjoyment of art works since the latter have always *required us to*—and, on the whole, succeeded in teaching us to—attend primarily to their structural properties. In this connection the enduring lesson of Wertheimer's *Pro-*

[24] The pathetic "fallacy" may be defined in Carroll Pratt's words as "the ascription of characters to visual and auditory processes which belong strictly only to bodily sensations." *The Meaning of Music* (McGraw-Hill, New York, 1931), p. 183. But where is the fallacy if such ascription is based on cross-sensory modalities?

ductive Thinking [25] may be taken to be the demonstrations of the intimate relation between quickness in the perception of structure and ingenuity in problem solving.

On the other hand, if Gombrich's claim that the process of representation in the visual arts is governed by the "rhythm of schema and correction," [26] is extended into a claim that the processes of perception are also governed by a rhythm of schema and correction, then there are a couple of simple tests to which we may submit both claims. We may, for instance, check with a sampling of visual artists whether they do in fact proceed by schema and correction when seeking to obtain some likeness. We will find that they do not all by any means use this method and that some even object to it. Similarly, with regard to the process of perception the fact that some people have developed an academic eye for the contour of a model, that some have an architect's eye for the geometry of space, and that *some* children's first representation of a human figure is roughly circular—these facts are far from establishing that we impose innate standard forms upon what we see, or that having done so the job of art in representation is to correct or improve upon them.

The other great concern of Gestaltism, the concern with wholes, fares better, as we shall see below, when brought to the test of a confrontation with art processes. It cannot indeed be repeated too often that the perceptual processes called into play by works of art have wholes for their objects, as long as it is remembered that these are fresh, non-stereotyped wholes truly intelligible only in melodic or harmonic or rhythmic or plastic or kinetic or verbal-exhibitive (not verbal-explanatory) terms. But to have explained how it is (not that the Gestaltists claim that they have done so fully as yet) that we are born articulators who grasp wholes before anything else, is still not to have explained how it is that some wholes are better than, or more enjoyable than, others. To explain this is the distinctive task that falls to the lot of aesthetics and the philosophy of art after all the results

[25] Max Wertheimer, *Productive Thinking* (New York: Harper & Row, Publishers, 1945).

[26] E. H. Gombrich, *Art and Illusion* (New York: Pantheon Books, Inc., 1960), p. 116. That Gombrich is wrong in this can be seen from his own example taken from Villard de Honnecourt (p. 151) whose "schema" for an eagle is a five-pointed star. Is the eagle a "correction" of this schema? It may be said that the five-pointed star is the "wrong" schema; but what is the right one? Obviously the *criterion* for the "right" schema is the final work! To invoke the schema to explain the work is, then, circular.

have been brought in of all the inquiries into why we perceive what we perceive in the way we do—just as it would still be the artist's job to continue to utilize his sense of our perceptual habits and powers, whether these have been fully codified by psychologists or not. The philosopher's task is not, however, made any easier; it is in fact made impossible or irrational when these inquiries are blind to the fact that perceptual responses are all also evaluational responses. And while Gestaltism, with Köhler's concept of "requiredness" or the demand character of an object or situation, does not share this blindness with atomistic sensationism—the job remains to be done of clarifying how it is that expectations of good articulation aroused by configurations make their contribution to aesthetic judgments. (See below, Ch. VIII.)

Existentialism and art

Men are made so that . . . they have to recreate
the universe whenever they wish to change
their way of life.

J. H. Randall, Jr.

In every rebellion is to be found the metaphysi-
cal demand for unity, the impossibility of cap-
turing it and the construction of a substitute
universe. Rebellion, from this point of view, is a
fabricator of universes. This also defines art.
The demands of rebellion are really, in part, aes-
thetic demands.

A. Camus

The proposition through which we may approach
Sartre's view of man as creative is that desires con-
stitute the core consciousness. Several things
follow from this premise: first of all, that a man
is what he prefers. To specify what he is, how-
ever, we must psychoanalyze what he prefers or
desires. This, says Sartre, will put us in possession
of the genesis of his aversions and preferences,

that is of his psychic structure or current behavior. As far as the subject himself is concerned, existential psychoanalysis consists in bringing him to a clear *knowledge* of what he was merely living with or by—not, be it noted, of what he was "unconscious" of; for Sartre does not admit the term unconscious into dynamic contexts, as being contradictory. Thus the clues to an individual's subjectivity are both aesthetic and genetic: if we know *why* he dislikes or likes *what* he dislikes or likes we know the man.

Since, however, according to Sartre, everything we are conscious of is therefore simultaneously desirable or undesirable in some way or degree, it also follows that significance (as with the Freudians) is not only formal. However, one thing that does not necessarily follow from the proposition that significance is more than formal, is the proposition that the material qualities of objects are fixed and unchangeable. It may be that an "aesthetics" or "psychoanalysis" of objective, material qualities is possible as Gaston Bachelard seems to have led Sartre to believe. And this may presuppose or imply the epistemological view that qualities are constructive of objects. But, given Sartre's position on how we *create* the properties—the serviceability—of objects around us, he cannot mean that the qualities of objects are fixed and predetermined. That would, in any case, be to introduce prior essences into his existential universe and contrary to his philosophy as a whole. Sartre is here at one with the pragmatists' view of the non-fixity and conventional nature of objects.

Another difference, besides the one about the term "unconscious," which Sartre has with the Freudians will serve to introduce us to his philosophy of the desirous and anxious consciousness. This is the denial that the basic modality or context in which we choose to become what we are is libidinal or sexual. In Sartre the "appropriation" of the world (the in-itself) which is the aim of consciousness (the for-itself), the way in which the for-itself desires to become the whole of the in-itself, is not merely sexual. Sartre does not accept the unproved postulate that pre-genital psychic energies are sexual; and if they are not it follows that different human activities like art, religion, and science are not manifestations of a repressed sexual life, but so many different (overlapping perhaps, but after a point irreversible) ways of appropriating the world in addition to the libidinal way. Let us next consider, then, what insights about art, life, and happiness we may garner from existentialism.

Existence and the sense of being

Taken as a whole, the existentialist movement seems to invest human experience with certain qualities to the exclusion of others. To the existentialists existence in general is absurd, all human action is tragic, and awareness itself is shot through and through with anxiety. What the individual and differing members of the movement have in common does not add up to a unitary philosophy. They do, however, unmistakably have in common certain themes and a similar type of sensitivity to certain features of the human situation. Yet, except for Camus, Sartre, and possibly Heidegger, this sensitivity has not included any responsiveness to or much awareness of the basic creativeness with which the human being in the history of his survival has rolled back the constant menace of engulfment by the non-human. In fact, as Camus pointed out in *The Rebel*, one kind of existentialism, like Puritanism and Marxism, ascetically and indefinitely postpones the enjoyment of beauty if not to the arrival of the millennium at least to the theologization of the universe—to the finding of God in it as the ground of it.

Now the existentialists, from Kierkegaard to Heidegger, are rightly understood to be a reaction against the intellectualism of Hegel's system; but equal emphasis has yet to be put on the fact that some of them were also reacting against his acquiescence in that very secularization of things spiritual which Hegel had found to be a characteristic of modernity. So much is this so that if humanism is made the test of pure existentialism, then only Nietzsche, Camus, Sartre, and Heidegger qualify as pure existentialists. Thus Tillich, sensitive as he otherwise is, seemed to be speaking for all the non-literary or religious existentialists when he said that the existentialist can *only raise* the question of the meaning of existence as it arises out of his analysis or depiction of the human situation, and that not he but only the theologian is properly qualified to answer it: for the answer must come from somewhere *outside* the human situation. This is not, after all, surprising, given that Tillich takes for granted man's estrangement from his own creativity. He seems to believe that all art contains an "element of unreality," and that only religion can "transform reality." And he is con-

vinced, finally, that the religious response or function is more pervasive and basic in human life than the creative response or function.[1]

Though it is frequently claimed that Heidegger is essentially a religious philosopher, he is better classed with the literary existentialists in not being a supernaturalist and in his view of poetry and philosophy as a kind of symbolic knowledge from within of the whole—that whole of which, by existing, we are the significantly constitutive part. If it is true that he wants a revelation of God, because our old God is dead, he also insists that it be—again—an internal revelation from within the human predicament, and that it be of an immanent God. And so far as he seeks to rediscover essence, at least he recognizes that meanings or essences are man-made. Heidegger is also a literary existentialist in having been seriously and extensively concerned with poetry as an art.

«32»

In his essay on Hölderlin, Heidegger reaches a conclusion similar to the position broached in this book that "it is poetry which first makes language possible . . . language must be understood through the essence of poetry," and not the other way around.[2] Man's speech and man's freedom of decision are together constitutive of his existence as a man, according to Heidegger. Language bears witness to and perpetuates the human; it allows man not just to testify as to what is but also "to stand in the midst of the open invitation of the existent"; it introduces him to the possible as well as being constitutive of the actual: it allows man, in other words, to explore the existent by holding the possible in view.

When, however, in meeting the challenge of the existent we respond by questioning—this questioning is itself a way to be. The difference, for Heidegger, between human existence and other existences is just this: the first is capable of existing for itself (Sartre's *pour-soi*) while the latter exist only in themselves (Sartre's *en-soi*) and cannot present existence *to* themselves. When Heidegger insists in *Sein und Zeit* that questions about existence can only be answered by humanly existing, it is clear that he means only that when understanding has succeeded questioning has a new mode of being become opera-

[1] See Paul Tillich, *Theology of Culture* (New York: Oxford University Press, Inc., 1959).
[2] Martin Heidegger, *Existence and Being* (Chicago: Henry Regnery Company 1949), p. 307. Yet he appears to contradict himself when he also says, "We must first of all be certain of this essence of language in order to comprehend truly the sphere of action of poetry and with it poetry itself," *ibid.*, p. 300.

tive. For Heidegger, as for pragmatism, to understand something is, partly, to constitute it.

Knowing, however, is not all of "being there" (*Dasein*). For, since human existence is thought of by Heidegger as a being cast-a-way (*Geworfenheit*), as a being there with a quality of *Befindlichkeit*, and not just as a cognitive involvement, then knowing obviously cannot be equated with human existence. Though human existence is a being there which can know itself, it is not to be identified with knowing. Knowledge is only that mode, or modification, of being in which being is possibility. The emphasis Heidegger is trying to achieve with this sort of language is, it seems to me, plainly anti-dualistic and a re-affirmation, much like that of Dewey's in a different language, of the continuity between essence and existence. Meaning, in other words, does not have its locus in a realm apart but is existential, is a *modification* of existence. As Dewey says, "The modification of existence which results from [its] application constitutes the true meaning of the concept." [3]

This emphasis prepares us for Heidegger's more radical statements that "our existence is fundamentally poetic. . . . Existence is 'poetical' in its fundamental aspect." In our stranded or forlorn condition the structure of being is qualitatively pervaded by anxiety. Anxiety is not caused by anything specific but, according to Heidegger, by the very possibilities of being-in-the-world. We *care*, he says, about possibility, that is, about the mode of being that is being created, about the modification of existence that is being made. We care about it because it is the mode of our involvement. To be there is to be stranded, but the way of detachment often only increases our alienation from the world. On the other hand the way of involvement must be dialogical:[4] to take possession of things humanly, they must exist *for us*, they must provisionally be detached as essences in being constituted and grasped as existences. Thus beauty, and other values, emerge in existence through our involvement with it: beauty, especially, is the mode of "the presentness of being" in the phrase which Heidegger took from Hölderlin.

This involvement, however, is creative; for human existence

[3] John Dewey, "The Development of American Pragmatism," *Twentieth Century Philosophy* (New York: Philosophical Library, Inc., 1943), p. 454.
[4] As in, for example, the following statement, "The being of men . . . only becomes actual in conversation." M. Heidegger. *op. cit.*, p. 301.

is, almost by definition, unfinished. As Dewey says in the passage quoted above, "this taking into consideration of the future takes us to the conception of a universe which is still, in James' term, 'in the making,' in the process of becoming, or a universe up to a certain point plastic." [5]

Existence is always individual (*Gemeinigkeit*), according to Heidegger, and it irreversibly ends in death. But it is not necessarily fulfilled by death. The escape afforded by the way of detachment during life, or by a flight into the impersonal, is likewise no fulfillment. The impersonal is not without its seductions but is, in the end, alienating. For the nature of existence reveals itself, and its modes are possessed, only in involvement with it; its beauty, for instance, the presentness of it—will not emerge for the uninvolved. In the detached view, likewise, things lose their quality of *Zuhandenheit*, that is, of being "good for" something. To see things at all is to see them in some relation; to see them as good for nothing is false in the sense of inhuman. The structure, or perceptibility, which they retain in abstraction from their "to-handness" is simply that of an older "to-handness" the sense or urgency of which has been lost; and this is the kind of structure the detached or impersonal view gives. True "to-handness" is creative relatedness; it is the view of things that involvement gives. "How long," says Heidegger, "are we going to imagine that there was first of all a part of nature existing for itself and a landscape existing for itself, and that then, with the help of 'poetic experiences' this landscape becomes colored with myth? How long are we going to prevent ourselves from experiencing the actual as actual?" [6]

« 33 »

What Heidegger calls, quite pragmatistically, the admanuality of things, Sartre, in *L'Être et le Néant*, calls their "material significance" or serviceability. The meanings of objects are constituted— these two thinkers have rather belatedly discovered—by their relations to other things and to a human existent. But if we stop to consider, that is exactly how the object itself is constituted: by the system of relations in which it exists and which comes together, or ends, in human existence (*Dasein*). Human existence itself, however, while itself constituted by its relations to the system, refers only to its own possibilities and not to the system for its meaning.

If objects were given only to sensation (were that possible)

[5] J. Dewey, *op. cit.*, p. 463.
[6] M. Heidegger, *op. cit.*, p. 275.

« Experiencing the actual as actual. »

they would appear (if at all) meaninglessly, as "merely encountered" things, indifferent. They become truly meaningful when the situation brings them into relation with the urgencies of our own "being there." They are given to intelligence, and their possibilities, in actively defining as well as resolving the situation, shine forth. As Dewey has also argued,[7] so-called original mental data, or givens, are in fact turning points in the readjustment or transformation of objective states of affairs.

Now, since for Sartre the essence of freedom is choice—the *rejection* of one set of actualities and the *projection* of other actuali-

[7] For example, in "The Practical Character of Reality," *Philosophy and Civilization* (New York: Minton, Balch, & Company, 1931).

113

ties, freedom is possible only to intelligence. So that if knowing is a kind of change in things, as Dewey and the existentialists say, then it would seem that so far both existentialists and pragmatists agree that freedom, like art, consists in intelligent or knowledgeable action.

It is interesting that just as Dewey took the occurrence of quality in the work of art as the paradigm of its occurrence everywhere, so Sartre's analysis of qualities and his hypothesis of their symbolism constitutes the capstone of his formal philosophy. Because, according to Sartre, the desire to *have something* is, indirectly, the desire to *be something;* whenever I appropriate something the act of possession has a symbolic dimension: in seeking to appropriate the being of a thing I am also trying to seize the whole world. To be in the world, according to Sartre, is to seek to possess the world, is to seek to seize the total world as what is lacking to the *pour-soi* [the affective-conscious] in order that it may become *en-soi-pour-soi.* Apprehension, as the rationalists sensed long ago, ever seeks to be total as far as its objects are concerned; and as far as itself is concerned its ever-renewed effort is to justify itself, to become its own basis—not just by grasping its own nature but by identifying with everything that is. In particular, things acquire all their qualities, favorable or unfavorable, through the projects which are my dealings with, and (therefore) interpretations of, the world. Outside of my acts as a creator or user things relapse into either sheer potentiality or the indifference of objects that were once meaningful to others but are only residually or derivatively so for me. More generally again, however, my basic project—in which Sartre finds the dynamic explanation of human life—is two-fold. In his own words:

Each human presence in the world is at the same time the direct project of metamorphosing his own *pour-soi* into *en-soi-pour-soi* and the project of appropriating the world as the totality of being-in-itself, under the varieties of a fundamental quality.[8]

Man, the reflective being, seeks existentially to realize his own identity; while man, the anguished creator of possibility, seeks to remedy the condition which is felt as a stranding and an estrangement by the symbolic appropriation of all that is. And fragmentary though man's success in this enterprise may turn out to be, it is nonetheless the locus of operative freedom—of the freedom whose nature is the same in art, in

[8] My translation. The reader may consult Jean-Paul Sartre, *Being and Nothingness.* (New York: Philosophical Library, Inc., 1956), p. 615.

science, and in that choice and those actions which are knowledgeable.

Sartre may have concluded this part of *Being and Nothingness* with an epigram about man's being nothing but a *useless passion*, but the statement was a flourish and not conclusive. The true application of his theory (out of which, even, the theory perhaps grew) is to be found in the dramatic example of the actions of members of the French Resistance which is recounted in his *What is Literature?* It is an example in which man stands out as the being who creates his own humanity. The Resistance workers found themselves in an extreme situation which called up again in them the primordial anxiety of those early civilizers upon whom the realization had dawned that "man," the emergent human ideal, had to be deliberately enacted by each one of us individually for this radically new, reflective and cooperative, value to take root in the coercive world of struggling and unfree social organisms:

For political realism as for philosophical idealism Evil was not a very serious matter. We have been taught to take it seriously . . . in a time when torture was a daily fact . . . the Rue de Saussaies, Dachau, and Auschwitz have demonstrated that Evil is not an appearance, that knowing its cause does not dispel it, that it is not opposed to Good as a confused idea is to a clear one, that it is not the effects of passions which might be cured . . . of a passing aberration which might be excused, of an ingorance which might be enlightened . . . in spite of ourselves, we came to this conclusion which might seem shocking . . . Evil cannot be redeemed.

But on the other hand, most of the resisters, though beaten, burned, blinded, and broken, did not squeal. They broke the circle of Evil and reaffirmed the human—for themselves, for us, and for their very torturers. They did it without witness, without help, without hope, often even without faith. For them it was not a matter of believing in man but of wanting to. Everything conspired to discourage them: so many indications everywhere about them, those faces bent over them, that misery within them. Everything concurred in making them believe that they were only insects, that man is the impossible dream. . . .

This man had to be invented with their martyrized flesh, with their hunted thoughts which were already betraying them—invented on the basis of nothing . . . they were still at the creation of the world and they had only to decide in sovereign fashion whether there would be anything more than the reign of the animal within it. They remained silent and man was born of their silence. We knew that every moment of the day, in the four corners of Paris, man was a hundred times destroyed and reaffirmed

115

. . . for metaphysics is not a sterile discussion about abstract notions which have nothing to do with experience. It is a living effort to embrace from within the human condition in its totality.[9]

Art and the tragic sense of life

That Sartre is actually a better philosopher than he is a novelist or playwright, and that Camus is a better story-teller and essayist than he is a philosopher, does not entail that they misconceive the relation between philosophy and "poetry"; or between thought and "life" for that matter, as some commentators have implied. It is true, however, that Sartre's "phenomenological" aesthetics [10] misconceives the nature of art in approaching works as illusionistic, non-real, and even non-natural objects. We have seen in earlier chapters that this approach both begs the question and is based on the mistaken and self-defeating assumption that objects have fixed and unalterable characteristics. This is an assumption from which we are emancipated, precisely, by art! But Sartre's essay on the psychology of phantasy just happens *not* to be the place in which we will find the existential attitude illuminating as to the processes of art. His metaphysics has afforded us some good insights in this connection; it remains to consider what we can learn from his essays about literature.[11]

It is a fairly common premise—not to say a standard rationalization—among French writers today that a life just lived is of itself not enough; that a complete life, that the worth-while life, requires reflection upon existence and an attempt to record or celebrate the values and discoveries which have revealed themselves to the existing individual. Being, in other words, has value only when it is sensitive and reflective, when it stands outside itself (or "ex-ists"—as the existentialists occasionally spell it).

It is also Sartre's view that to write is, first of all, "to disclose

[9] Jean-Paul Sartre, *What Is Literature?* trans. by B. Frechtman (New York: Philosophical Library, Inc., 1949), p. 217 ff.
[10] See *The Psychology of Imagination* (New York: Philosophical Library, Inc., 1948).
[11] Mainly, *What is Literature?* and *Literary and Philosophical Essays* (New York: Philosophical Library, Inc., 1949) and (New York: Criterion Books, Inc., 1955), respectively.

116

the world." By this he means that "the function of the writer is to act in such a way that nobody can be ignorant of what it is all about." [12] We see that this is a theory of art as revelation combined with a view of literature as the conscience of a society.

In the second place, to write is, for Sartre, "to appeal to the consciousness of others in order to get one's self recognized as essential to the totality of being." [13] Sartre is quite serious about this; he means it literally: "One of the chief motives of artistic creation is certainly the need of feeling that we are essential in relationship to the world." [14] Here is how this need arises. In laying out his perceptions, the artist becomes conscious that as a human being he is a revealer of what is, that man is the means by which things are manifested. At the same time, however, his feelings about the deep-seated objectivity, or otherness, of what he creatively discloses cause him to fear or recognize that he might, after all, be unessential in relation to the things revealed. "If we turn away from this landscape," he says, "it is we who shall be annihilated, and the earth will remain in its lethargy until another consciousness comes along to awaken it." [15]

The alienness of the in-itself is, as it were, a challenge to the for-itself to bring it under control. It would seem that to the human being, the conviction that the world is utterly indifferent to all his purposes is not tolerable. Therefore, when consciousness seeks to make the world intelligible and seeks to understand or constitute it as a totality, consciousness not only aims to present or recover it *as it is*, but *as if* it were compatible with human freedom—with the purposes, that is, of free men.

the creative act aims at a total renewal of the world. Each painting, each book is a recovery of the totality of being. . . . For this is the final goal of art: to recover this world by giving it to be seen as it is, but as if it had its source in human freedom.[16]

With this Sartre adds to his characterization of art the view that art is both a reconstruction and the symbolic projection of a reconstruction.

Like the pragmatists on this, Sartre believes that "the real world is revealed only by action," and that "one can feel himself in it only by

[12] Sartre, *What is Literature?*, p. 24.
[13] *Ibid.*, p. 60.
[14] *Ibid.*, p. 39.
[15] *Ibid.*, p. 39.
[16] *Ibid.*, p. 37.

going beyond it in order to change it." [17] Consequently he insists that the universe of a novel, for instance, must, to have reality, be a discovery made as a part of attempting to transcend, or change, reality.

The error of realism has been to believe that the real reveals itself to contemplation; and that, consequently, one could draw an impartial picture of it. How could that be possible since the very perception is partial, since by itself the naming is already a modification of the object? And how could the writer, who wants himself to be essential to this universe, want to be essential to the injustice which this universe comprehends? Yet, he must be; but if he accepts being the creator of injustices, it is in a movement which goes beyond them toward their abolition.[18]

Not only does the writer give society a guilty conscience, but when society "sees itself as seen" it acquires, by virtue of that very fact, a sense that its established values are challengeable and subject to change. "The writer presents [society] with its image; he calls upon it to assume that image or change itself." [19]

A negative way of defining the artist's job is to say that he should be less occupied with celebrating spiritual things than with the spiritualization of the actual; he should be more concerned with renewing things in and through his vision than with a mere vision of renewal. We see in this definition an extension of the activism which Sartre has emphasized as a basic characteristic of his philosophy. But he also spells out the relation between art, or vision, and action which is implicit in this emphasis:

as the simple presentation is already the beginning of change, as the work [is] . . . a judgment of this present in the name of the future; finally, as every book contains an appeal, this awareness of self is a surpassing of self. The universe is not contested in the name of simple consumption, but in the name of the hopes and sufferings of those who inhabit it.[20]

Sartre, like other existentialists, is no doubt liable to the charge of romantic voluntarism; but he is here unequivocally against the consumer complex about art which I earlier identified as an unfortunate accompaniment of nineteenth century aestheticism, itself the outcome of peculiar developments in Western industrial and imperialist society.

[17] *Ibid.,* p. 60.
[18] *Ibid.,* p. 61.
[19] *Ibid.,* p. 81.
[20] *Ibid.,* pp. 158-159.

Romanticism, of course, is not to be blamed for the abuses of "symbolism" and "aestheticism." On the contrary there is nothing decadent about Sartre's romanticism. In the quotation just given, for instance, his definition of essence is every bit as dynamic and healthy as Dewey's practical definition of essence as actually a turning point in the readjustment or transformation of objective affairs. Sartre says:

The theory of the primacy of knowledge, unlike any philosophy of work which grasps the object through the action which modifies it by using it, exerts a negative and inhibiting influence by conferring a pure and static essence upon the object. . . . What is needed is, in a word, a philosophical theory which shows that human reality is action and that action upon the universe is identical with the understanding of that universe as it is, or, in other words, that action is the unmasking of reality, and, *at the same time*, a modification of that reality.[21]

If social reality is always changing, literature is a mode of existence which projects this process, making action knowledgeable. "In short," Sartre says, "literature is in essence the subjectivity of a society in permanent revolution." [22]

Sartre's peculiar language should not be allowed to hide the fact that, like Dewey, he recognizes the pervasiveness and inevitability of change in the social organism. Because it is the nature of society to change, however, is it therefore advantageous to think of social change under the aspect of "permanent revolution" or to introduce, like Camus, the category of rebellion as explicatory of the historical and philosophical relations between the (humanly) individual and the (humanly) social?

As it happens the language of the French existentialists has both literary advantages and philosophic aptness. But it is necessary to understand the constructive, and crucial, distinction which Camus' philosophy of revolt makes between "revolution" which is absolutist—and therefore totalitarian and negative—and "revolt" which is relative to the condition of man and, in being a perennially necessary criticism of it, is also an affirmation of human possibilities. It has been an insight not clearly gained till our time that the social rebellion of each generation against the last is a normal stage in the course of the continuous

« 34 »

21 J.-P. Sartre, *Literary and Philosophical Essays*, trans. by A. Michelson (New York: Criterion Books, Inc., 1955), p. 213.
22 Sartre, *What is Literature?*, p. 159.

34. Louis David, *Oath of the Horatii. Cliché des Musées Nationaux, Musée du Louvre, Paris.*

« The social rebellion and affirmation of each generation. »

renewal or reconstruction of social affairs or institutions, and that this revolt is both psychologically explicable and politically healthy. It is also clear, however, that progress requires a transmission of the accumulated knowledges that constitute the culture. So, if we define education, as Dewey does, in this context, as the transmission by renewal of culture, we see that civilization cannot be transmitted without "revolt," for there can be no renewal without criticism. As it is the nature of an institution—as a mechanism for coexistence—to develop, like all mechanisms, its own inertia, it is too frequently the case that any reflective attempt to modify the direction of its momentum is felt as a rejection, or revolt against, the institution by those immersed in the routines it has facilitated or those to whom the adjustment it has created still seems viable.

120

But because *unlimited* rebellion against imposed absolutes always seems, as a matter of fact and of history, to lead to the extreme of a new totalitarian system, Camus pushes this thesis one step further. To those revolts that ruthlessly replace one set of absolutes by another set of absolutes he assigns the derogatory term "revolutions." Camus, in other words, has understood that revolt, like art, is a matter of equilibrium; and that, like art's, the unities which it seeks to achieve are *inclusive*, not exclusive or restrictive like those of the totalitarian utopias. In fact, he hardly admits that what the latter want should be called "unity"; for what they want is *totality*. In this, however, the totalitarians, like the victims of tragedy, fail to recognize the existence of human limitations. They plunge humanity, consequently, into a nihilistic cycle of violent oscillations between repressive orders which, in the end, are equally unfree and uncreative. Because totality in the absolutist sense is impossible the cycle threatens to become eternal and tragic unto human extinction. The only alternative is a balance-seeking philosophy of revolt as critical reconstruction, and a humanism religious in its quality and creative in intent and effect.

It is against this background that Camus develops his view of art. He shows how it is inevitable that the totalitarian should be suspicious of and hostile to the creative artist's rebellion against "reality." The totalitarian senses that the artist's rejection is not total, that is, not nihilistic; that it is not only a refusal, for "no form of art can survive on total denial alone." Here is how Camus puts it:

By the treatment that the artist imposes on reality he declares the intensity of his rejection of it. But what he retains of reality, in the universe that he creates, reveals the degree of consent that he gives to at least that part of reality which he draws from the shadows of evolution to bring it to the light of creation.[23]

Camus' point of view makes it clear why both (escapist) formalism and (socialist) realism negate the critical-constructive nature of the creative act. They do so insofar as the former is a total denial of reality and insofar as the latter is an absolute and slavish acceptance of it.

Formalism and realism are, according to Camus, both absurd as well as impossible concepts. "The only real formalism is silence"; and even photographic realism is no more than the "result [of] an act of

[23] Albert Camus, *The Rebel* (New York: Alfred A. Knopf, Inc., 1961 edit., 1956 copyright), p. 268.

121

selection" which "imposes a limit on something that has none. . . . To be really realistic a description would have to be endless. . . . Realism is indefinite enumeration." [24] The trouble with both formalism and realism, Camus says, is that they look for unity in the wrong place, that is in the mere materials of the work, in reality in its crudest state, or in pseudo-morphous phantasy and deductive irrelevancies. The unity in art is not, however, something given beforehand, as we have seen; it is developed in the *transformation* of reality. This unity is what we also call style, and is a necessary concomitant of the need to communicate and the requirements of communication.

The reason that realism is the official aesthetics of the totalitarian revolution is "that its real ambition is conquest, not of unity, but of the totality of the real world." [25] In realism "the event enslaves the creator," and in denying his freedom is as nihilistic as formalism which "claims to deny the event completely." Because creation "always coincides with rational freedom," because "the greatest style in art is the expression of the most passionate rebellion," [26] because "genius is a rebellion which has created *its own* limits" true art will, as long as it survives, be at odds with the totalitarian nihilism of the new world conquerors and their combination of preconceived doctrinal rigidities and unprincipled, Procrustean adjustments to reality. On the plane of history what we are witnessing is a "struggle between the artists and the new conquerors, between the witnesses to the *creative* revolution and the founders of the *nihilistic* revolution." [27]

But as, on the technical plane, art is also an activity which is the model for those who in social life seek to be free and to govern themselves, "every act of creation denies, by its mere existence, the world of master and slave." [28] The procedures employed by the artist to bring refractory thematic materials and resistant physical materials to expressiveness in genuine stylistic unity are, indeed, entirely analogous to the procedures of creative revolt which both resists the conventional realities which have become spiritually mutilating and seeks to remold the social environment into a fresher and freer coherence. "Creation," says Camus, "is like civilization: it supposes an uninterrupted tension between form and matter, between evolution

[24] *Ibid.*, pp. 269-271.
[25] *Ibid.*, p. 270.
[26] *Ibid.*, p. 271.
[27] *Ibid.*, p. 275.
[28] *Ibid.*, p. 274.

and the mind, history and values. If the equilibrium is destroyed there is dictatorship or anarchy, propaganda or formalist fantasy. In either case, creation, which coincides with rational freedom, is impossible." [29]

That art and civilization are not separate enterprises, as Camus is saying with his perception of the similarity between creation and political culture, is something that cannot be repeated too often. Man does almost all he does by art, or culture. Animals have instincts and biological adaptation or specialization; but man has his arts, or cultural adaptations. And of these it has rightly been said that the intellectual arts are those that free men most to be themselves.[30] We must think of the arts, as Véron insisted, not as the fine late flower of human culture, not as the fugitive bloom of civilizations as they emerge into the sun, but as the very germ and active principle in culture-building from the ground up. From the bonetools and pebble tools of the small-brained men of a million years ago, and the hand axes of full-brained men in lower Pleistocene times to date, the process of man's adaptations has been artful. Man and his arts were born together, however long they may have been aborning; that is what the "sapiens" in *homo sapiens* means, namely, that man has abandoned the biological method of adaptation by speciation in favor of "technological" and social or cooperative methods.

All this, of course, means that Camus is one intellectual artist not afflicted or inhibited from action by the tragic sense of life—as Unamuno called it. Greek tragedy itself was indeed an intellectual art, perhaps the greatest so far. But tragedy, the dramatic form, and the tragic sense of life are two different things; the former by no means entails the latter. The tragic sense of life results from a disappointment with, or inability to accept, either the fact of human mortality or the optimistic Christian mythology which seeks to deny it. Life is not tragic simply because it ends in death; life is what we make of it. It is choice that can be tragic either in being unaware of all the factors and consequences involved, or in being between two *conflicting* goods. So it is choice, not death, over which we may legitmately agonize. As Sidney Hook pointed out, it is not clear how it is that those who are nauseated by every kind of life should be so fearful of death.

[29] *Ibid.*, pp. 270-271.
[30] Mark Van Doren, *Autobiography* (New York: Harcourt, Brace & World, Inc., 1958).

Wisdom is knowledge of the uses of life and death. The uses of life are to be found in the consummatory experiences of vision and delight, of love, understanding, art, friendship and creative activity. . . . The fear of death, the desire to survive at any cost or price in human degradation, has often been the greatest ally of tyranny, past and present. "There are times," says Woodbridge, "When a man ought to be more afraid of living than dying." And we may add, there are situations in which because of the conditions of survival, the worst thing we can know of anyone is that he has survived. We have known such times and situations. They may come again. . . . I conclude therefore that death as such is not a tragic phenomenon and that its presence does not make the world and our experience within it tragic.[31]

This returns us to, and consecrates, Camus' proposition, in *The Myth of Sisyphus*, that a philosopher, or consistent human being, cannot *both* conclude that life is not worth living *and* continue to live. Camus' own choice was to live and make the best that he could of his life and world. One of the results of his choice, in the vital dilemma of which he made the logic clear, has been to increase our awareness—in a precarious world sadly lacking in the creative arts of intelligent social control—of the intimate connection between the arts, political freedom, and culture as a whole.

As civilization transforms the environment and creates a social one, so the universe is always the universe *of* a civilization. And as Greek tragedy was, in its origin, a civilized surrogate for human destruction or sacrifice, so all three great tragedians premised both that the order in the universe at large is incomplete, and that the moral or social order in human life is incomplete. Though Euripides tends to rest in a sorrowful recognition of the destructive stresses between man's passional nature and his prudential nature, Aischylos, in contrast, believed that human conflicts are surmountable through the anxiety and intelligent exertion which create new or better social and moral orders. Both of them, however, share with Sophocles a basic conception of Greek tragedy that the human condition is a precarious balance ever prone to lapse into a state of partial or great disorder.

But the humane man, the anguished and intelligent protagonist of Tragedy, that is, does not on that account despair—even if

[31] Sidney Hook, "Pragmatism and the Tragic Sense of Life," *Proceedings and Addresses of the American Philosophical Association, 1959–60*, Vol. XXXIII (Yellow Springs, Ohio: Antioch Press, 1960), pp. 12–13.

he must resist the gods. He does not despair because he cares more about the human consequences of his acts than about what the gods can do to him. In fact, the gods he is resisting turn out (in Aischylos and Sophocles) to be only the symbols of an old order that needs reconstructing. It is very strange, but poetically right, that the reward of his anguished and intelligent embattlement is that the Greek tragic hero, in his humane consequentiality, both discovers and is adopted by the new gods or symbols that invest the new order, if it is just, with their own sacredness or attractiveness.

And this outcome of Greek tragedy is entirely congruous with that of Camus' philosophy: man is worthy but unlucky. Ever capable of great good he is nonetheless forever liable to folly, disaster, and useless suffering. Were he ever to reach a heaven made eternally safe from suffering, and survive, however, he would still be eternally gnawed by pity for whatever was outside it and still suffering.[32]

[32] Cf. P. B. Rice, *On the Knowledge of Good and Evil* (New York: Random House, Inc. 1955), chapter 16.

CHAPTER SEVEN

Art and the art work

Abstraction and representation

A work of art is not good as a work of art because it is a good likeness—contrary to what Aristotle seems to have said when he cited the pleasure we "naturally" take in a likeness as one of the reasons why we enjoy mimetic makings. This, it should be noted, is not an explanation but an observation; and it is an observation which is itself in need of explanation. Our pleasure in a good likeness is only *aesthetic* if what it is a likeness of was already beautiful. An accurate representation is enjoyed either as a feat or bit of virtuosity,[1] or, in the absence of the original, for its mnemonic, not suggestive or expressive power.

But neither is a work of art not good be-

[1] Wilhelm Worringer called it a "sportive, trite joy," in his book *Abstraction and Empathy* (New York: International Universities Press, Inc., 1953).

127

« 35 » cause it is representative.[2] When a representational work is not good it is because it is merely the execution of something pre-existent and pre-conceived. It has brought nothing new into being, and may be counted superfluous, in the sense that translations are superfluous.

 Again, a work which is *merely* abstract is neither good nor bad on that account. To speak of a work either as an "abstraction" or under the aspect of representation is, we must realize, to have re-
« 36 » sponded to it only partially—and is evidence that, knowingly or not, we have approached it from the point of view of "subject matter." The

[2] As Clive Bell pointed out, realistic forms in a good design tend, by their extra-aesthetic reference, to distract from the significance of formal relationships. C. Bell, *Art*, 1928 ed. (London: Chatto & Windus, 1927).

35. *Dominique Ingres*, Portrait of M. Bertin. *Cliché des Musées Nationaux, Musée du Louvre, Paris.*

« Representation versus abstraction. »

fact is that the quarrel between representationism and abstractionism is a false issue; the difference between them does not define an exhaustive alternative. It will be seen, too, that even the modern abstractionist is still arguing from within a perspective that is, at bottom, representationist. Even though it is to insist that he is not bound by it, he continues to talk of subject matter. To talk of subject matter, however, is to lapse into the set of assumptions within which art is supposed to state (in the discursive sense of "state") something about this subject matter. But this supposes that art is statement, and reduces creation to statement. The expressionist or abstractionist counters by claiming that art is expression, not statement, but gets no further than claiming that expression is statement *plus* something else, or that expression is a kind of statement. Obviously, the expressionist and the abstractionist have remained bound in their thinking, though not in their practice, to the approach by way of subject matter. Contrast the "conceptualistic," or realistic, titles of many twentieth century works with the sheer "constructivism" of the works themselves.

36. Willem de Kooning, Excavation. Courtesy of The Art Institute of Chicago. Mr. and Mrs. Frank O. Logan, Purchase Prize. Gift of Mr. Edgar Kaufman, Jr., and Mr. and Mrs. Noah Goldowsky.

The representationist account derives its plausibility from the fact that anything we care to think of, or make, will always look like something else. It will always be found that, in some aspect or connection, anything is like some other thing. It is, of course, not noticed that any such comparison involves *abstracting* the likeness. It is forgotten, however, that nothing is anything else; and that even a copy, in being only like something else, is an abstraction or selective translation into some medium of some aspects of the other thing.

There are several questions involved here, but I do not think there can be any doubt that if we ask which is more basic activity, imitation or abstraction, the answer must be abstraction. Even "learning by imitation" turns out to be, on examination, an abstractive process. Still more so is this the case in the active process of artistic creation.

If we ask, next, which is more explanatory, as a category, of what art does and is, namely, which is the more basic concept—it follows that we will again answer abstraction.[3] But this does not mean that we have forgotten that abstraction is itself expressive and can be mimetic, as we saw in Chapter IV; for what we have just been saying is that representation is a kind of abstraction.

I also seem to have assumed, by implication, that there is no such thing as a perfect copy. And this is, in fact, true; but not because there is no such process as copying, only because there is no such thing as perfection. As I have tried to show, all representation is basically abstraction, and those representations are good, aesthetically, which are expressive in their selectiveness or inventiveness. What about copies which are commercial reproductions, then? Are they not literally copies? As copies of works of art they are, of course, not quite exact. They are judged by reference to the original work which they seek to, but never quite, duplicate. If they are free enough of grosser deficiencies they will serve, up to a point, and less effectively, the same function as the work of art.

It follows that there is no other way of understanding the usual formulation of the general program of what is called "representative realism" except as involved in an unnoticed self-contradiction. It should also be noted that this program has an aesthetic and a non-aes-

[3] If music is the most primitive of arts, as it is sometimes claimed, and if "pure music is pure abstraction," as Santayana said, then abstraction is also the primordial process in expressive making.

thetic phase, signified indifferently by the adjective and the noun depending on how we take them. As we have already seen, if taken literally it is, as representation, an impossible program; as realism, in the sense of social criticism, it is—considered purely technically—a program for focusing attention upon *selected* aspects of the environment and commenting upon them. As Baudelaire said about Millet: "Au lieu d' extraire (!) simplement la poésie naturelle de son sujèt, M. Millet veut à tout prix y ajouter quelque chose." [4] The non-aesthetic component of the doctrine may tell us where the realist artist went for his models, but it also has the unfortunate effect of reinforcing the illusion about the possibility of copying. In fairness, however, it is to be remembered that the great realist artists are as completely *exhibitive* and as little *expository* in their works as any other artists.

One thing further should be noted about this program, and that is its assumption that there is a reality out there with shapes or forms proper to it that are waiting to be reproduced in a medium and by techniques of the artist's choice. For man, however, reality does not have determinate structure or distinctions prior to his determination of them within it. In any case, the belief that it does have them, taken together with the doctrine of representationism, condemns art to be forever unoriginal in being only the transference of already discriminated forms to new mediums. The dualistic doctrine of representationism, understood as the making of objects for perception that are *like* previously isolated things, may be more intelligible than the idealistic version criticized in an earlier chapter, but it is not creative.

When it is claimed, as it sometimes is, that the overall tradition of Western art is that of "naturalism," it is a way of talking rather than a program, or a criterion of recognition, that is being enforced. It is certainly stretching a point to imply, as this way of talking does, that "naturalism" has been an intent common to—among others—Homer and Anatole France, to Proust and Appollonios Rhodios, to Romantic painting and Gothic sculpture, to the frescoes of Lascaux and Altamira and the works of Daumier and Toulouse-Lautrec, to Sophocles, J.S. Bach and Ingmar Bergman. We can speak of intent here

[4] Charles Baudelaire, *Curiosités Esthétiques* (Aubry, Paris, 1946), p. 327. Notice that the assumption behind Baudelaire's criticism is also couched in terms of subject matter.

because it is a program that to be carried out at all has to be carried out deliberately. But if it does not describe the differences among what the artists have sought to do, it would seem rather that "naturalism" does categorize the way in which non-artists in the West have, of late, looked at art. This usage, however, has had the disastrous effect of causing the best students of art to equivocate the term "naturalistic" with the term "representational."

The question naturally arises whether these differences cannot be accounted for as merely due to different stylistic programs superimposed, like so many flourishes, upon the basic tendency postulated. This, however, misunderstands style; for style is not an accretion or increment or additive to "naturalism" or to any art movement. On the contrary, a true understanding of style takes one so far toward understanding art itself that the assumption that art and style are identical seems thoroughly justified. As Middleton Murry says, "Style is not an isolable quality of writing; it is writing it-self."

In the meantime the fact must be noted that we still have an attitude to the arts that is analogous to that embedded in the usage "society" when what is meant is the "world of the socialite." The latter is obviously the outgrowth of an attitude [5] that will not advance the study of society in the serious sense that sociology takes it. Aesthetics will likewise remain frivolous until we stop presupposing that art, and delight in art, come only after survival has been insured and that the pursuit of the arts is a prestigious and "cultured" way of filling our leisure. One thing this forgets is that there is an art of survival, and a joy, however fugitive, in it. It also overlooks, however, a quality present in everything we do or make presciently. This quality is not necessarily unanalyzable, but it does seem to be universal; it is the quality—to borrow a very effective example of Bosanquet's—associated with the experience of finding exactly the right words for what we have to say. The current world crisis, moreover, shows us that art works are being made, and things are being done artfully even though survival is by no means assured. This is, perhaps, because disgregated as our participation has become in political affairs, we have

[5] See the statement of the XVIIIth c. moralist quoted by Robert L. Heilbroner: "To make society happy it is necessary that great numbers should be wretched as well as poor." *The Worldly Philosophers* (New York: Simon & Schuster, Inc., 1953), p. 31.

either lost our sense of priorities in these matters, or else we cannot en-
force it.

The identification of this quality will account for the feeling
of having learned something that so frequently accompanies the
assimilation of an art work: the feeling is a consequent of the shock
of breakthrough achieved by a new way of perceiving. Partly it is the
secret joy for the artist that springs from difficulty or frustration
overcome. The feeling is also fed, however, by perception of the apt-
ness of the means by which we have been so lucky or so canny as to
solve our problem. The *hallazgo* or development, in the arts, of a new
instrument of perception, the exposure to a novel sensibility, is an
occurrence which runs ahead of the theory of that instrument or
sensibility; so that behind what it is initially revealing is the promise of
an imminent readjustment of the system of knowledge. In the exposure
to any novel and creatively articulated sensibility there is also felt an
implicit appeal to a further range of considerations and values than
those to which we are accustomed. But the powers of the artist and
the perceiver are not only challenged, they are rewarded as they are
challenged by, or exercised upon, the new perceptibility, or style.

Art and technology (*technē* before it was institutionally
differentiated into the two things) are not only coeval with civilization,
its very life and necessary condition, but they afford the individual in
the practice of them psychological rewards so real that they come to
be treasured beyond the ulterior benefits consequent upon artistic or
scientific success. The feeling of having learnt something from a work
of art, then, is the just effect of the noetic power of style; and style is
just that characteristic of the new attack upon reality—a reality-in-
-process-of-being-reconstructed—which carries the claim, or assurance,
that the reconstruction will be a coherent and better one. As such, it
follows that its style will be a main source of the peculiar or distinc-
tive interest of a particular work or movement.

Let us return, in order to recapitulate, to our point about ab-
straction as a fundamental ingredient in the process of suggestion. All
art is abstract; but abstraction may be (1) representational (2) nat-
uralistic or (3) non-semantic or "autontic," in the senses which I
will now stipulate. Abstraction is representational when, as in linear
perspective, it makes things to look as they appear at one moment from
just one point of view. It is naturalistic when, without resorting to the
above device, it still suggests something about an actual or possible

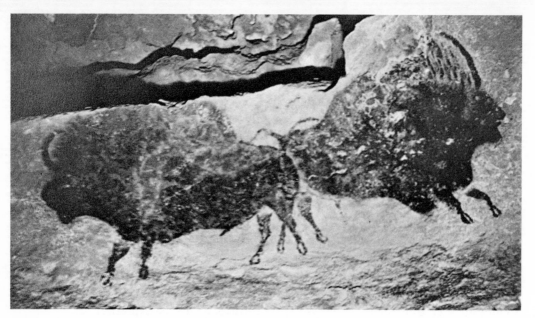

37. Two Bull Bisons. *Cave of Lascaux. From* Art in the Ice Age, *by Mariner and Bandi. Published by Frederick A. Praeger, Inc., New York.*

« We are able to describe paleolithic art as abstract and naturalistic. »

model. Abstraction is non-semantic, or autontic, when it is self-referring or only syntactically developed. Here it, the abstraction, becomes the model in the light of which a subject matter, if there is one or even though it is not namable, is seen or felt. The abstraction creates the subject matter, as does a quartet by Beethoven or an action painting by Pollock or Kline. Thus all art is meaningful, but not all art is semantic in the usual sense.

As an indication that this proposal may be helpful, let us make a test of the case of "geometric" art. It is not non-semantic or autontic when symbolic. If it is symbolic it would still, in referring to something, rightly be called naturalistic; if it is non-symbolic, however, it would be self-referring and both non-naturalistic and non-representational. Again, taking the perhaps crucial case of palaeolithic cave art, « 37 » we find that we are able to describe it correctly as abstract *and* naturalistic. We find, too, that we are able to say what needs to be said: that all art is decorative, that is pleasing in itself as a design; it does not have to be self-referring to be decorative. We will not call surrealist art either non-objective or "abstract," for it is not the former and is more than the latter. Strictly, we should have

134

to call it super-naturalistic; but we realize that super-realist, its old name, is the equivalent and we may continue to call it surrealist. Meanwhile, our proposed distinctions have served to remind us that surrealism does work with bits of previously given reality which it assembles according to its own principles. Incidentally, Hieronymus Bosch, on the basis of our proposal, does not get entirely assimilated to the Surrealists if he is characterized as super-naturalistic: an acceptable pun emerges which prevents us from equating super-realistic with super-naturalistic.

Creative abstraction and expression

For the purpose of understanding the generic process of abstraction, the mathematical or logical model of abstraction is inadequate. At the start of a logical system you have an abstraction, or set of abstractions. The resultant isolates, or terms, are then interrelated and their interrelations are developed, or expanded "deductively," that is according to trans-formation rules that can be made explicit. The transformations here are "substitutive"; they may, without prejudice, be called "mechanical." In any case, the outcome of development is dependent on the original abstractive acts symbolized by the postulates, definitions, and transformation rules in a peculiarly restricted way.

In art too one begins with an abstractive act; but nearly every succeeding "decision" in the development of the work of art is a *fresh* abstractive act—even if there are factors which control individual abstractive acts within this development. Even when "parts" of a work are being "related" the point is to create a fresh interrelation, or mode of interrelation: and this too requires an original abstractive act. Any-one who works "deductively" in art is using a crutch: he is falling back on habitual gestures, or clichés, or established conventions, which in being predictable risk being too obvious to be interesting. At best, a previously obvious connection might serve as a "punctuation" mark should the context require this service of it.

In a previous section we discussed the differences between statement and expression. Here it has become necessary to examine the relation between abstraction and expression. It should be noted at once, however, that if the above difference between deductive wholes

135

and artistic wholes is well drawn, then it would seem to follow that logical and geometrical analyses of works of art cannot be expected to parallel, or to serve as models for understanding, the design of works of art. A work of art is not put together "logically"; so that if it is analyzed logically, it has failed of being analyzed aesthetically.

If architecture is pleaded as an exception to this "rule," it will be seen to be only partially an exception, if at all, and one that clarifies the claim just made. Architecture is conveniently recognized to be a "science" as well as an "art"; but, in any case, the connection between the parts of an architectural work will be, as Aristotle has taught us, hypothetical (contingent) not logical (necessary). It is what the blueprints and scale models do not show, and what in strict logic cannot—but can by the "art" of the architect—be inferred from them, that constitutes the artistic development of the project. There is a visual and a spatial phase as well as an enjoyable and to-be-felt economy, or pleasingness-in-use, to the work which is as little mathematizable as the design qualities in a painting or the style in a sculpture. The case in the arts is, perhaps, much as it stands in the psychoanalytic "prediction" of conduct: it is only in retrospect that the determinacy or directionality of the process is seen to appear "inevitable," or consequential.

This is what such a careful workman as Henry James was emphasizing in his essay "The Art of Fiction" which assumes the existence of, and develops, a complete analogy between the art of the painter and the art of the novelist. "The good health of an art," he says, "must demand that it be perfectly free." [6] He admits just one obligation to which a novel may be held *in advance*, and that is that it must be interesting. But he hastens to add that "the ways in which it is at liberty to accomplish this result (of interesting us)" are "innumerable and such as can only suffer from being marked out or fenced in by prescription." [7] His understanding of the *ex post facto* nature of the tests we apply to artistic execution is consecrated in the remark "that the form [of a novel] . . . is to be appreciated after the fact." [8] Only after an author's choices have been made, and his standards implied, only "then can we follow lines and directions and compare tones and

[6] Henry James, "The Art of Fiction," reprinted in *Criticism: The Foundations of Modern Literary Judgment*, edit. by Schorer, Miles, and McKenzie (New York: Harcourt, Brace & World, Inc., 1948), p. 47.
[7] *Ibid.*
[8] *Ibid.*

resemblances." [9] Now we have insisted in this book that as an executant the artist must have a technical mastery of his medium; in other words, that artistic activity is a knowledgeable activity. So we are led to ask, how can an exercise (James' word) such as a painting or a novel be both free and knowledgeable, that is both free and subject to some technical requirements?

Obviously we cannot by free mean "arbitrary" in the sense of "capricious." As James says in the preface to *The Tragic Muse*, "the sense of a system saves the painter from the baseness of the arbitrary stroke, the touch without its reason; but as payment for that service the process [system] insists on being kept impeccably the right one." [10] Since a work cannot be structureless if it is to be both coherent and free, this coherence must emerge as novel or original, as well as apt. Had it been prescribable or predeterminable the work would not have been interesting. Exposure to it would have brought the boredom of the expected rather than delight in the discoverable.

Yet we must admit, as James does and any artist would, that the progress of a work is in some ways a process of responding to certain necessities. And if this is so, then part of the secret of the artist's originality must, I think, be a knowledgeable ability to respond *non-compulsively*. Some of these necessities will be "technical," for example, the need to be utterly economical of means employed to achieve a particular effect, or, on the contrary, the need to wring from a situation every last drop of significance. There may be a need to establish a certain tone, or a certain pace, or certain change of pace, a need to linger or a need to leap, a need to comment somehow on the exhibited—or in the exhibiting—or a need to abstain from any inter-calation, a need to intercept or a need to articulate. At the same time, however, there are needs deeply related to these but distinguishable from the technical. These other needs might loosely be said to be of a psychological rather than a stylistic nature: the need to turn attention in a certain direction, the intellectual scruples and priorities that must be observed, attitudes that must be developed and interadjusted (often, precisely, by means of style); emotion that must be clarified, themes that importune an artist to be handled, the very need to find significance just where in raw experience we could not have said,

[9] *Ibid.*
[10] Henry James in *The Art of the Novel: Critical Prefaces*, 1953 ed. (New York: Charles Scribner's Sons, 1934), p. 89.

137

without the art work, what that significance was. Certainly, the artist must *know* something about *how* to attend to all these needs and satisfy them; he must be able and prepared to respond. But his response should not be predetermined.

In the language of psychoanalysis, he should enjoy an inner freedom which allows his preconscious processes which are adaptive, playful, and associative to operate upon the pressing problem without interference from the tendentious and repetitious influence of fixated and unconscious, or repressed, processes. The artist, it would seem, is one who makes his own "rules" and who keeps or changes them according to a free decision as to whether the creative occasion requires them to be used in a new way or meet a new challenge, or whether what is required is a new extension of technique or a new technique altogether.

Of course, unconscious compulsions seem both to provide and to limit the artist with regard to his thematic materials—what used artificially to be called "subject matter." But he comes out in control of his thematic material, or he is no artist. I think this is proved by the case of Dostoyevsky. There does indeed seem to be a repeated reversion to certain themes such as the relationship to—or rejection of—the father, or the self-destructiveness of the human individual. Such themes, however, are properly speaking only materials; and what artist is not, in some way, limited as to the materials he works with? We have said above that what matters is what he does, artistically or stylistically, with his materials. So in Dostoyevsky we must understand that these materials are dredged up, so to speak, from his unconscious —are available to him as materials at all—only by virtue of the ability to bring them into apt and intelligible association with other materials and interests. But this ability is, precisely, the power of (a function of) his style; and we have here an unusually clear case of technique acting as discovery—acting, that is to say, to exhibit certain things about humanity or human individuality at the perception of which Dostoyevsky worked. It might be claimed that this is just a case of a man with a strong confessional impulse; but it is more than this, it is the confessional impulse—as in *Notes from Underground*—being used stylistically.[11] It both affects the prose technique in appearing to constitute almost the whole of it, as in the other famous instance

[11] Notice that the impulse, from the very first, has a tendency to take on form —here, the form of a confession.

of Mark Twain's use of the mock-vernacular, and gives the technique material to work on. The result is a cluster of new perceptions.

While the above explains something about an artist's characteristic preoccupations, however, it does no more than say that there is a reciprocal relation between them and his style. The characteristic ways by which he achieves the wholes which we enjoy as his finished works remain as the technical aspects of his style. But, in an art like music where the artist's concerns, as reflected in his failures as well as his successes, seem to be entirely technical or formal, the reference to thematic experiences as generating materials is less obviously an explanation. It becomes an explanation, however, if we can get used to the idea that there is *medium-bound thinking*, that musical thought is genuine thought operative in an other-than-verbal medium but handling its themes, bringing them under control, no less intellectually or formally than literature.

Let us take advantage of this allusion to music to face, without further delay, another fact that is crucial for the philosophy of art. This is the fact that a consideration of the phenomena of music forces us to revise our notion of what constitutes explanation. Customarily, analysis of a phenomenon, process, or situation into its constituent *elements* seems to us explanation enough. The peculiarity of "analysis" when applied to music, however, and indeed to art, is this: that instead of the elements explaining the effect of a particular combination, the particular fusion or melody or complex artistic whole has to be invoked to explain the effect of the elements! In art, then, analysis can specify the elements that "make up" a whole, but we don't get an *explanation* until we have apprehended the whole of which they are parts. Thus explanation, in art, depends upon prior enjoyment or perception of the work as a whole, or better, of the pervasive quality which gives the work its aesthetic unity.

This, by the way, is the simple sense in which works of art are said to be organic, that is the sense in which the operation and effects of the parts can be understood only by reference to the whole. Art works are in this respect quite like both living organisms and machines: but related to this characteristic there is a group of qualities (two of which we have already discussed) to a degree distinctive for art and which art maximizes; and these are interestingness, originality or unpredictability, and "vitality." It is the last which we will next discuss.

Art works and organisms

By vitality more is meant nowadays than the power to endure while continuing to interest.

More even is meant than the success some works have in capturing the quality of being alive, or lived with, of either their animate or non-animate models, a phenomenon studied by Roger Fry in the essay on vitality in his *Last Lectures*.[12] Fry, of course, was right in noting that the emphasis on vital stress is characteristic of Expressionism. In saying, however, that "the vital image is one which arouses the idea of an inner energy expressing itself in the form," he was far from the latter day suggestion that art works are more like living organisms than not.

But the analogy between works of art and living organisms has its merits. It extends, for instance and first of all, to the sense in which works of art "generate" other works of art. However far we go back in time we find, in the history of art, developed forms that presuppose earlier forms; so that, always, it would seem to be by intercourse with art that the artist creates new art.[13]

Now machines are also human products, and works of art seem to have a fundamental property mentioned above in common with them, namely, the characteristic of exhibiting design. The differences, however, between these two sorts of human product still seem to modern common sense to override this similarity. The design of machines is a preconceived one and externally determined in the sense that it does not respond either to suggestions or leads provided by the *medium* itself nor to the expressive requirements of the designer. It responds rather to ulterior, appetitive or "practical" needs which the machine will be merely instrumental in satisfying. Also, in a work of art the design as perceived and enjoyed is a *process* lived through, where the machine is seen as a *thing* with a restricted purpose.

There is nothing that shows more clearly than this difference

[12] Roger Fry, *Last Lectures* (New York: The Macmillan Company, 1939).
[13] See André Malraux, *The Voices of Silence*, trans. by S. Gilbert (New York: Doubleday & Company, Inc., 1953), p. 283 ff.; but Gombrich in *Art and Illusion*, p. 108, has an alternative explanation, which, however, also presupposes that works of art are born out of intercourse with available thematic materials. See below, Ch. IX.

in kinds of design that works of art are enjoyed for their own sake, that is, for the sake of the satisfactions received in the very perception of the work as well as in after-thought. To say, however, that works of art are made, as well as enjoyed, for their own sake is also to say that they are designed for the sake of the design. Whether or not an artist believes that his ulterior motives (fame, sexual allusion, emulation, economic return) are secondary, if he does not solve his compositional problems "for their own sake" it will be doubtful that he qualifies as, or will long be, an artist. What, then, does generate problems of artistic design?

The reason there are problems of design is the same as the reason there are changes in style from generation to generation. Were we not ever questing for new significance or a fresh vision we would be forever bound to imitate and repeat the works and the ways of our predecessors. Artists are probably forced to tackle new design problems more often as a concomitant of this search for new perceptual satisfactions than by deliberate technical or cold experimental intent. Feelings tire, as the way we feel about things fades, but we do not like to be without feelings. And as our responsiveness, fed by the very interactions of living, renews itself so it eschews old ways worn out in the taming of no longer rampant claims. The remarkable thing is that throughout these changes, and real as these changes are, art remains the same from epoch to epoch, at another level. It is these changes that redefine reality for every generation, but it is just this permanence that makes art what it is, and which allows us to make similar predictions of an Aurignacian figurine and a Sophoclean tragedy.

One reason that the analogy between art works and living organisms has persisted is that it draws attention to certain properties of—precisely—the design of works of art that, without the analogy, might be overlooked: such is the characteristic which design, in experience, appears to have of being a growth, a developed and matured thing, in the making as well as in the perceiving. Yet both the observations which led to it and the analogy itself are in need of detailed review.

One characteristic of living beings is that they have a past which is operative in their present. Their history is cumulative, as Dewey was at great pains to point out. In fact, in some kinds of organic unity, for example, the kind of which the human self is the

141

prototypical instance, the unity in its entirety is identical with the process of polarized and interconnected accumulation and fusion of experiences that are, in turn, partly determinative of the future of that self. And it is to be noted that this unity of the self is generally thought of as "psychological." Sometimes it is thought of, rather loosely, as a social product or, more exactly perhaps, as a product of interactions that are social; but the self is seldom thought of as a unity which is purely biological.

That plastic, melodic, and literary wholes exist which have to be invoked to explain the parts, and are in that sense "prior," is the main observational basis and central doctrine of "holism" applied to aesthetics. Now, any artist knows that, perceptually, any detail (not just the outline) influences any other detail in a work and that (again perceptually) the character of the work as an entirety gives some of its character to the details. Independently of the practice of artists, however, experimental work of Benary and others allows us to conclude that there are many instances in which the perceived outline of an object has an effect on other perceived features of it. This should certainly help to orient the lagging public, and some thinkers, toward more holistic and functional explanations in the arts as well. This line of psychological research has also confirmed that how we identify what we see influences the look of what is there to be seen; in other words, that there is a judgmental as well as a holistic phase to perception. Of course, it is possible, as we have seen the Gestaltists doing, to overemphasize this judgmental ingredient in perception by claiming that it proceeds physiognomically or by the interposition of innate standard forms. But do all these findings and experiments imply that the artistic wholes in question are "organic" wholes? And if so, are they organic unities in the biological, the psychological, or the social sense?

In recognizing that there is psychological growth and that there is social development and cohesion, we allow that the latter is somehow a less unified process than the former. We also recognize that either kind of development may be sought deliberately or may occur unnoticed by its subjects. There is only one sense in which biological growth may be deliberate, however, and that is in the case of humans who decide to aid and nurture growths that are fundamentally involuntary and, like all processes, the result of interactions.

That works of art are physical wholes no one will dispute, but

neither will anyone find it very interesting. The thesis that works of art are perceptual wholes is much more interesting and, one would think, undeniable; yet it is implicitly denied by some of those who maintain that works of art are ideal wholes—ideal in the sense that their unity has to be thought out, or inferred. It would seem that for these there is no feeling without conceptual thinking, conceptualization is a necessary prerequisite of the aesthetic response; so that the unity of any perceived thing is really, or merely, ideal. But this is an approach which separates thinking too sharply from sensing and perceiving—a thing which philosophers, since Plato, too easily do—and which tends to forget, at the same time, both that thinking is a psychological and interactive, or performative, process and that ideas are mediatory and not quite those clear, unchanging and terminal eternal entities that the Platonic tradition has made them out to be. Art does not "embody" *ideas* of feeling but articulates feelings themselves. The terms of the intellectual process in the arts are plastic, tonal, haptic, kinetic terms, and what are ideas of shape, tonality, and others but attenuated images of tones and shapes? The visual and tonal dynamisms that shape the artist's experience, the plastic paces he puts himself through, appear to be inaccessible to some thinkers whose gift is for deduction and who can only "see" experience, or give form to it, through conceptualist symbolism, that is through schematized after-images or conventional signs organized, or made consistent, by strictly deductive, not aesthetic, principles.

But a perceptual whole is a psychosocial whole with a biological basis. And over and above this, artistic wholes are, from the side of the perceiver, primarily felt wholes. To the maker they must, above all, seem constructed and developed wholes with an individuality of their own. In claiming credit for the work the artist is making himself responsible for having originated its particular unity, or design, or—in the case of assemblages or touched-up cast-offs—for having originated the perception of the design.

If psychological wholes can be the result of growth so, it would seem, can perceptual wholes. But are psychological wholes themselves more than metaphorically organic? And what will we have gained in understanding by establishing that they are? It should be noted that here we would seem to have an exceptional instance in which assimilation of the psychological (the perceptual) to the biological (the organic) is felt to be honorific and value-conferring

143

upon the human product. This assimilation, for reasons that echo the Pygmalion myth, is somehow not felt to be a reduction!

In allowing this reduction we must be careful, however, not to lose sight of the exact place of the deliberative, or non-automatic, ingredient in these affective, sensuous, perceptual wholes which are made by virtue of individually developed and socially transmitted skills out of the transformation of given but apt materials. Because thinking is done by the creator as he works them out, that does not make the works, or their design, ideal products. Again, because thinking is required to give successful shape to art works, that does not mean that their design is preconceived. Some writers on aesthetics have made much of a letter of Mozart's (of doubtful attribution) as affording proof that works of art are conceived (or conceptual) wholes, realized all at once, and then transferred into a sensuous or concrete medium. But this it seems to me is a complete misunderstanding of the letter,[14] and neglects the fact that it is rather about a postulated habit of Mozart's of not writing down a work until he had it all completed in his mind. A closer look (waiving the question of authenticity) at the text shows that, with all his inspiration, composition took time to reach completion, after much humming of, and hovering over, his themes. Interestingly, a close look also shows that the "turning to account" of "morsels" took place by reference to a "whole" which was simultaneously being "enlarged" and systematized ("methodized"). This point has already been made, however, in connection with the genuinely illuminating example of Henry James; and other authors have used Matisse's account of how a work grows under his hand for the same purpose.[15]

To answer fully the questions about expressiveness with which we have been dealing, however, we must still add to what we have learned so far. It is an extraordinary confirmation of his perceptiveness that the American sculptor Greenough's definitions of "beauty" as the promise of function, of "action" as the presence of function, and of "character" as the record of function [16] can be translated into statements about three kinds of expressiveness which we will find

[14] The text is given in B. Ghiselin, ed., *The Creative Process* (Berkeley: University of California Press, 1952), p. 34.
[15] This could actually be seen happening in the documentary film about Matisse that was released in the late 'Forties.
[16] Horatio Greenough, *Form and Function*, edit. by H. A. Small (Berkeley: University of California Press, 1947).

it helpful to distinguish, though observing that they operate simultaneously in the work of art. Closer attention has been called of late to the first kind of expressiveness by the terms the existentialists have used for it, namely, *Zuhandenheit*, serviceability, or admanuality. Similarly, I think it can be agreed that Dewey's functionalist definition of design corresponds fairly well with Greenough's of action. And what the latter calls character can be equated, finally, with what Santayana called "expressiveness" as being the result of associations entered into by the object of perception.

It would seem, then, that in great works of art there is a manifold of wholenesses. A work of art has promise in the sense that it invites our attention and is committed to reward it both because it is new or original, and because its interest will not wear out: it promises enjoyment from every act of communion with it; and in its ability to live up to this promise lies a measure of its integrity. In a work of art, however, the design, or means, must be well adapted to the purpose, effect, or action of the work; and this kind of technical fittingness introduces another type of harmony or wholeness into the work. Since it is also the case that the design or organization of a work of art seeks to be "immediately" and "by itself" pleasing, we also get a wholeness or fullness given by the unquestioned (pre-reflective, non-inferential) acceptability of the work of art. Character in this sense funds experiences, to be sure, but it is also an allusiveness that must be patent or effective without explicit inference.

It is no wonder, then, that these manifold wholenesses of the work of art are taken by some thinkers for a special, single, kind of wholeness which is so remarkable that an honorific title must be given it. The title "organic" is conferred by antithesis with "mechanical" which is made to stand for only the means-end kind of wholeness, the latter necessarily coming out, by that much, the poorer than the expressive or artistic, complex kind of wholeness. In other words, whether "organic" wholeness is more in some relevant sense than "mechanical" wholeness is a separate question. But there is no doubt that artistic, or expressive, wholeness involves more; so that this understanding of "expressiveness" makes the polemical adjective "organic" superfluous. If we decide to retain the term organic in discussions of expressiveness, however, we must remember that we have dropped its usual dictionary meaning.

As a call for a definition of the sense in which works of art are

organized, however, the invitation to employ organistic terms has had a salutary effect. There are at first glance obvious differences between a biological organism and an artistic organization; but there are also some unexpected similarities which both analysis and enjoyment reveal. From the psychological and technical point of view there is no doubt that works grow; from the stylistic and perceptual point of view they have the kind of coherence in which the nature of the whole conditions the parts and in which modification or removal of a part provokes a readjustment throughout the whole. No part is unrelated to any other part, and the parts have a function as they relate to the whole. There is a vital rhythm to the enjoyment of the completed work and its perception by an appreciator, as there was satisfaction and a sense of termination in its creator. Of course, when we say that a work of art is immortal we have both abandoned the strictly biological analogy and introduced another metaphor. If we say, however, that a work of art is an organization which as such never declines from the mature state which signalled its completion, then we have retained something of the biological analogy and still been instructed by it.

Art as design

In terms that would be fully acceptable to most art historians and critics, and to a few artists, Gombrich has said about the modern movement in painting that "art has begun to cut itself loose from anchoring in the visible world." [17] This statement misconceives both the historical situation and the aesthetic facts of the case. It is not that modern art has detached itself from reference to the visible world but, rather, that art is now looking at the world in another way than the way it has taught us to see it in the post-Greek West. The common view of the matter reflected in Gombrich's statement is based on an illusory contrast between visible fact and artistic expression (or impression), and is itself but the reflection of an old and worn distinction between appearance and reality. Gombrich's wording forgets that what is actually being compared are two (or more) different ways of seeing things. Even more serious is the fact that such a formulation auto-

[17] Gombrich, *Art and Illusion*, p. 263.

matically judges the later way of seeing as a departure or falling away from the earlier.

It also happens that the earlier way of seeing things, that of representational art, nowadays accords more effortlessly with the kind of representation (including photographs) to which our culture habituates us and which is used for all kinds of practical purposes with the greatest frequency; so that though there is nothing about this kind of representation, except its familiarity and culture-bound practical efficiency, that warrants its use as a standard, it is nonetheless unavoidable for the Western-educated to take "representative" images as a standard of comparison for any other visual images which might confront them. Art design, even at its most objective, has more fundamentally the character of an abstraction than of a copy, of a suggestion than a transposition. The "thing" character of works of art, and even of the materials of art, is unimportant except to curatorship and antiquarianism. But works of art are never really, in any sense, non-objective: an art work is at least always a psychological object and, also, always attestive (expression) and informative (form) of some experience. Thus Giedion quotes Fernand Léger as saying that the creative process is a transformation of the subject, or subject matter, into an object, or artistic expression.[18]

The mode of speaking quoted from Gombrich would, of course, have been impossible had he been dealing with the history and aesthetics of music, or of poetry. Melody and metaphor are each connected to the audible world and the world of action in varying peculiar ways; in general, however, they are quite in the same situation as the visual arts in not being required to depict, or refer to, or embellish upon, things *given* in the world of sight or sound or action. The only difference is that their freedom not to do so is more readily conceded by the public at large than is painting's. The great similarity is that they all place or *bring into* these worlds something in the artist's experience to which we accord a deep assent—whether this assent is slow or sudden, difficult or effortless.

The experience to which the artist is testifying, or expression, becomes formal, that is more significant, more evocative or allusive, more sharable and strangely enough more exciting,[19] by the process

[18] Siegfried Giedion, *The Eternal Present* (New York: Pantheon Books, Inc., 1962), page 16.
[19] Perhaps this is because we fight and dampen stimuli that cannot be given form.

of medium-bound creative thinking. In the journey from expression to form an emergent perception succeeds in being communicated; but expression culminates in form because of the need to share the perception. Man's sociability is rooted in his communicativeness.

It is form that makes communication possible; for form not only has a consummatory aspect; in being transitive as well as completive, it becomes communicative. The form about a center of energy not only has a self-enfolding consummatory rhythm, it is a transactional sequence of ingesting and ingestible terms. Form not only "swings," it "speaks"; its terms fall into phrasings, its shapes into articulations—not, however, as codified signals do, but as terminal and self-explanatory segments of experience. The stimulus pattern in the arts mediates and is mediated by configurations, indeed, that make it possible for us to take hold and rehearse portions of our experience that we would like to control and, hence, are gratified to control through the art work. Therefore, the more experience we truly control through the art work, the greater we think it is. The more allusive the work the richer will it seem—as long, that is, as the allusion remains assimilable. But its assimilability depends upon the cybernetic power and aptness of the form. Perhaps we will be allowed to speculate, however, that the greatest art of all could well be that which stirs some near-total mode of responsiveness that cuts across our several specialized sensory modalities while exercising to the full our intellectual powers. Limited as works of art must be to a given medium or combination of mediums, there are probably few that do not have some cross-sensory or synaesthetic reverberations.

If words can be used to make "pictures," so can images be used to make ideas—whether verbal or non-verbal ones, that is, untranslatable ones. But the images can be kinetic or haptic as well as pictorial, they can be rhythmic or melodic or sculptural or "conceptual" (i.e. directive) images. It will have to be granted, however, that if there can be images in all these and other modes or mediums, there can certainly also be ideas in them, as for example, painterly ideas, tonal ideas, literary ideas, or ideas of motion in music and the dance; for ideas, including "ideas of relation," are the offspring of our sensory-motor versatility or anticipativeness. It will be granted, too, that as they are elaborated in a traditional or given medium they must be understood in terms of that medium. On this basis it becomes clear that when art is claimed to be "inexplicable" it is only being

recognized as "untranslatable" into some medium in which the critic is more at home in expressing himself. The untranslatability of art remains a wonder, though deeply felt, in that a work of art, on later reflection, reverts to being something observed, and this observed (rather than lived) thing gives us the emotional and formal equivalent of something undergone or something done.

It is because form is the cooperation of forces that carry an experience, whatever it is, to its own integral fulfillment, that is, to a fulfillment consonant with the expectations the experience has raised, the suggestions it has broached, the psychic tendencies or stored energies it has tapped, that form and the matter-to-be-expressed are so inseparably [20] one in the arts. We do well to remember, with Peirce and Freud respectively, that experience is an affair of shock, resistance, constraint, and that psychic structure is a scarring, the resultant of successive traumas. The corollary is that art, knowledge, and health are all organizations of energies. It follows, however, with the activation of this reservoir of impressions, that the achievement of unified perceptions becomes no easy thing. Great art is rare because it has at once to touch and encompass the traumatic, desirous core of experience *and* meet the conditions of form.

What can be said about the conditions of form in general, in the different arts, can be said briefly; but it is not trite, and is quite denotative. Thus there would be no form without the process of cumulation; for, without it, there is no complication, no growth of interest. Again, a cumulation that was not suspenseful would not make for form; it would be mere dead repetition or self-defeating saturation. Through suspensefulness a demand is developed for an unforseeable resolution—unforseeable if it is not to destroy the suspense. In the very suspensefulness, however, preparation is being made for a fitting resolution that will bring closure to otherwise targetless direction-

[20] An apparent overemphasis on the unity of form and matter-to-be-expressed is possible. Thus one source of interest in art works is the tension, the seeming divergence, found in some genres like the American folk-song between the (hypostatized) form and the (implicitly paraphrased) story. The former will be gay while the latter is sad, as, e.g., "Wild Wood Flower." Dewey's example of the disunified perception created by a man laying bricks in evening clothes is overemphatic; a man laying bricks in evening clothes is not *only* appropriate in comedy, it could well be the culminating scene in a tragedy, or the Voltairean symbol in a didactic drama of adjustment of how we must "cultivate our gardens." Dewey's mistake results from an unnecessary stereotyping of the associations of bricklaying and evening clothes respectively.

alities and that will channelize still unspent energies. The requirements of the form-creating process make it a rhythmic process, then; and if it is rhythmic it must be punctuated. This means that there will be what we can call subconsummations in the process. These will have to have pregnancy or onward projection and tension. There will, of course, be other tensions created by those resistances and difficulties that accompany expression which we discussed in previous pages. The means by which we overcome the difficulties, the ingenuity with which we advance an utterance or an experience to fulfillment, constitute the formal core of the creative act. As Dewey says, when we know what these means are, then we know what form is.

Technique, then, is the way in which the conditions of form are brought about by the artist. He will be said to have a style when something about the technique of realization begins to appear characteristic, or identifiable from work to work and problem to problem. This accords with the general understanding of style according to which it is a differential aspect of technique, more appropriately predicable of the way in which an artist achieves a design than the design itself, which will differ from work to work. Thus style, though differential in one respect, is common or pervasive in another.

Designs are of course continuous with the techniques and concerns which generate them. Design is perhaps the more easily understood aspect of the form-creating, consummatory process; and it may be defined as the record, in the medium, of the creative operation of technique. It will be noted that the form-creating process is an activity; so that to speak of form by itself is a hypostatization unless one is speaking of the result of the activity; in the latter case, "form" and design become one.

The creative process, when at work in the arts, is not overlaid with distracting exigencies. If there were practical obstacles in the way of creation the artist has overcome them or set them aside by the time the work is finished. They may even have become part of his thematic material, in which case they are being made to serve the formal process. It is for the reason that in the end all is vital form in a work of art that we can say that works of art are the place where human creativity is most clearly celebrated and where it *will* be found in as pure a state as it *can* be found.* It is in the arts as it is in those

* As Conrad Fiedler said, "In the presence of works of art [many people] feel a release from all that obstructs them from the enjoyment of beauty in looking

religions devoted to the untrammelled pursuit of charity where we find human cooperativeness exercised, and celebrated, in undiluted form. We are likely to find human cooperativeness anywhere, but it is not everywhere unmixed with other motivations. So will we find creativity, or creative intelligence, or the form-creating process everywhere at work, but not everywhere unfettered by purposes that are destructive of form or as yet untamed by it. Perhaps an ulterior reason why works of art are so impressive, so loved and respected, is their promise—not of perfection, but of the achievability of vital order in every sphere. Perhaps some of the fascination that art works have comes from their being tacit lures that awaken us to the notion that human life, genuinely human life, tends to the condition of art.

An addendum is owed here to the reader with theoretical and historical interests. In focusing on the general way in which "expression" becomes "form," I have borne in mind but have hoped to supersede those fairly recent distinctions which correctly sought to counteract and rectify that very much older Alexandrian and neo-classical sundering of "form" from "content" which has long plagued aesthetics. I have borne in mind the distinction I. A. Richards developed between "vehicle" and "tenor," and the one the New Critics make between "structure" and "texture." I leave out the attempt by the so-called Aristotelians of Chicago to revise Aristotle's distinction between "substance" and "form" on scholastically tinged, neo-classicist and formalistic lines by making "form" primary, that is by giving over to "form" the functions of the *efficient* causes. I leave it out as not really tending to heal the dichotomy, and as having, rather, suppressed one term of it in engrossing the hypostatization of the other. The Chicagoans' approach does raise the issue, however, of the serviceability in aesthetics and criticism of a logic of classification based on reified and rigid artistic "genres."

What needs to be emphasized, for purposes of practice and understanding, is the continuity between expressiveness and design, between the process of expression either as utterance or symbolization and the process of invention either as formalization or discovery. Perhaps Ransom's distinction between structure and texture succeeds better than Richards' between vehicle and tenor in achieving this emphasis; it seems, in actual critical practice, to have been more

at nature." *On Judging Visual Works of Art*, transl. by H. Schaefer-Simmern and F. Mood (U. of California Press, Berkeley and Los Angeles, 1949), pp. 5-6.

151

productive of results. Richards' concept of the vehicle seems to require that one term of a comparison be taken as more basic than the other—whose reality is consequently downgraded. Perhaps the best way of taking Ransom's distinction is as one between macro-structure and micro-structure. Usage, which confuses texture and structure (see Webster), hardly allows any other understanding of them if they are to remain distinguishable yet continuous. It seems to me, as a matter of fact, that to require compatibility between them is to presuppose that pervasive quality is the basis of vital form or expressive design. That pervasive quality *is* the basis is not, however, an assumption of pragmatism but an observation which anybody may make. Among artists it turns out to be an unavoidable implication of their actual, very varied, procedures.

Art and judgment

The art of judgment

What, exactly, is meant when it is insisted, as we have insisted, that inquiry must be into the work *as such?* Neither inquiry nor judgment will be into, or of, the purely physical aspects of the work. Nor will inquiry, if it is to be aesthetic, be into the psychology of its creator. If we inquire into the materials, as materials, which are being worked or enjoyed it will be in relation to the effects (artistic or aesthetic) that they produce. But, of course, the materials of works of art are always context-steeped or thematic, ideational as well as physical. Then, however, would not such an inquiry be the same as an inquiry into technique?

Similarly, if the inquiry is into the enjoyment of the work one will be inquiring, not into the enjoyment as such, but in relation to the work. But to inquire into the enjoyment in relation to the work is, again, to be inquiring into

153

technique. We should also note that enjoyment itself can be inquistitive or exploratory. Neither do I mean to imply that creation or appreciation are all enjoyment. We may remember what Degas said to Valéry: "If there were no tedium [in the making of the work], there would be no enjoyment in it." [1] E. M. Forster, on the other hand, thought of artistic work as "hard, hot, and generally ungraceful work, but it is not drudgery. For drudgery is not art, and cannot lead to it." [2] Appreciation is, surely, enhanced by the effort invested in fully apprehending a work of art; and just as surely, within appreciation, it is really not possible to tell just where discovery ends and enjoyment begins.

Psychoanalysis, for its part, would have us remember that works have therapeutic effects upon both their makers and their perceivers. The subject matter of the psychoanalyst's inquiry is, thus, not the work of art but the work as therapy; and his inquiry does not eventuate in an aesthetic judgment. Neither does it do so when he inquires into the psychogenesis of the work. When the psychogenic factors become indistinguishable from the technical factors, however, the psychoanalyst may have light to throw on the work—as he would have when he uncovers contributing effects, devices, or orderings not at first perceivable in the work but which reinforce its total effect and integrity.

But before we can discuss what judgment involves when art is its subject matter, we must consider the nature of judgment in general. It is a consequence of the theoreticist bias of our culture that judgment, in the sense of valuation, is believed to have no place in the natural sciences and often, by extension, no place in the social sciences. In this view, the only scientific outcome of inquiry is a description, classification, or generalization about the way things are or are related. And these scientific classifications or generalizations are said to be clearly nonvaluational; so that, if one of them is taken as a premise, there is no way of reaching a conclusion which is a valuation unless the scientific premise is combined with a specifically ethical or aesthetic premise. And these ethical or aesthetic premises, it is further claimed,

[1] In *Collected Works of Paul Valéry*, trans. by D. Cooper, Vol. 12 (New York: Pantheon Books, Inc., 1960), p. 50.
[2] E. M. Forster, *The Longest Journey* (New York: New Directions, copyright Alfred A. Knopf, Inc., 1922), p. 25.

are not themselves derivable, by any good logic, from purely scientific or non-valuational statements or generalizations. This in turn implies, of course, that any premises or claims that are valuational are not scientifically warrantable or justifiable.

The consequence of this position is that ethical and aesthetic judgments are thought to be ultimately arbitrary. In the fields of conduct and creative production comparisons and judgments are thus supposed to be purely preferential and—though perhaps capable of explanation in terms of custom, culture, or conditioning—not capable of rational or scientific justification. But judgments of the origins of works do not provide a basis for judgments of the value of those works. Thus an impasse is reached which makes a problem, difficult of statement and difficult of solution, *easy* of statement but *impossible* of solution. So Reichenbach tells us, in *The Rise of Scientific Philosophy*, "the modern analysis of knowledge makes a cognitive ethics impossible." [3]

As a matter of fact this approach to the problems of valuation overlooks two important contexts or occasions within which valuation persistently, if unremarkedly, occurs. Because a description is often a judgment with little that is problematic about it, it is forgotten that descriptions are, after all, judgments, even if settled judgments; and the mistaken belief grows that there is such a thing as purely descriptive discourse. All discourse will be observed to be, however, at bottom valuational by the philosophical or coenoscopic observer. In the second place, the observer of human behavior as a whole will find that other activities than discourse can be the vehicles of a judgment; not only action but products, including works of art, are capable of effecting judgments. If it is added that even so-called ejaculatory or emotive expressions are incipiently cognitive, then we may reject as working hypotheses both the sterilizing dichotomy between fact and value and the rigid, unperceptive discontinuity between emotion and cognition which have vitiated the very formulation of the problems of judgment in recent philosophy. Thus, by way of immediate illustration, the student of the arts can point to the fact that some works of art are, in a real sense, questioned by other works of art. It is also accurate to say that works which appear to

[3] Hans Reichenbach, *The Rise of Scientific Philosophy* (Berkeley: The University of California Press, 1951), p. 276.

155

challenge other works are often only trying to answer a question, which itself has been understood in a new way, in different manner from that in which the earlier work answered it.

Phenomenology and the basis of aesthetic judgment

The question is how can judgments of value be made reliable? By making value a function of requiredness, the Gestaltists and phenomenologists seemed to open an approach that would result in verifiable assertions about what we do in fact prefer in certain conditions. Two questions, however, always remained: what could we justifiably infer about preferences under other conditions or in other cultural contexts; and, what could we justifiably assert about what we ought to prefer when it was a question of deciding between two alternative requirednesses or demands?

Köhler himself, for instance, implies toward the end of his "analysis of requiredness," in Chapter three of *The Place of Value in a World of Fact*, that there are invalid as well as valid requirednesses. He explicitly recognizes that requiredness changes in the course of history, and that one requiredness may "in actual life" conflict with another. He notes also that any aesthetics and ethics which did not take these changes into account would be remiss, and that some ethics claim to settle "in their field" conflicts of requirednesses. In any case, however, he concludes that it is not the job of phenomenological psychology to distinguish between valid and invalid requiredness; rather, it is the job of aesthetics and ethics.

Now this is puzzling and discouraging, because one stated aim of Köhler's book had been to introduce "interest" or requiredness, that is value, among the data of a natural science. But it turns out that *this* natural science, namely, Köhler's psychology, is not going to distinguish between valid and invalid values or requirednesses: ethics and aesthetics have to be called in, after all, to do the job. Yet the impasse which called forth Köhler's analysis was just the impasse created by the dualism of fact and value in which fact is construed as "neutral" (valueless) physical fact.

156

Thus, if value is wholly phenomenal, Köhler has not introduced it into the world of fact successfully, unless fact is also shown to be phenomenal. But Köhler does not undertake to do this for all fact; he does it just for the subject matter of psychology. He seems to make all *objects* which are experienced phenomenal (unless he is inadvertently equivocating the term object), but he retains the concept of physical *fact*. Physical facts, we can agree, are constructs and though they may be called "objective" in the sense of publicly verifiable, they are not phenomenal.

So, if among the phenomenal facts (for example those which are the subject matter of psychology), phenomenology must leave it to ethics and aesthetics to judge between valid and invalid "demands," the impasse between fact and value will have been bridged only if we allow that ethics and esthetics are themselves sciences. This is, of course, what Aristotle, the pragmatists, and other philosophers have done.

In the contrast which arises between Köhler's notion of phenomenological (as distinct from phenomenal) objectivity and his notion of physical objectivity, there remains a difficulty. Are not both kinds of objectivity, in the statement of them, equally products of analysis in contrast to experienced phenomenal "objectivity"? It must also be admitted that though one understands the statement [4] that requiredness may emerge from, or refer to, the world *beyond* phenomena, it is difficult to see how this statement can avoid reinstating the old dualism unless the canon is adhered to that all transphenomenal factors or operators have been experienced at an earlier time or will be realized in a proximate future. If this canon is not adhered to the honesty of the appeal to experience, the positivity of phenomenal fact, and the consistency of phenomenological analysis are all seriously compromised by the notion of "transcending requirednesses." It seems to me that the only way in which the concept of "transcending requiredness" can be made denotative is in some such way as Dewey or Merleau-Ponty have followed in their accounts of the phases of life situations.

Merleau-Ponty's *Phénoménologie de la perception* [5] posits a distinction between non-thetic experience of a situation and the

[4] Köhler, *The Place of Value in a World of Fact*, p. 331.
[5] Maurice Merleau-Ponty, *Phénoménologie de la perception* (Paris: Librairie Gallimard, 1945).

thetic or intellectualized awareness of the situation. Merleau-Ponty's distinction is between awareness of the pre-rational elements of experience and the reflective determination of the meanings and structure of a situation. Thus non-objective, as in pragmatism, means pre-objective, not subjective. And if indeed the pre-rational, non-thetic, pre-objective domain is like William James's world of pure experience or Dewey's indeterminate qualitative situation, then *judgments* about what "requirednesses" ought to be acted upon will be reached in a manner similar to that in which Dewey has said judgments are reached in clarifying or making determinate a given situation.

In Maurice Mandelbaum's *The Phenomenology of Moral Experience* [6] there is to be found a more explicit and more developed idea of fittingness as the basis upon which we judge the morally relevant value of an action.[7] The "fundamental characteristic of the act of judging" is said "to lie in the element of reflexive demand." [8] Mandelbaum's explication of fittingness and its apprehension (but is there any fittingness apart from its apprehension?) as the basis of the experience of obligation is most promising in being subject to experimental verification. It is admittedly naturalistic in that moral fittingness is not distinguished as unique among the other cases of fittingness or requiredness. This means that judgments of value are not arbitrary, but may be reached by observation and reasoning without the intervention of any special ethical intuitions.

Mandelbaum, however, contributes some difficulties of his own to the state of the question. One arises from the habit of using "fittingness" as if he equated it with the "sense of fittingness." But this is analogous to the *équivoque* that Santayana made over sixty years ago, and later admitted, between "beauty" and the "sense of beauty." Again, Mandelbaum understands that fittingness is relational [9] but then goes on to maintain that it is indefinable. He states that he can, however, try to define it ostensively, and makes a good literary job of giving us an idea of what fittingness is. Why, then, talk about ostensive definition at all in this connection as if philosophers from J. S. Mill to Arthur Bentley had not invalidated it—and as Mandelbaum

[6] Maurice Mandelbaum, *The Phenomenology of Moral Experience* (Illinois: Free Press of Glencoe, Inc., 1955).
[7] *Ibid.*, p. 101.
[8] *Ibid.*, p. 115.
[9] *Ibid.*, p. 60 ff.

himself actually does with his own quite adequate *induction from examples* of fittingness.

How, indeed, can Mandelbaum say that fittingness in being relational is essentially "an apprehended internality of relationship among the parts," [10] and also say that fittingness is not definable? But perhaps it is of greater positive interest to note that this apprehended internality of relationship among the parts looks a lot like the "quality" which, by pervading them, gives unity to the parts of a whole. It may not be analyzable without being destroyed while this analysis is proceeding; but will it not, as in works of art, reassert itself thereafter? And is it not definable operationally in terms of the effects it sustains? If so, pervasive quality, or internality of relationship, is not only the matrix of determinations within, and about, the work of art but a good control in experience upon whether our aesthetic judgments of a work are pertinent to it or not.

Pragmatism and the judgment of art

The question is how are judgments made which prove, in the event, to be relevant to the works being judged? The question is *not* how are judgments to be made of *any* work (including as yet uncreated works) we might choose to "judge"; to seek to answer this question is to try to provide a preconceived schema according to which we may speak in "judgment" of any work. But this is both a reversion to the ancient Sophistic (or rhetorical) tradition as well as an essentialist or Platonist illusion. Above all, it is anticreative, unscientific, and impertinent. It is uncreative because it prevents us from ever being surprised by art works and because it supposes either that all future aesthetic experiences are more or less like past ones or that the phases of aesthetic experience which are not verbalizable by the schema are insignificant. It is unscientific because, while the results of inquiry are often reducible to formula, inquiry and exploration do not themselves proceed by formula. It is Platonist as well as Sophistic because (1) it assumes there is an unchanging essence of art which can be indefinitely exemplified, and (2) it allows us to speak of a subject matter without any special knowledge of that subject matter.

[10] *Ibid.*, p. 64.

Similarly, the primary question is not can standards or criteria be worked out such that by applying them we can distinguish art works from non-art works. Art works are not, in the first instance, criticized: our reaction to them is not, to begin with, mostly or fully reflective. Thus the attempt to differentiate between art and non-art is not distinguishable from that of discriminating between "bad art" and "good art." The distinguishing of art from non-art, and the distinguishing of good art are one and the same activity. Also, the characteristics which were isolated in Chapter VII will be seen by the reader to be too general to be directly usable as a basis for informative critical statements about single works. More than this, the fact of the matter seems to be that art must first be experienced before it can be judged critically; but that it *is* judged on the basis of experience proves that experience is already appraisive. Much as in the case of other problematic situations one is aware *that* there is a problem before one recognizes *what* the problem is. Response to, or apprehension of, a work of art is initially qualitative, and to or of the work as a whole— not analytical or separative. Now, judgment of a work will be called for most when it is most original, when ways have not yet been found of making verbally or analytically explicit the main bearings, in the current state of the culture, of the new experience created by a genuinely fresh work. Hence the near impossibility of stating, at once and in so many words, whether it is a work of art or not.

Our view of the judgment of art will depend upon what we believe the function of art to be. The work of art, we can agree with Dewey, "reconstructs experience"; it educates and re-educates us to see or experience the world in fresh ways. The creator of works of art, through his work or in it, shows us how to use our senses and our minds with greater skill and effectiveness; he shows us how we may use or renew our feelings, and what we may make of them. Art, however, in the sense of human ingenuity, of constructive or contriving intelligence, is also exhibited by the work; so that the work of art may also be said to be celebrating sheer ingenuity as well as to be educating us in perceptiveness.

The judgment of art will, therefore, have two complementary phases. It will have a philosophical or "perspectival" phase in which what is being judged is whether a new unity or fresh coherence has been given to an area of experience, or whether some new experi-

ence has been brought to light; and it will have a technical phase in which what is being analyzed are the ways by means of which the above has been achieved, and how this achievement comes to be as enjoyable as it is. On this basis, it will readily be recognized that the judging of art will itself be an art, skill in which can only be the result of long acquaintance with several arts in their world history. In any case, however, the judgment whether a work is good, less good, or a failure will depend upon the effectiveness of the means employed to achieve the discernible ends of the work. It will also depend upon whether the segments of experience involved have been given a distinguishing form, unity, perspective, rhythm, sequence, or complexity such that in attending to the work our experience is both "consummatory" and "eductive." By an eductive experience I mean one of initiation, renewal, or development for the observer as perceiver or experiencer. By a consummatory experience I mean one which is in some degree climactic and completive.

If this implies that the artist is always ahead of the public, it follows that the good critic is one who makes it his concern to keep up with the advancing or changing work of the artist. It does not, however, imply that the public may not be able to enjoy the artist's work. On the contrary, the public will always begin by responding with excitement (that is, with incomplete discrimination) to his work, and only later be capable of explicit verbal judgments about it that are not covert defences of aesthetic achievements with which it was already familiar. It would seem, too, that a work of art about which you could, on first exposure, easily make explicit judgments is probably either not very original, or obviously defective in some respects—provided, that is, that the perceiver has not mistaken the nature of the work of art's achievement.

The judgment of art

Philosophical reflection is itself an exercise in the art of not misleading and an exercise in the art of coenoscopic observation, as Peirce called it. Coenoscopy is the art or science of inquiring into those things or phenomena which are hard to observe, or which escape notice, for the

peculiar reason that they are—so to say—right under our very noses or so taken for granted and pervasive that it requires special effort to bring them into focus.

The pervasiveness of phenomena of this kind which creates difficulties for the observer is, of course, by definition a property of the assumptions which the culture as a whole shares. Now, when the unnoticed phenomena are pervasive beliefs they will, as assumptions, often be the unspoken or unnoticed premises upon which a critical judgment is based; so that a critic not skilled in uncovering such assumptions will sometimes not know that he is not keeping an open mind before some strange development or experience. Of course, critics have other unstated premises than the broad assumptions or "indubitables" of the culture, but these additional premises are more easily confessed by the critic or spotted by those who dispute him. It is not that we can make judgments without making assumptions, but that the judgment of art must discount or make explicit those assumptions which are unavoidable.

The question arises why do most philosophers assume, and some critics admit, that judging works of art is a philosophical task. We can now answer that it is because discursive criticisms of art are so often involved in unnoticed crossings of categorial boundaries, and because in connection with the aesthetic experience judgments about particular works are felt to have hidden and systematic implications which only a philosophical critic is equipped to elaborate explicitly. It is further to be noticed that because original work is often original precisely for the reason that it has found a way of effectively challenging cultural habits, the defense of such work quite naturally falls to those who have made it their job to challenge rigidly fixed beliefs wherever they occur.

The judgment of art has another duty, however, which is not only preliminary or systematic or just philosophical. A specifically aesthetic function of the judgment of art will be that of bringing to light the operative assumptions on the basis of which the artist himself is, or was, creating his achievement. But this specifically aesthetic duty is not discontinuous with the coenoscopic task already mentioned. As a practical matter, and of a piece with his talk about the enjoyability of the work, the philosophical critic of art will find that he has to point out the values which it seems to him the artist is originating

162

or celebrating. These might be very novel; or they might be very deeply embedded in the culture, or very deeply suppressed by it.

The artist, however, is an intellectual historian only as much as the rest of us; he takes a cultural situation as he finds it and addresses himself to that, to removing the stalenesses, the ineffectualities, the distortions, and monstrosities to which he cannot give his assent. The artist who does this is an implicit critic of his society's moral, practical, and perceptual habits; he is, as Camus and Sartre pointed out, functioning as the conscience of society. He does not always mount, in his work, an emotional assault upon his public, but where the artist does it will inevitably be even the technical critic's job to reconcile the public to the readjustments in its scale of values, modes of thought, and ways of perceiving that the artist is legitimately or implicitly demanding. Because, in the past, he could not do all this the critic was driven, like the artist, to the doctrine of "art for art's sake." This doctrine correctly celebrates the technical factor in art—what I have been calling the human ingenuity of it. When the ingenuity exhibited is a function of controversial and implicit re-evaluations, however, the doctrine of art for art's sake is an insufficient defense against the negative excitement and massive response of the sectors threatened by this art.

Is there any effective, and generalizable, reciprocal relationship between the artist's own "views" about the world and his artistic know-how? This question can, perhaps, best be answered with an another question. Why is it that an artist's technique (in the simplistic sense of "manner") can be imitated but his total achievement never equalled by a disciple—unless the latter branches off to make discoveries of his own? And this question answers itself: technique excites the appreciator when it is making discoveries (when it is eductive) or creating new kinds of integrity, when it is part of a total human and aesthetic intent. But technique for its own sake, as in the imitator, is technique without import.

The perceptual discoveries of the plastic artist, the social perceptiveness of the novelist, the metaphorical wrenches which the artist as poet gives to current realities, the constructive principles according to which any artist builds, are certainly the subject matter of criticism. But the latter will seldom be able to relate them determinately to the artist's *Weltanschauung*, unless by the latter we

163

mean not his general beliefs, but the view of the world created or suggested by him *in* his special medium. However, even if by his *Weltanschauung* we mean the imaginative and created world which as an artist he inhabits, and develops as he inhabits it, critical statement will in the nature of the case lag severely in rendering what it has taken all the specialized artistry of its creator to bring into being. If, however, by the artist's world-view we do naively mean his stated general beliefs then the lesson to be learned from the history of the arts is that this sort of belief is not aesthetically operative in, or very relevant to, the enjoyment of the work of art. Of course, the case is different if world-views are part of the artist's materials and treated as materials. A more chastening lesson to be learned from the history of art is that a predetermined set of beliefs, or official philosophy, such as that which the Counter Reformation imposed upon some painters and sculptors or that which Soviet Marxism has imposed upon some poets and novelists, can turn what might have been art into propaganda when this "philosophy" is allowed to dictate subjects, styles, and values.

Granted, as Buchler pointed out in *Nature and Judgment*,[11] that discursive inquiry and exploratory conduct transmute their fields no less than what he aptly calls "exhibitive query" in the case of the artist; and granted that the view is crude which maintains that we affect the characters of existence only when rearranging bits of matter; the fact remains that the transformer *par excellence* of the look which existence wears is the artist. We have maintained that creation is never out of nothing by stating that it is always the transformation of given materials which are knowledgeably treated as both thematic and physical. How does the artist, with relatively few works, also transform the outlook of a generation? Does he, in fact; or does he not, rather, bring to some climactic expression new intellectual interests and responses that are already emerging or taking hold at themes? He takes his cues from the way people perceive, act, and feel as much as, or more than, from what they say; and he dramatizes and responds to those cues by treatment and development of them in his medium. This is one reason why genuine works of art seem to be exemplary for our perceptual modalities and moral reactions. The hard question for the critic is how can the perceiver, from a sampling of

[11] Justus Buchler, *Nature and Judgment* (New York: Columbia University Press, 1955).

the artist's works, sense the more total vision or feeling or approach toward which the artist is groping, in the light of which his single works can then be judged and which allow a full statement of his aesthetic premises or intent?

Theoretically, the job seems impossible. In practice, however, much criticism has, as a matter of fact, found ways of talking with insight about single works by using the artist's total output, or a whole period or tradition, as a basis. This, of course, can only be done in retrospect. But finding where to place a given work within the artist's, the period's or the tradition's overall development does not, by itself, constitute an evaluation. It is only insofar as the artist's aesthetic thinking is made more available, or clearer, by this "placing" that we are helped by the critic toward an evaluation of the work.

When the critic's problem is whether the new work has or has not realized a new kind of integrity, it seems to me that we have implicitly recognized another factor which causes works of art to be, in effect, "exemplary." A positive answer to the question implies that the work can stand any amount of scrutiny, and that it has an individuality of its own. A work of integrity forces us to ponder what the giving of our assent to it implies for received knowledge and current perceptual habits. If we have the courage of the knowledge thus gained, then we must also assent to changes in ourselves and conditions.

As long as we avoid the dangers of over-conceptualization and the excess of abstraction we may want to ask what features of the human condition are being exhibited, or exploited, in the work? I do not mean to say, however, that art works wear on their sleeves the answer to such big questions; it would seem, that is to say, that when an art work genuinely moves us, it also moves us to ask such basic questions whether we are philosophers or critics or neither. For such basic questions arise from the work as matrix quite as well without the benefit of criticism as with it. Professional criticism, indeed, really only justifies itself when the work it is about is either very new, very much forgotten, or from a quite distinct culture—and this is just where criticism is hardest to perform. In the latter two cases it will appeal to, and merge with, intellectual history and cultural anthropology; in the first case it will be, as we have said, coenoscopic and prospective.

In any case, however, criticism will always be under the pe-

165

culiar obligation of taking care to avoid special as well as general mistakes of categorization. Thus, for example, Greek tragedy is generally misconceived as either modern drama or an ancient form of enlightened but institutional religion; it was, in fact, a highly developed and artistic substitute for a primitive religious ritual, which had to meet a number of formal conditions postulated by the ritual. More specially, Aristotle did not mean by the thought in a tragedy what *we* mean today by the thought in a play. Again, a beautifully worked item of Kwakiutl equipment is really impoverished, its beauty is not enhanced, it seems to me, if it is admired as a cabinet piece in ignorance of its function. Of music the perceiver only asks that it be good to listen to; but he wrongly persists in insisting that other works—which are also only for the delight and refreshment of his mind and senses— must tell him a story or carry a message, as if all art were narrative or all art symbolic or homiletic. We all now know that a film is not a stage play and that a photograph is not a painting, though we will always let the different arts inspire or fertilize each other as long as they do not mislead one another. Examples could be multiplied from among as well as from within the arts. Finally, there are category mistakes which a culture, or large segments of it, makes about the arts as a whole. Thus the Middle Ages thought of works of art as anagogic symbols of an imperceptible supernatural order. In the future our age may be accused of thinking of the arts as really only forms of entertainment. In our own day we hear such conflicting things as that a work of art is a *proposition*, to the horror of those who are equally wrong in maintaining that a work of art is a *thing*.

But works of art are neither statements nor things; they are exhibitings, or experiences put upon exhibition. A work of art is a thing only when it is not being experienced. A work of art is a term in a human process which it also serves or seeks to bind psychologically. To talk about a work of art in the language which is most apt for things is either to assume that its physical properties are the most important, or it is to do justice only to its physical properties. This, however, is a two-fold mistake. It assumes, in the first place, that there are physical properties in themselves, or apart from observers. This is a working fiction suitable to the unintellectualized practice of scientific research where "the physical" is defined, precisely, as that set of factors in the field which affords manipulative control to the human over the non-human conditions of the environment. These conditions

are those that relate objects only to each other as far as that is possible; and their statement is a statement in physics insofar as it neglects those conditions that relate objects to perceivers. But scientific objects, of course, are the sort of objects they are only in the context and formulation which the scientific enterprise has provided for them; they are not objects in themselves, but relative to their context—just as common sense objects are what they are only in the framework of routine commonsensical activity. It is just as much a violation of context to speak of a table as an orbiting swarm of charged elementary particles as it is to speak of a work of art as if it were a common sense thing and a member of a class connoted by a common noun. As there is no such thing as a table—that you can eat your dinner on—in theoretical physics, so your works of art become common sense objects only when you move from house to house and they have to be handled like furniture! Because an object of attention, to be spoken about, must be put as the subject of a sentence, it does not follow that what is being spoken of is a thing. Two thousand years should have sufficed to let us see that the language of things will not do the job with any adequacy when it is a question of discussing experiences, processes, changeful events or eventful changes, doings and happenings.

In the second place, it should now be clear to the reader, the physical properties of a work may matter not at all outside of the context of physical science or physicalistic common sense. They may matter to the artist as technician, but even then only insofar as he manipulates them according to the dictates of artistic, intellectual, or psychological requirements of his own devising—or generated (directly or indirectly) by the tradition of the art he is working in. Materials, that is to say, are never purely physical not only because there is nothing purely physical except in the formulations of physics, but also because the raw materials involved in art (tones, pigments, metals, minerals, words, etc.) are not abstractible from *all* ideational association and hedonic coloration. And to say this is to say that the raw materials of art works must be handled within, or bent away from, artistic or thematic associations from the first moment that the artist begins to use them.

Judgment and intent

Apprehending the intent of an interlocutor or signaler is a basic requirement for utilitarian communication or for spoken language. This being the case, if we are to consider art under the analogy of language as a kind of communication, we will have to examine the presumption that intent is relevant to the apprehending and judging of art works. In doing this we will remember that instrumental utility may not be a generic or universal trait of human communication.

« 38 »

It is clear that artists, like all of us, have intentions; these intentions, however, are not necessarily or unquestioningly to be identified with the intent of their works. If we consider that the aesthetic intent of a work is often something that develops as the work progresses, it would seem that this intent is elaborated, realized, in the working of the medium by the artist. Drawing, as Valéry said, is a way of thinking. The prior terms of an artistic commission undertaken by the artist are as little, or as much, a clue to the aesthetic intent of a work as its frequently *ad hoc* title. We do not literally or without question judge artists' work on the basis of their enunciated programs though the latter, when they exist, can be of help to appreciation. Artistic manifestoes have sometimes served this critical function in the past; but they have also often just lapsed as inapplicable or irrelevant. Such manifestoes appear to have been a stimulus to creation for their promulgators. But would it not be more accurate to say that they are simply another product of their promulgators' creativity? Is the Surrealist manifesto, for instance, the right place, besides Surrealist works themselves, in which to look for the *aesthetic* intent of Surrealist works of art? Are we to judge Sir Philip Sidney's poetry on the basis of his *Apologie for Poetrie?* The *Apologie* must certainly be taken into account, but we find that parts of it must also be discounted in the light of Sidney's actual poetic practice. A different instance is provided by Tolstoi about whom we know, from some autobiographical statements, that in the early part of his productive career he greatly desired fame, and intended to get it by his works. This intention, however, is not exhibited in those works; it is not aesthetically germane to those works, and it is impossible to judge them by it. They

168

38. Facsimile of drafts of William Blake's poetry. *One page of the Rossetti manuscript. British Museum, London. Reproduced by permission of the Trustees of the British Museum.*

« The intent of a work is often something that develops as the work progresses. »

do, however, exhibit an intent which has been variously, if summarily, described as "narrative," "documentary," or "realistic"; they have been said to exhibit "romantic" or "panoramic" intent—an intent, in any case, which turns out to be simultaneously imaginative and craftsmanly: broadly human and technical rather than personal and prudential. This is what I call the aesthetic intent.

Intentions that eventuate in ordinary actions are formulatable in propositions in advance of the actions. But creative intent is so much in the nature of a discovery that it sometimes surprises the artist himself. This intent is suggested, in the completed work, from the early moments of exposure to it. Some might say that it should not even be called intent—except that a design which functions communicatively certainly seems as entitled to intend something as propositions are. And if only the work can adequately express the creative intent of the artist and not anybody's words, this means that, in the arts, propositional intentions are adducible only *ex post facto* as much by the artist as by the critic.

What we must remember, here, is that there are non-assertive, or non-propositional forms of appraisal as there are of determination. These non-propositional judgments are to be found in the forms which, antonomastically, constitute the arts. It would seem to follow, that if verbal commentary on a work is possible and relevant, it is in effect a verbal judgment upon the primary, non-verbal judgment which the art work is making. The artist purposes something which, if put into words, seems very general in nature and too vague to supply a basis for either criticism or self-criticism. This is because the artist does not conduct his creative thinking in words but in terms of his medium. He uses aspects, tendencies, connotations, concrete leads embedded in his medium (as contextualized by its tradition and culture) in the elaboration of his creative thought, which is to say of his aesthetic intent, which is to say of his design. In seeking to achieve what he can state only generally and vaguely, he attends concretely and concentratedly to details of execution and to the particular, as well as overall, suggestiveness of every step he takes; for, as far as style is concerned, everything depends upon the differential but coherent way in which the artist *completes* his work.

A non-verbal, or poetic, work of art exhibits its intent in the completion of its design. The realization that a design works comes in and through the experience which the art work is informing, so that

the consummation of the experience of the work—given the requisite mastery in it—is probably the best sign not only that its intent has been made effective but also that its intent has been grasped. As we have already said, this intent will hardly be formulatable in words either by the artist or the perceiver. If it *had* been, the artist would not have had to appeal to his particular medium and his non-conceptual technique to express it, and the perceiver would not have felt it as novel in experiencing this work.

The artist, of course, exercises judgment in creating his work: we all now recognize that there is a critical phase in creativity. But the completed work itself constitutes a non-propositional appraisal of, and determination within, reality.

As Buchler has quite rightly pointed out, to subsume intelligent contrivance under conceptual thought is a mistake. I would add that it is a mistake due to the prevailing assumptions of our culture; for, as a covert imposing of a scientific model on all purposive production, it remains unquestioned only because we make scientific explanation and scientific discourse normative for all discourse, action, and production. Works of art, however, have an experiential coherence or unity which is not primarily conceptual: they "make sense" sensuously or affectively—even when, or just because, they are products, in part, of intellectual ingenuity. They are also products of sensory motor exploration of a medium and an environment in which chance and need both play a part though counterweighted by intelligence. And it will be the part of intellectual ingenuity to disentangle the artist's aesthetic intent as his probing, playing, or searching proceed.

Thus if it is granted that art is basically contrivance, then whether intention is a kind of purposing, or whether it is a kind of attention. or whether it participates in the nature of both, as I believe it does—it is hard to see how the thesis that art is not purposive can be so enthusiastically defended by some theorists. We can guess that "purposive" has been confused with "utilitarian" in a narrow sense. For, as an enjoyable experience, the work of art will be *intelligible* just in the degree that its aesthetic intent is discernible, and it will be adjudged good to just the degree that its discernible creative intent is creatively fulfilled. But not only is contrivance purposive, it may also be interrogative; the initial phase of contrivance would seem, in fact, to be always interrogative. It will be said that a contrivance completed is not an answer if it is a product. Even in that case, how-

ever, the product is a determining factor in an experiential process. As such it is an answer even though non-propositional.[12]

Another mistake that our culture makes is to believe that non-discursive products are necessarily non-cognitive. Dewey, for instance, thought of creative or inventive products as resulting from what he aptly called qualitative thought. Surely enough, qualitative thought is a central ingredient in the creative process; but it is not the whole of it. The actions, gestures, and manipulations of the artists have not been allowed to count for as much both because critics and aestheticians have not been artists and because it has been forgotten that doings and makings can be, as we have said, both interrogative (or exploratory) and judgmental (or determinative). When they are the latter, non-discursive products make discriminations in the environment which are just as effective as those made by cognitive judgments.

Finally, on the subject of intention, it may be asked whether those who claim that any intention is irrelevant to judging the work of art have realized that this implies that they are requiring works to be spontaneous. This, in turn, would mean that works *merely* "grow" or "happen," and that works are not made! Obviously, chance, both invited and awaited, plays some role in the making of art works. But equally obviously, so does "design" in the sense of aesthetic intent; aesthetic intent is the controlling intent, even if it is non-verbal, and the guiding intent even if it is not self-powered or self-stimulating. I have often wondered why, given the recognition that writing is often a search for the "mot juste," or for the most suggestive or appropriate word, there is not also a more general recognition, in connection with technique, that intent is operative in this search. Is it not, in fact, through intent—intent in process of becoming aesthetic —as well as practice that the artist's technical power is harnessed and applied?[13] The Chicago school of criticism and literary theory seems to mean something quite similar to what I call aesthetic intent by what *they* (but not Aristotle) call the "formal cause" of the

[12] In this connection, Buchler gives as an example of an action or product that is interrogative the play-within-a-play staged by Hamlet—who gets his answer from another action, the startlement of the new king. Buchler, *Nature and Judgment*, p. 62.
[13] Thus, for example, the *Scrutiny* reviewer's criticism of W. H. Auden opened with the statement that "this poet's greatest difficulty lies in determining quite what he wishes to express." *Scrutiny*, Vol. XIII (1945-46), p. 138.

poem. As for Aristotle himself, what I call the aesthetic intent corresponds to a combination of his efficient and final causes, as long as it is also remembered that he himself allowed chance a certain role in creation with his neglected pun between *tyche* and *techne*. It is also inviting to draw a possible parallel between his concept of *proairesis*, which relates choice (fore-choice) to action, and the idea that chance operates in the emergence or realization of aesthetic intent.

It would seem to follow, from what we have been saying, that the job of criticism is, as Blackmur has said,[14] that of finding ways of enlarging its own and the public's aesthetics so as to contribute to the enlargement of the aesthetic experience. Needless to say, the trick is to enlarge the public's aesthetics to the point where it fuses with the artist's aesthetic, and the challenge is to infer the artist's aesthetic from his work.

Yvor Winters rightly censured Parrington for mistakenly believing "that we can know what an artist thinks without knowing what he does." [15] What the artist, as artist, is thinking can indeed be gathered surely only from his work. But if there is a fallacy in connection with the intention of the artist, it is just this, that it is sometimes believed that we can best tell what an artist has created when we have learned what he was "thinking" as he created it. This equivocates or confuses artistic thinking with conceptual or prudential thinking, however, as has been suggested above. The artist's artistic thinking is better observed in his work than in his statements about his work, if what is meant by his thinking is that constructive, creative, or expressive activity which is at the same time a knowledgeable, or technical and communicative activity. Of course, a literary work of art can be rehearsed in verbal terms which are more conceptual than its own: a brilliant example of this is E. T. Owen's telling of the story of the *Iliad*.[16] Owen's book is itself a little work of art—of the art of exposition, that is; the sacrifice of the imagery, the music of the verse, and the original rhythm of the events makes it a work of a different grade from Homer's. It succeeds, however, in the artistic

[14] R. P. Blackmur, "A Burden for Critics," in *Lectures in Criticism* (New York: Bollingen Foundation, 1949), p. 203.
[15] Y. Winters, *In Defense of Reason*, p. 559.
[16] E. T. Owen, *The Story of the Iliad* (Toronto: Clarke, Irwin & Co., Ltd., 1946).

173

sense of succeeds, because in exhibiting the narrative and dramatic structure of the epic in expository terms it shows why the *Iliad* is such a well-told story. Such a critical exposition is judgment in action, for it has premised that the work of attending to the story is worth while and, as it proceeds, it progressively substantiates that implicit judgment.

To understand that works of art are, in their own mode, judgments is to imply that criticism is the judgment of a judgment. But as no rules, in the usual sense of rules, can be given for the creation of works of art so none can be given for criticism. Criticism, too, is an art: it is the art of judging or exhibiting the effectiveness of art works. And, if there is circularity here, it is a circularity which criticism can, and must, break out of by being creative. Criticism feeds upon past art, but must be open to and ready for the new—in this its situation is no different from that of the creative artist himself.

As the poet and critic Yvor Winters pointed out two decades ago, one way of understanding the creative process is to see it as a process of adjustment. The artist's problem—which we will try to generalize from Winters' statement of the poet's—is one of adjusting the emotion which the work is expected to, or should, induce to the motives, themes, or ideas in the work. For instance, one could "respond" to a situation of parricidal incest with a mere "ugh" exploiting the medium of language thus far only. But this "ugh" is disproportionate to the possible conceptualizations or dramatizations of such a theme, it is disproportionate to the reactions and judgments that such a situation calls forth and needs to be met with. For Winters the main concern of criticism is the relation, or adequacy, of the feeling in the poem to the motive of it. But for him the motive is the rational meaning. He maintained, in his *In Defense of Reason*, that the relationship in the poem of rational meaning to feeling is that of motive to emotion. It is at the satisfactory adjustment of this relationship that the poet works. Hence, Winters sees the critic's problem to be that of determining whether such a relationship *is* satisfactory; and he adds, in the light of his conception of the relation between art and human action and of the relation between concepts and emotions, that the task is a very difficult one. It is, we would add, indistinguishable from the critical phase of the poet's task.

Winter's conception of the medium, however, is not appropriate to arts which do not use language. In language the world comes already

partly or potentially determinate, as it does to a lesser degree in materials which feature color or shape or non-verbal sound. The way Winters formulates his observation of the fused language of poetry it is the rational element (as he calls it) which effects classifications or sorts things out, and it is the other element—the feeling—which has infinite possibilities of variation and, hence, of adjustment or maladjustment to the motive which is, for Winters, the conceptual content.

But what is the conceptual element in the medium of painting or sculpture or music which effects the identifications to which the artist must adjust the feeling of the work? The conceptual content of sculpture or music does not come separately from the feeling, nor are the concepts and feelings aesthetically determinate before the symphony or sculpture have themselves begun to take shape. This is why I prefer to say that the critic's job is to judge the satisfactoriness of the adjustment, neither of feeling to concept nor yet of concepts to feeling, but rather of creative, or aesthetic, intent to artistic means employed in the realization of this intent. It is understood that feelings and concepts are continuous with each other and inextricable, and that means and ends are, in the arts even more than elsewhere, inseverably fused and interdependent.

Pluralism and the basis of judgment

Let us now consider the view, pluralistic in intent, that discourse about art works and their appreciation can best be based on the consideration of the distinct and conflicting theories that exist in relation to them. The assumption does not seem unworkable, and is indeed to be found in some recent aesthetic writings. We will give it the name of "theoretic pluralism." This, as we will see, is not the same as the "primary pluralism" with regard to art which not only tolerates but is able to enjoy an indefinitely wide range of works of art from all parts of the world and any given time. There is also a pluralism which is distinguishable from the latter in recognizing, or understanding, that the values of art are many and diverse. It is also possible to be pluralistic by recognizing—beyond the diversity of *artistic* values in works of art—a variety of supererogatory grounds for prizing them as different as the psychological and political, the moral and the documentary.

Applied to the criticism of works of art the senses of pluralism given above imply that, as a discipline, criticism is richest and most capable of uncovering values in works of art when it is multiperspectival and interdisciplinary, that is, when it draws from other disciplines available tools and insights which it applies to understanding enjoyed works under scrutiny.

But the phenomena of criticism as it is actually practised, and reflection about how it ought to be practised, force upon us some further meanings. Thus there is, in criticism, the sense of pluralism in which it is understood that a combination of a variety of critical methods judged to be appropriate is capable of pointing out more values in, and contributing to a deeper understanding of, a work than any single method. And it may well be that the best critics are those not previously committed to any one doctrine about art or method of criticism. Such critics, however, should be aware that their methods have theoretical implications as well as practical ones and that reference to either of these may constitute a legitimate appeal from their results.

The existence of works in the history of criticism obliges us to recognize a contrasted sense of pluralism as a lack of commitment to any conception of the best in methods. Atkins' five volumes on English literary criticism evince this defect. Such an "uncommitted" history of criticism is, for some purposes, better than a doctrinaire—and also monocultural—history like Saintsbury's. But dissatisfaction with uncritical histories of criticism causes the question to arise, what is the alternative in history of criticism to a mere enumeration of the doctrines about art with which critics have worked and the opinions reached by them?

Menéndez Pelayo's *Historia de las Ideas Estéticas en España* [17] provides a partial answer. In the first place it is not "monocultural": the ideas referred to are contextualized comparatively in their connections with their counterparts in some other European countries. In the second place Menéndez' procedure opposes, to both doctrines and theories, aesthetic ideas in the technical sense of operative principles constitutive of actual works, or notions of technique with which the artists worked and which works reflect. This presupposes in the critical or aesthetic historian a complete openness to the aesthetics (in the

[17] Marcelino Menéndez Pelayo, *Historia de las Ideas Estéticas en España* (Espasa-Calpe, Argentina, S. A.: 1943).

sense of the poetics of art) of every school, period, or movement in
art as well as to the aesthetics of singular figures and works. Now,
since such openness can result only from primary pluralism about all
art, and since the aesthetic historian must also know the opinions that
have been held about it, the full answer to the question must be, briefly,
that histories of criticism or of aesthetics may only be undertaken by
great art lovers who are also philosophical, or at least, intellectual and
cultural historians. This answer is of a piece with the view that the
historical and "critical" function of philosophy is to bring to light
the underlying and operative collective presuppositions successively
held by a culture.

In connection with differences which arise among critics them-
selves another meaning of pluralism emerges. Pluralism, for some of
the Chicago theorists, means the ability in a critical polemic to under-
stand the grounds of another's critical judgment and the willingness
to develop the issues with reference to just those grounds and not on
the basis of one's own implicit generative assumptions—unless these
are first made explicit and shown to be relevant. This kind of pluralism
aims to avoid futile argument over differences that derive from differ-
ent ulterior or philosophical frames of reference in critical discussion
of art, and to concentrate on the different responses that arise regard-
less of frame of reference.

It is ironic, however, that critics and literary aestheticians like
E. Olson and R. S. Crane who have developed this acceptation of the
term cannot be construed as encouraging a diversity of approaches to
literary works of art. For Olson and Crane hold out for an indefinitely
extensible but single method: and this is better called Ptolemaicism than
pluralism. Aristotle, according to Olson, "can be said to have devel-
oped . . . a permanently true but also indefinitely operable poetic
method . . . the theory can be extended to cover . . . new forms
of mimetic art as they emerge by one with sufficient knowledge and
skill in . . . methods." [18] Olson seems to believe, further, that to one
philosophy, one criticism belongs: "the number of critical positions is
relative to the number of possible philosophical positions." [19] This
overlooks the fact that different critical judgments or methods may

[18] Elder Olson, "The Poetic Method of Aristotle," *English Institute Essays
1951* (New York: Columbia University Press, 1952), p. 94.
[19] E. Olson, "An Outline of Poetic Theory," *Critics and Criticism* (Chicago:
University of Chicago Press, 1952), p. 547.

be deployed on the basis of the same philosophy, and is to this point not pluralistic.

The ease with which the mere awareness of a plurality of theories is confused with genuine pluralism is illustrated by Richard McKeon in his essay on "The Philosophical Bases of Art and Criticism." [20] He distinguishes there between dialectical and literal methods of criticism. In another essay, "Philosophy and Method," [21] he distinguishes between dialectic, logistic, and inquiry as methods of philosophy. His discussion of criticism in the first essay is dialectical in his sense and purports to be an approach to art and criticism that isolates the virtues and discloses the failure or perversions of the several methods of literary criticism. But this dialectical method of philosophizing, as applied to art and as McKeon formulates it, would seem to consist of the treatment of works of art in the exclusive context, and in terms only, of the differences between the theories that exist about them: it is a dialectic which does not allow itself to be directly confronted with works of art. As McKeon actually applies it to criticism it amounts to a rejection of critical methods that believe they can treat art as art. But if, as McKeon also says in *Thought, Action and Passion*, "the interrelations of aesthetic theories are more difficult to explore than the coexistence of aesthetic qualities to which they direct attention in poetry," [22] what is the advantage of discussing art works in terms of the theories about them? If criticism can be only about "second intentions," if second intentions only are discussable and not primary responses to works of art, then this boils down to another version of *de gustibus non disputandum*.

But primary responses to works of art—which are not nonintellectual just because they are also qualitative—can as a matter of fact be discussed to the same extent that any qualitative experience can. Works of art involve more than the sheer qualitative response to them, and to that extent are also more amenable to discourse than isolated qualitative experiences. If, however, by critical judgments we mean ratings or assertions of comparative standings among works in

[20] R. McKeon, "The Philosophic Bases of Art and Criticism," *Critics and Criticism* (Chicago: University of Chicago Press, 1952), pp. 463-545.
[21] R. McKeon, "Philosophy and Method," *Journal of Philosophy*, Vol. XLVIII, no. 22 (October 25, 1951), p. 653-682.
[22] R. McKeon, *Thought, Action and Passion* (Chicago: University of Chicago Press, 1952), p. 107.

the same medium and of the same kind (where this kind is determinable and clearly the same), then only to an extremely limited degree can these ratings and determinations find a rational basis for themselves. Such discussions presuppose or imply some order of preferences peculiar, and even exclusive, to the discussant which reflects more or less accurately his inadequate verbalization of aesthetic experiences. Thus the comparisons will be valid only for the one who makes them, and will make sense to few besides himself. Such lists or ratings, in any case, are based on the false assumption that there are degrees of goodness within a kind (and, perhaps among kinds) of art works. The fact is, however, that works of art are all good in their particularity—not in the degree to which they share features with some ideal or actual best of all works of this kind; for, to just this degree, they will be unoriginal and thus not good.

Because a work of art seems to observe the same conventions which others do, it at first sight seems that the originality of the work consists in *what*, within these conventions, it seems to be saying. On closer inspection, however, it usually turns out that what can be gathered as having been *said* by them all is, in propositional terms, pretty much the same and that what differs from work to work is the attitude toward what is said. But this attitude can be conveyed, under the same conventions, only by *the way in which* what is said is said. So, the difference is found to be one of human attitude and artistic style, and these may certainly be discussed fruitfully. On the other hand, most works supposedly of a kind will be found to have only some conventions in common, and their different originalities correspond to the devices in which they differ. Shakespeare is a noteworthy case of appearing to use some conventions of Elizabethan drama, but of actually using them only in the sense of taking them as material; he uses them, the revenge theme in *Hamlet*, for example, as subject matter and not as part of what is usually called "form."

Because works of art are good in the particular organization of their qualities, and because works of art are enjoyed for just what they are, judgment of works that *have* very recently been enjoyed will actually eschew comparisons between them and others formerly enjoyed, but which are only a memory at the moment. Judgment will be internal to the work enjoyed, in the manner previously discussed, by becoming aware of the whole burden of its design and by under-

standing the nature of the means by which this design, as a creative or expressive success, was achieved.

When we find ourselves recommending one work over another, what we are in part doing is assessing the ability of our interlocutor to respond to works that we, and probably others, have responded to. On the basis of this assessment we suggest an order in which a set of works should be read, heard, or looked at; and we prepare and alert the percipient to what he might miss or be especially challenged by in the works to which we want him to expose himself. Finally, whenever we go beyond the poetics of the creation in question to discuss the place the work might, or should, occupy in the thought and conduct of men, what we are doing is appealing to our theory of man, to our assumptions about human nature, its ills, powers, concerns, and proper occupations. If we are honest critics we will be ready to make this theory or set of assumptions explicit.

PART FOUR

Creative man

CHAPTER NINE

The creative animal

In short, the history of human experience is a history of the development of the arts.

J. Dewey

Tools and art

The biological foundations of man's aptitudes all emerged and were reinforced during the first and longest, but least known, phase of his history. Manhood began between one half and one million years ago with the bipedal, tool-using man-apes of the genus *Australopithecus*. The latter, though capable of bipedal running, were from the evidence of their transitional pelvis apparently not capable of bipedal walking: an ability requisite for covering long distances, itself a precondition of efficient hunting.[1] But the competent hunters—early men of the genus *Homo*—who

[1] S. L. Washburn, "Tools and Human Evolution," *Scientific American*, Vol. 203, no. 3 (September, 1960). Reprinted in *The Human Species* (Scientific American, 1960).

183

followed them during the several hundred millennia before *Homo sapiens* appeared, also both used fire and *made* tools according to a transmitted pattern or "tradition." Acheulian industries already included what must be considered as tools to make tools with.

Neither the man-apes nor ancient *Homo erectus* had the fighting incisors and canines of the great apes. This implies that defense had shifted from teeth to tools and hands early in the history of the ancestral man-apes; and this implication has led to the suggestion that redundance of the canines was due to the attachment of the ancestral primate to the use of weapons.[2] Weapons, in other words, preceded—may even be said to have fathered—large-brained man. For expanded cranial capacity is a concomitant of reduction of the canines; and this reduction entailed, besides a shortening of the jaws, a decrease both in the bony ridges over the eyes and the bony shelf in the neck area. According to C. P. Richter, small brow ridges are invariably correlated with the diminution of rage and uncontrolled aggressiveness or dominance. The brain seems to have doubled in size between the man-apes and man; and although the brain of *Homo sapiens* (70,000–50,000 B.C.) is not much larger than that of Neanderthal man, the indirect evidence seems to show that the former was overwhelmingly more creative than the latter who, as a tool maker, must be classed as human.

While all primate species may be said to have what psychologists call affectivity, Neanderthal man—who buried his dead with some ceremony—was certainly already intellectualizing his affectivity. Though he had coloring materials, there is no evidence that he made either chattel art or mural art—unlike Cro-magnon man who superseded him. It is legitimate to conjecture that the capacity for great art, evidenced by Altamira and Lascaux, is significantly related to Aurignacian man's ability to displace the Mousterian men, or Neanderthalers, who were both more numerous during the third Interglacial period and otherwise just ab ut as well equipped. When exactly in the Aurignacian period the first tools were made for the carving and engraving and painting of works of art, and what all of them were, we do not know with certainty. Because Neanderthal man was also large-brained, however, it would seem of crucial importance if we could locate the causes for which he did not have plastic art where *Sapiens* man did in terms of the differences between Neander-

[2] R. A. Dart, *Adventures with the Missing Link* (New York: The Viking Press, 1959).

thaler and *Sapiens* physiology and social organization.[3] These causes were undoubtedly part of the set of causes which gave the latter a more versatile cultural development.

Man's brain is not just an enlargement of the ape's.[4] The areas of sensory motor cortex controlling the hand and thumb are proportionately enlarged, making skillful use of them possible and easy. Likewise, the areas adjacent to the primary sensory motor centers are inordinately expanded: and these are precisely the areas concerned with memory and foresight, word storage and language, the powers which make cooperation possible, or social life, and technology, or the human arts. In other words, the increase in brain size was directly related to tool use, speech, and increased imaging, recall, and foresight. Lastly, the decrease in size of the bony birth canal occasioned by erect posture combined with the enlarged skull to make education both necessary and possible; for the child had now to be delivered at an earlier stage of development and taught what other primates do "instinctively." This phenomenon, called paedomorphy, is as basic to human culture as education is. It means that the nervous system is much less developed to begin with; for example, the baby cannot hang on by itself but must be carried by the free-handed mother. On the other hand the organism born with such a nervous system is much more educable than other primates given, in addition, the unusually

[3] Neanderthaler endocranial casts show a smaller amount of brain and a simpler structure in the frontal region. This is the seat of the prefrontal lobe and corresponds to persistence in a course of thought or action, to initiative and foresight. In the skulls compared by H. Vallois it is about $8\frac{1}{2}$ percent less than in *Homo sapiens* and only $2\frac{1}{2}$ percent more than in apes. We must remember, however, that if in comparing the two types of man we are comparing a domesticated version of the species to a wild version, it is a universal rule that domestication reduces cerebral weight by at least 20 percent. Thus the fact that the *Sapiens* brain was hardly larger, overall, than the Neanderthaler's might also show that *Homo sapiens* was the product of, or associated with, a great—even a crucial—intensification in the social organization of his culture. See H. Vallois, "The Social Life of Early Man: The Evidence of Skeletons," in *The Social Life of Early Man*, edit. by S. L. Washburn (Chicago: Aldine Publishing Co., 1961).
[4] "The distinctive feature of the human cerebral cortex is not so much in overall volume nor in relative size of the frontal lobes, but rather in the way that the projection areas are connected with association areas, especially in the temporal lobes, and in the way the whole thing works." J. N. Spuhler, "Somatic Paths to Culture," in *The Evolution of Man's Capacity for Culture*, ed. by J. N. Spuhler (Detroit, Mich.: Wayne State University Press, 1958), p. 9. Projection refers to the power of analysis, association to synthesis.

large number of cells and possibilities of interconnection in his expanded brain. Man is, distinctively, the only animal with a childhood in the true sense. And because, in him, matured animal instincts are replaced by learning and socialization, man also becomes the only animal to have abandoned the biological method of adaptation by speciation in favor of technological and cooperative methods. Man's arts of social organization and his techniques of production have made purely biological adaptation obsolete.

Now the ability to appreciate shape, color, and texture is genetically associated with the process of learning to perform skilled movements with the freed hands. This is so because these came more and more under the guidance of *visual* control. Reciprocally, however, *handling* itself became a means of acquiring a new and fuller understanding of things seen. From the moment, moreover, that skilled or controlled movements became possible they must also have been kinetically or kinaesthetically enjoyable.[5]

The sense of sight had already supplanted, since the Lemurs, the sense of smell as the dominant sense. In the monkey the development of the prefrontal area, according to Elliot Smith, increased the power and range of conjugate eye movements to the point where the eyes could follow the outline of a large material object and fix its shape. Attention, in the wider sense, seems to have had its beginnings in the complicated muscular coordination involved in the convergence of the two eyes upon an object. Binocular vision becomes stereoscopic and highly discriminatory with the development in man's retina of the sensitive spot, the macula lutea.[6] It is in this context that

[5] As Charles Bell enthused, in his antiquated but wonderful book about the human hand, "We find every organ of sense, with the exception of that of touch, more perfect in brutes than in man. . . . But in the sense of touch, seated in the hand, man claims the superiority." *The Hand, its Mechanism and Vital Endowments as Evincing Design*, 1837. Ariens Kappers confirms this in his book on *The Evolution of the Nervous System in Invertebrates, Vertebrates and Man* (New York: Van Riemsdyck Book Service, 1929, p. 177), "The differentiation of the cell groups innervating the fingers is specially striking in man, even in comparison to the anthropoids." All quoted in Pannekoek, *Anthropogenesis, A Study of the Origin of Man* (Amsterdam: North-Holland Pub. Co., 1953). Anaxagoras had brilliantly guessed all this when he said that "man is the most intelligent animal because he possesses hands." (DK 59A 102) Of course, hands are not the unique cause of the development of intelligence.

[6] G. Elliot Smith, "The Origin of Art," *Art and Civilization*, ed. by Marvin and Clutton-Brook (New York: Oxford University Press, Inc., 1928).

we can guess the sense of wonder to have been born. But visual exploration could always be supplemented with manual exploration; and, as dexterity was gained, cross-sensory correlation of tactile and kinetic with visual information became habitual.

This correlating of information led, of course, to an increased appreciation of the possibilities, or meanings of things in experience. One great concomitant of the acquisition of stereoscopic vision enhanced even further the significance of all experience, however, and that was the sudden expansion of the auditory area of the cerebral cortex as the cortex evolved and grew from the originally small neo-pallium enlarging the association centers. This increased both acoustic discrimination and vocal aptitude. By being integrated with other sensory experience sounds now acquired more practical and exact meaning.

Vocal aptitude was used to attach acoustic symbols, or denotators, to the now sharply distinguished visual objects dealt with. These diffuse denotators must, by gradually imposed connotative emphases, have differentiated themselves into names for the objects, so that they were verbally as well as visually separated from each other. Other sounds could be made to stand for the movements of which the thing was seen to be capable, and still others for the powers that further experience proved the object to have. Thus two things from the first seem to have been true of language as a psychological function: (1) it was stimulated by, and under the control of, visual experience which it also sought to order; but (2) it was based upon synaesthetic experience or multisensory dealings with the environment. In the difficult and danger-laden conditions of survival which we may postulate, speech, as part of the social situation, must have been fraught with excitement, or emotion, and imperatives, or signals for action. It hardly seems possible, to the student of prehistoric anthropology, that emotion-free indicatives could have been, as it is sometimes claimed, the basic mode of speech. Moods, in any case, are purely grammarians' fictions. We don't have to appeal to the evidence of comparative linguistics to state that it seems idle to argue with passion (and not always in the indicative mood) for the greater normality, or importance, or primordiality of the indicative over the imperative or vocative or conditional. It is strange that many of the same analysts who like to point out that, in certain ethical contexts, sentences have

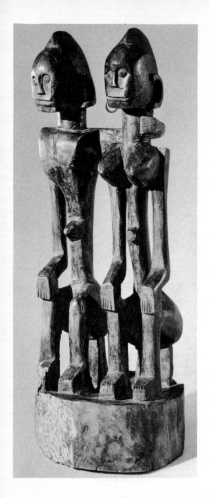

« The intellectualization of sex. »

39. Ancestral Couple, *Seated figures,*
Dogon, Nali, French Sudan. Rietberg-
Museum, Zurich; Von der Heydt Collec-
tion.

functions which clearly belie their mood designations, fail to notice that in all other contexts the force of an utterance nearly always goes beyond the grammatical mood that can be assigned to it.

The development of handiness or dexterity under the direction of the eye must have built up the intricate neural networks for integrating the factors which make any purposeful action possible. Similarly, the ability to learn from individual experience must have become, with the advent of language, the power to share in the accumulated knowledge or experience of the group. But the symbolic sharing of experience, or communication, presupposes cooperation which, in turn, presupposes the emancipation of the human organism from rage and uncontrolled dominance. In a parallel development the progressive dissociation, which Beach has observed in the primates, of sexuality from hormonal control culminated in man with the preponderant control of his sexuality by social institutions. Sex, in other

188

words, is controlled more by the cerebral cortex of man than by his « 39 » glands. When it became possible to regulate behavior by rules, or the standing injunctions of the group, sexual activity was thereby intellectualized. Conscience, as has often been said, is a social invention.

How soon man began to make artefacts better, in the aesthetic sense, than they needed to be is difficult to determine. It seems obvious that, within limits, there are alternate ways of shaping the tool which meets a need and that the differential shape is decided by aesthetic preference.[7] Even in the case of the earliest tools of the Upper Palaeolithic period, while the results of chipping and flaking depended mainly upon the nature of the material used and only up to a point upon the way and place on which the material was struck, this does not obviate, rather it confirms, the fact that the earliest artificers had reached an appreciation of the relevant structural properties of this material to the point where they could take advantage of it. It is not impossible, either, that a material shape first attracted attention to itself by being beautiful or unusually interesting, and that subsequent « 40 » handling of it revealed practical uses for it.

Man, or protoman, began to have tools hundreds of thousands of years before he began to paint the walls of his caves. If we could tell, however, when *Homo sapiens* began to try to make his tools pleasing, then we could also tell when it was that the wanted, or emergent, association between the artful and the beautiful began to be materially, deliberately, and repeatedly satisfied until it had become an ineradicable, or easily reinstated, tendency in the human nature that was then in the making. We could tell, in other words, when it was that the sense of wonder—stimulated so far only by natural objects, given or discovered—became operative upon manufactured objects too. If early Acheulian industry already had its beautiful hand-axes, however, the achievements of Palaeolithic cave art seem a little less startling; for it then appears that, as traditions of *working* certain materials developed, these traditions also became habits of *workmanship*, or of working with an eye to the feel and look of what was being made.

[7] But this presupposes that aesthetic preferences have already emerged. In this connection Jacquetta Hawkes says, "The form of the best Acheulian hand-axes is fine enough, sufficiently removed from purely practical needs, to demonstrate the existence of an aesthetic sense in their makers." J. Hawkes and L. Woolley, *Pre-history and the Beginnings of Civilization* (New York: Harper & Row, Publishers, 1963), p. 187.

40. A. Natural Horn: Ram's Horn. Hebrew Shofar. *The Smithsonian Institution, Washington, D.C.*

40. B. Artificial Horn: Hand horn crooked in Bb. Made by D. Jahn, Rue Mandar, Paris, 1820-1837. *The Smithsonian Institution, Washington, D.C. Property of Mr. Robert Sheldon.*

« Beauty attracts attention to material shapes
and handling reveals practical uses for them. »

Reinach and Elliot Smith believed that man's first attempts at artistic expression were not motivated by a feeling for beauty but by the practical purpose of making magical, or symbolic, devices with which to protect his well-being. This leaves unexplained why the magical symbols in question are done so beautifully. The feeling for beauty, though not always in the forefront of early man's mind, must have been operative (even when semiconsciously or unsuccessfully) from the time of his first deliberate efforts, else there would have been only extrinsic satisfaction to hold the primitive artificer to his irksome task, requiring as it did an unusual and novel amount of concentration.

«41»

Furthermore, if art in the strictly aesthetic rather than practical sense is too sharply separated from magic, the efficiency of magic [8] is scanted so far that efficacy had a symbolic basis—a basis, that is to say, in its psychological and reassuring effect as symbolic action. If the purpose of magic was to safeguard life and human existence, then this purpose would appear to be entirely continuous with that of art. For is not the general aim of works of all the arts the safeguarding of perceptions, states of being, discoveries, or adjustments that are held to be valuable? In this context art is a truly, not incidentally, efficacious extension of magic so far as magic does some personal good to its performers rather than seek to change directly the material environment. It would be just as true to say, however, that magic, as symbolic action, is an important ingredient in the practical efficacy of art.[9]

It should be noted that it is the use of tools which gives rise to man's idea of causality (as opposed to the idea of invariable conjunction or succession) and, hence, to the causal order. But the sensory images continually being produced by man's central nervous system give rise to metaphors; for, as symbols of things, images can always fuse with other images or be the forms under which other things are

[8] It is tempting to hypothesize that we call magic just those beliefs persistently practiced by other people which we—but not they—can judge to be ineffective, from the material and scientific point of view, in promoting their objective welfare.

[9] Cf. L. Buermeyer, *The Aesthetic Experience* (Merion, Pa.: Barnes Foundation, 1924), p. 150: "The ritual of the conventional or established religions, unless we take seriously its claim to miraculous efficacy, is to be regarded as symbolic and so of the nature of art; it owes its value to its expressiveness and not to its effectiveness."

seen. Light, for example, can be seen under the image of an arrow as in Homer, or time in the image of a river. For that matter, we speak both of time's arrow and of a stream of light; while light is an image under which many other things and events can be seen. The poetic order, as we may call it, takes its rise from the image-making power. Magic, then, is perhaps best understood as a case of extreme and literally implemented confusion between the causal order and the poetic order. I do not mean that the two orders do not borrow from one another in discourse, but that it is magic to act as if things in the causal order were responsive, directly and without intermediate physical agency, to the principle operative in the poetic order.

Art, language, and abstraction

Protoman, or the hominids, also appear to have had some power of speech long before they had art. Here we mean art in the sense of chattel art and cave art, not in the sense of primitive tool using and making or hominid cunning. By how much tool using and making were also antedated by speech is not known; and it depends, partly, upon what is meant by speech. If we grant Dart's hypothesis [10] of an osteo-dontokeratic weapon tradition, or bone age before the stone age, the origin of tools is pushed back several hundred thousand years. If we agree, however, as it seems to me we must, to the validity of Hockett's application (or zoological extension) of the comparative method to all kinds of communication systems in order to isolate the most basic

[10] Dart, *op. cit.* See also Robert Ardrey, *African Genesis* (New York: Dell Publishing Co., Inc., 1961). But the late date Dart assigns to speech, 25,000 years before the present, does not seem acceptable. His result can be explained, however, by his reliance on the necessarily insufficient skeletal evidence and by the fact that he seems to have fully articulate human speech in mind. Hockett says that the "successive evolutionary changes leading to language did not begin more than 10 to 15 million years ago, since our nearest non-human cousins do not show the consequences, they may have begun much earlier. They were concluded at least 50,000 years ago, and may have been completed much earlier Indirect inferences, based on archaeological reconstructions of palaeolithic life, would suggest a much earlier terminal date. Quite possibly Pithecanthropus, if not Australopithecus, shared with Homo the power of speech." C. F. Hockett, "Animal 'Languages' and Human Language," *The Evolution of Man's Capacity for Culture.*

192

features of human speech,[11] then the beginnings of speech are pushed back beyond the hominids to the hominoids and protohominoids, the common ancestors of apes and men.

When human language as a whole is compared to other communication systems, those of animals and those of machines, basic features come into relief in it such that all human languages exhibit all of these features but such that the communication systems of animals do not. Animal call systems from which speech developed will be seen to lack certain features—just those, of course, which make it human; while some artistic activities, like music, will show themselves as having some of the distinctive properties that make speech human but as lacking some of the properties that make it speech or natural language.

In distinction from other modes of communication such as gesture, the dancing of bees, or animal courtship rituals, human communication relies upon (1) the vocal auditory channel, though it is not limited only to it. In consequence of this reliance the signals in the system are subject to (2) rapid fading, and (3) broadcast transmission and directional reception. Unlike many other systems, however, human and protohuman language generally exhibits (4) interchangeability, though adult-infant communication makes an exception—the infant cannot reproduce all the signals characteristic of the human adult; just so, the male and female stickleback cannot duplicate each others' courtship motions. (5) The speaker of a language should be able to hear all the language signals he himself makes; this ability is called total feedback. It will be noted that interior monologue or subvocal verbalization derive from this ability, are based on feedback. (But if the apes have feedback but not subvocalization, or internal speech, additional factors must be responsible for this power in man or the hominids that might have had it.) Because the acoustic symbols of the system serve no organic function (for example, symptomatic or homeostatic) but serve exclusively as signals, they are said to show (6) specialization. And because these signals refer to situations in the surrounding world they are said to

[11] See C. F. Hockett, *A Course in Modern Linguistics* (New York: The Macmillan Company, 1958). See also, "The Origin of Speech," *Scientific American*, Vol. 203, no. 3 (Sept. 1960); reprinted in *The Human Species* (Scientific American, 1960); and, "Animal 'Languages' and Human Language," in J. N. Spuhler, *op. cit.*

exhibit (7) semanticity—even if, as among the gibbons, the meaning of the call is much more diffuse than that of words. Communication systems which are semantic may be (8) arbitrary, as in human language or bee "language," or non-arbitrary, as communication with pictures can be said to be because they look like what they represent. Hockett points out that the advantage of arbitrariness is that of itself it sets no limits, theoretically, to what may be communicated. Lastly, it will be agreed that if calls are to be effective even if diffuse in meaning, they must (9) be discrete, or clearly units.

Hockett notes the interdependence of several of these features but, more importantly, calls attention to the fact that these are the properties which human speech has in common with the signaling, or call, system of the contemporary gibbons. By inference, these features must have been present, in some primordial form, in the communicative system of the common Miocene or Pliocene ancestor of both man and gibbon. With this inference Hockett transforms the problem of the origins of human speech into the problem of how it developed from an animal call system into the system it is today with the additional characteristics it exhibits, and has exhibited, as far back as it can be reconstructed, from graphic sources, since the early Neolithic period.

It is clear that a communication system with only the nine properties so far enumerated would, as in the non-human primates, be unable to refer to things remote in, or absent from, space or time (though bee "language" can refer to things remote in space). It would also be a closed, or unproductive, system incapable of saying or coining anything not heard before *and* being understood. But the language which we, as humans, use is capable both of (10) displacement, and (11) productivity, as these last-mentioned abilities are called respectively. In connection with the carrying of a bone or stone weapon Hockett notes that a kind of displacement is already involved, a carrying, or referring, today to something to be done or encountered tomorrow.[12] Productivity, it should be remarked, is at the basis of the exploratory power of language and of literary creativeness. The development by its users of these properties in their

[12] We may quote Spuhler again in this context, "The neural delay required when some extra-organic tool is interposed between stimulus and response probably had much to do with the first ability to use symbols and the start of language." *op. cit.*, p. 6.

communication system marks the crossing of the threshold into humanity.

A call system which is inherited genetically would, from any but the long, secular point of view, appear to observation to be a closed or unproductive system. A system which is (12) transmitted culturally, however, will be comparatively capable of much faster change or development, and greater complexity and flexibility. (To what extent traditional transmission, as opposed to genetic, plays a part in the call systems of other mammals has not been sufficiently investigated.) The last basic characteristic of human language is probably not shared by any other animal communication system, certainly not by any hominoid system. This is what Hockett calls (13) duality of patterning, the property by means of which a small set of acoustic elements in a number of different combinations can give rise to an enormous number of morphemes or words.

Now consider what is presupposed by the specifically human traits in speech when taken together, and what they make possible. They presuppose or imply, among other things, that dominance and territorial relations have been tempered, that there is reciprocal food sharing, that there is mutual aid in hunting, in short, that there is co-operation among and within human groups. As Hebb and Thompson have said, "Teamwork makes intellectual demands of the same order as those made by language. Psychologically it may, in fact, be difficult to distinguish between the two." [13] These characters are, in their simultaneous operation, the conditions with which choice becomes emancipated from material or actual trial and error, and

[13] In G. Lindsey, *Handbook of Social Psychology* (New York, Addison-Wesley, 1955).

« Action selects from and modifies the environment. »

42. View of Machu Picchu. *Cuzco, El Zorrein.*

« 42 »

in which speech becomes more discursive as well as independent in its discursiveness, of the materials of the environment. I do not mean that choice or action, to be fully reflective, have to be fully verbal; for action may select from and modify the environment materially and rationally without benefit of words. So, for that matter, can there be (at another extreme) mental elaboration of possibilities without words. Still, the process of thought, this mental weighing of anticipated alternatives, is made easier by discourse. What speech makes possible, however, because it is a systematic symbolism capable of displacement and productivity, is the sharing, in a most efficient way, of trains of thought and the elaboration of them by groups of individuals. Other symbolisms, gestural (sign language), or visual (semaphore or smoke signals), or even acoustic (morse code or drums) can be made to serve, but not as well. Only the sharing of experience made possible by works of art cuts deeper, but for practical purposes the effect of art generally takes longer to become operative in conduct. I do not mean the effect of art upon the perceiver as perceiver, but upon his conduct. This effect is indirect;[13] it is a *psychagōgē*, as Aristotle called it, a leading of the organism into appropriate ways. Visual symbolism, by the way, would seem to be at its best as utilitarian communication when it is oral language made visual. On the other hand, the most universally intelligible kind of communication will be of the kind that is found in those arts which are not bound by a code or convention of interpretation or by national languages.

The human traits of natural language, in short, both contribute to and presuppose the power of vivid imaging and of discursive abstraction. With the latter the making of generalizations and the effectiveness of eloquence are both facilitated. The effectiveness of evocative discourse is of a piece with the power which art has to define or promote an ethos. It must be realized, however, that generalization is itself an instance of abstraction; for there can be abstraction without generalization, but there is no generalization which is not based on abstraction. It thus appears that the mimetic activities of art,

[13] In the case of music there is also a direct effect; as Santayana said, "it is not so much the music that moves us as we that move with it. Its rhythms seize upon our bodily life, to accelerate or deepen it . . ." *Reason in Art*, Triton Edition (New York: Charles Scribner's Sons. 1936), p. 239.

196

the problem-solving activities of technology, and the referential activities of language all presuppose the power of abstracting. Perhaps it should be added that we are referring here to knowledgeable abstraction—not all abstracting; strictly organic or automatic abstractive responses, such as the motion of an amoeba away from intense light regardless of the color, are excluded. I do not mean to imply, however, that there is discontinuity between human organic processes of adaptation and human intellectual processes.

Just as we have noted that there is thinking without verbalization, thus confirming that there might be problem-solving without words, so it must be noted that there is some independence of thinking from imaging—though this independence may have been somewhat exaggerated by some recent researchers. Certain kinds of deduction or calculation seem to be performed imagelessly. But it should be noted, in all this, that something is being left out unwittingly: for to say that thoughts are independent of images is to limit images to visual images. On the contrary, it seems to be the case that there can be images without consecutive or consequential thinking, but no thinking without some kind of imagery whether acoustic or visual, in general sensory, or kinetic or motor, or even kinaesthetic.

Where speech is concerned (and saving what we have said about the exploratory power of language) the perception is, in general, prior to the vocalization of it. Speaking and perceiving, of course, also interact. As Russell Brain puts it, "If we are to name something, the nervous system must be capable of recognizing a common pattern in a number of different objects; and when an object has already been named, this in itself helps us to detect what it has in common with other objects of the same name." [14] Sensation repeated allows the perceptual memories to revive which make recognition possible. It is a necessary condition of survival among animals that they should recognize not just a particular thing again but a pattern which any other thing of the same sort fits. "What the animal reacts to is not a mosaic of all the individual features of the object perceived, but

[14] W. Russell Brain, "Speech and Thought," in *The Physical Basis of Mind*, ed. P. Laslett (New York: The Macmillan Company, 1950), pp. 51-52. "All stimuli whether sights, sounds, or other sensations, reach the brain as electrical patterns, and it seems to be a basic function of the nervous system to analyse these patterns so as to detect similarity amidst differences." *Ibid.*, pp. 53-54.

a pattern which constitutes an abstraction from any particular in-dividual . . ." [15]

Just so do humans, by the abstractive and mnemonic work of the image-making power, create knowledge out of sensation and motility, out of their receptivity and needs, in the upper brain stem, or thalamus, and in the corresponding association, projection, and control areas of the cortex. Sensory memory, having become asso-ciated with somatic excitations, can be activated by internal as well as external stimuli. It is characteristic of humans, in fact, that they produce a superabundance of images involuntarily, without stimula-tion from the end organs. It seems to be the case, further, that the features emphasized by, or in, our images correspond to the permea-tion of the processes of imaging and abstracting by emotional factors. As, of all incoming sensations, only those of pain go directly to the clearing and control station of the upper brain stem without a detour to the cortex, it would seem that there can be no perception not touched by a degree of feeling.

The simplification, the fusing, and the easy reactivation which are characteristic of images combine, given their involvement with emotion, to make imaging a more or less orderly and directed process in case of need: this is when imaging, or imagination, becomes refer-ential or symbolic in the first instance and reflective, or knowledge-able, in the second. This knowledge can, of course, express itself in action, in production, or in theory, or in any of these combined; for these are the most broadly distinctive though overlapping modalities in which human intelligence operates.

Language makes the environment conceivable; art makes the world memorable, and science makes it predictible. Language creates those patterns which impose themselves upon the welter of experience which we call the world. Out of this order, which is an order merely of survival, an overflow of the very ingenuity and wonder which it has called forth creates a more characteristically human order of aspiration and freedom. Science, in the service of the ethos which

[15] W. Russell Brain, "The Cerebral Basis of Consciousness," *Brain* Vol. LXXIII (1950), pp. 465-79. This passage is also quoted by S. K. Langer in her suggestive essay, "Emotion and Abstraction," *Philosophical Sketches* (Johns Hopkins, Baltimore, 1962). In this same volume another essay, "Speculations concerning the Origin of Speech," contains a valuable discussion of human image production.

the arts of the culture are projecting, makes that freedom practicable in fact by turning ingenuity back upon the order of survival, but with more exactitude and persistence, at the same time that it liberates humanity to further aspiration. But the power with which language, art, and science do their distinctive work is, basically, the same in all of them; it is the power of imagination. As Dewey has said, philosophy begins in wonder and ends in understanding; but art starts from what has been understood and ends in wonder.[16]

«43»

We can now assess the scientific and aesthetic value of the analogy between art and language. The analogy is made possible by the fact that they are both based on our power of imaging and abstracting. Art is more heavily dependent on the former, language on the latter. But imaging itself, it was noted, involves abstracting— under the influence of emotion as well as need. We have also taken note of the creative role which language plays in our conception of the world. This is comparable to the role which art performs in teaching us (also unnoticedly for the most part) how to look at the world in the way we do. We may recall Irwin Edman's well known witticism that the emotions of the middle-brow turn out to be mostly Shakespeare's poetry; and so also, horses gallop in dactyls, frogs croak as in Aristophanes, and owls hoot as in Coleridge.[17] The untutored are not really untutored, it is just that they see the world in the terms of some past scientific conceptions which have been assimilated by common sense or in the terms of some past artistic movement, or in terms of some diluted combination of both.

The similarities and the differences between natural language and instrumental music are illuminating when itemized on the basis of a list of attributes like that isolated by Hockett for natural language. If music is compared to poetry the latter will still evidence the semanticity which the former lacks; but it seems to me that poetry, in being musical, is less arbitrary than ordinary language. For music, it may be hypothesized, is less arbitrary than natural language, since it controls, informs, or gives shape to excitability without words which, as morphemes, are, of course, arbitrary. Music confers pleasantness upon auditory excitation by making it rhythmic and harmonious in any number of ways. And it does this with, or to, the

[16] J. Dewey, *Art as Experience*, p. 270.
[17] See above, p. 47.

43. *Hokusai,* Cranes. *From* Drawings with One Stroke of the Brush, *1823.*

« Art starts from what has been understood
and ends in wonder. »

200

sounds themselves and only the sounds, *not* with acoustic symbols of some perceptual objects as in poetry—where the perceptual or imagined objects themselves perform a major part of the work of evocation and exhibition. Yet there is a syntax to music as there is to natural language; and it communicates without being semantic because it relates listeners to each other and because it allows experiences to be shared.[18] But it is communication for its own sake. And it is curious that the more we avail ourselves of this means of expression the more it does become (not just seem) a vital language for us, fusing with or displacing areas of interior monologue in the stream of our consciousness.

Does the analogy highlight, in a way that is not misleading, any noteworthy features of the visual arts? In a first and notable similarity which shows as much about speech as it does about painting, the analogy seems to work both ways. Just about every one of the comparative linguists has emphasized the fact that the complexity and flexibility of the very earliest reconstructible languages are as great (or greater) than that of the languages of today. So too are the cave paintings of the Upper Palaeolithic startlingly sophisticated in their suggestiveness, as to subject matter, in the abstraction of their design, and in their exploitation of the medium. So much so that an appreciation of this art leads to the realization that all art is "modern," in the sense of "advanced," and that the principles of good design—verbally unformulatable as they are—have ever and from the first been the same. In the case of cave art, of course, we are not dealing with a reconstruction: it antedates the most ancient reconstructed languages by some ten to fifteen thousand years. Here it is language that is illuminated by the beauty and knowingness of cave art, and its ancient complexity is made somewhat less surprising. For it is not so surprising that a people capable of such art should also have been, or developed into, peoples of sharp and fertile minds who enjoyed working out their complex language systems.

[18] "Is there a meaning to music?" . . . "Yes."
"Can you state in so many words what the meaning is?" . . . "No." Aaron Copland, *What to Listen for in Music* (New York: McGraw Hill, 1939), p. 12.

Art and the creation of the ethos

As for cave art itself, how instructive it would be if we could know what conception its makers and original viewers had of its role in their lives. Commentators have all remarked the habit these murals have of depending upon, or exploiting, the nature of the cave surfaces they were done on. I do not know, however, if any have given this as the very reason for the frequently inaccessible locations of the paintings. The palaeolithic cave painters may well have followed the practice of scanning cave walls for configurations that suggested to them, or took well, the superimposed image of an animal design. Finding such a configuration may have been a catalyst for, or a condition of, the practice of their art. This, at least, is an aesthetic reason for their peculiar placing where we have so far been given only rather implausible and unverifiable non-aesthetic reasons on the analogy of post-agricultural or historical religious cults.[19] Whether the postu-

« 44 »

[19] As S. Hepworth-Nicholson says about contemporary tribal art, "Answers in terms of religious functions do not answer the question, 'Why that way and not another? Why that particular (unique) set of visual qualities?" *The Artist in Tribal Society*, edited by M. W. Smith, (New York: The Free Press of Glencoe, Inc., 1961), p. 108.

« The medium suggested some of the shapes. »

44. Herd of Deer Swimming, Cave of Lascaux. Painting in black. From Art in the Ice Age, by Mariner and Bandi. Published by Frederick A. Praeger, Inc., New York.

lated practice was continuous with the process by which men came to paint their *first* paintings we cannot tell, but it possibly was; it is also not impossible that the "catalytic" rock conformation may have become a traditional preliminary requirement.

It is noteworthy, in this connection, that the cave paintings would have had to be seen by (flickering) torch light; for this is a condition which enhances intensely the already great success of these compositions in expressing movement, force, and vitality. It has been thought that they were, quite probably, the product of an originally centralized school or tradition. This does not at all preclude the possibility that they were made for the benefit of individuals who would get from them a truly impressive emotional and intellectual experience. Isolation and surrounding darkness are, after all, a condition of the aesthetic experience of film. For all we know, they may have been made mainly for the sense of power and understanding the initiated maker himself got from them. The state of the evidence is certainly insufficient to verify any of the hypotheses so far advanced.[20] However, the limited hypothesis just suggested at least does not, like all the others, fight against the few certain facts we do have, but is based only on them.

Unless we make our claim specific, it is a sheer truism to say that all other art we know has reflected the psychological concerns of its society and the techniques available to that society. Quite often, and at the risk of circularity, we even identify that culture's concerns and types of productivity from the evidence of its art. This identification is compounded, unavoidably, with some extrapolation from our own experience.

This is just about all we can say, however, without going beyond the evidence, of cave art: namely, that it reflected a concern, among other things that we can only guess at, with the food animals of the time and a desire to get power over them or over the idea of them. That these paintings were part of food increase rituals is entirely conjectural.[21] Given the established abundance of the game

[20] See, for instance, Annette Laming, *Lascaux, Paintings & Engravings*, Pelican Edition (Baltimore, Md.: Penguin Books, Inc., 1959), esp. Chs. 4 and 5.
[21] It is known, for instance, that the ritual of the Veddas, a still primitive hunting people of Ceylon, may have been of agricultural origin since it included cultivated plants like rice and coconuts. I do not wish to make an analogy between societies tens of thousands of years apart, but merely to point to a possibility. As A. M. Hocart says in *Social Origins* (London: C. A. Watts & Co., Ltd.,

supply during the Upper Palaeolithic period, to say that the Aurig-
nacians and Magdalenians were deeply concerned about animal fer-
tility is an extrapolation: gravid bovids and pregnant reindeer, among
the painted animals, may only reflect the fact that that they were
easier to hunt. The concern with human fertility is probably another
matter and, given the occurrence of female statuettes from Aurig-
nacian times down to Neolithic times, not so inferential. It is to be
noted that the examples of the art which reflect *this* concern—whether
engravings, reliefs, or statuettes—are not as impressive as the wall
paintings. These paintings establish Upper Palaeolithic man of this
variety as a very intelligent observer.

I do not mean to say that art has not most often been deeply
involved in, and simultaneously practiced alongside of, other human
activities—the manufacture of tools and clothing, the construction
of shelter, the shaping of ceremony and ritual, the crystallization of
status orders, the elaboration of language (that tool of tools), and
so on. Art, like science, never exists in isolation from the other activ-
ities and concerns of the culture, no matter how much art and science
may have become departmentalized and come to be pursued as activ-
ities apart and for their own sake. This is no less true of art and
science in the sense in which art is the intelligent principle or know-
how behind the art products of the culture and the sense in which
science is the experimental, inductive, and deductive know-how be-
hind its technology and theory construction.

Art and labor, upon which social bonds are so heavily de-
pendent, are as thoroughly interfused as the science and technology
which create the material conditions and possibilities of the culture.
Take the science out of technology and what is left is a blind con-
formity to a pattern of production. Take the art out of labor and
what is left but a blind coping with problems of immediate survival?
Technology is the mechanical facilitating of labor by means of

1954), p. 129, the comparative evidence does not suffice to show that ritual is
older than agriculture. Nonetheless he takes up Frazer's suggestion about the
origin of sowing cereals: "In a food-producing ceremony the Australian
aborigines scatter seeds just as in a rain-making ceremony they scatter down.
Sowing may have begun as a ritual act analogous to many such acts." Logic
suggests, however, that if planting originated from the rain-making ceremonies
of a hunting or herding people, then ritual *is* older than agriculture, though it
may have had no more of a direct connection with hunting than the upkeep of
the water supply.

created devices. Art is one manifestation of the ingenuity, or artfulness, at work in technology in which that ingenuity is celebrated for its own sake and for the delight it gives, so that without art technology is only a concern with easier survival. But take the art out of science and you would have no more pure science; you would not have science for its own sake or systematic theory construction. This is because the satisfaction of curiosity is a kind of aesthetic satisfaction, since it is aroused by the perception of a lack of connection and order, and order at the moment of theory construction is sought for its own sake.

Scientific activity, of course, is not only or mainly determined by the need to calm curiosity; it is also determined by the appetitive needs which give rise to technology and social cooperation. This means, as we have said, that the order which science creates is a refinement upon the order of survival. It is an order in which all, or nearly all, hypotheses have practical implications and can be made operational. It would be of the greatest interest, by the way, to inquire into the history of the physical sciences in order to establish what part of, or to what degree, the determinants of great theoretical mistakes were the aesthetic preferences of their makers. The hypothesis about the circular orbits of heavenly bodies is a case in point, for the circle, as the perfect figure it was considered to be, was the astronomer's preferred figure.

This is the difference between scientific hypotheses and what we usually call myths: that, in them, the preferences—sometimes aesthetic, sometimes wishful—of the myth-maker replace the sense of the probable and the logical. It is not that, unlike science, myths lack practical determinants but that these practical determinants are of another sort. The latter are things which the group already believes and is already doing and for which reasons have come to be required. In this aspect myth is "rationalization." It is not, however, just the image-making and metaphorizing power which has run away with theory construction; it is concerned with establishing plausible (to the culture) and interrelated antecedents to existing beliefs and practices.[22]

[22] This is one reason we reject E. Kretschmer's hypothesis about supposed "laws of imaginal projection" which first separates images into two main groups, ego images and non-ego images, and then revokes the distinction in the case of "primitive man" on the ground that the mechanisms of imaginal projection

Ritual was a means, or habit, of dramatizing these beliefs and actions in a public and formal way; and the original office of myth was to support, or comment upon, the rituals while harmonizing them—generally on the basis of what we have named the poetic principle, but sometimes also on the basis of the principle of causality. The myths often survived the associated rituals, in which case their form ceased to be predominantly determined by the rituals, but was modified by being called upon to meet such non-ritual, but often still ceremonial, functions as the need for history, for entertainment, for precedents, and so on.

« 45 » This may make it seem that the ethos of a people was mainly a creation of the myths freed from their ritual associations and developed, under the influences of community needs, according to some combination of the poetic and causal principles. However, the relation between the myths and the ethos is clearly reciprocal. The *living* ethos of a culture is not the resultant of any single factor but of a complex interaction among the human productive and practical needs, the psychological and intellectual, or spiritual, needs which are emerging in the society and the established rationalizations, accepted lore, and prevailing knowledge. Thus, as Malinowski pointed out in his *Myth in Primitive Psychology*,[23] the myths are intelligible only in the fuller context of the society's customs at the same time that they are the sanction for these customs—including, of course, what we distinguish as moral behavior. Though art is operative in myth— and to that extent myth is literature—because its intelligibility is not exhausted with its text (as in a literary work of art), myth remains distinguishable aesthetically from literature. If the internal, aesthetic

are incompletely developed in him. "They [these laws] operate uncertainly— the groups 'ego' and 'non-ego' (outside world), 'conception' and 'perception', are not sharply divided; they overlap in wide and variable border zones." *Textbook of Medical Psychology* (New York: Oxford University Press, Inc., 1934). The imputation of deficient powers of observation to the Palaeolithic hunters who were artists (if by primitive he means primeval) is unacceptable in the case of a people who though (or because) not numerous were intensely social, who were not our inferiors in painting and engraving, who probably were not our inferiors in linguistic development, and who must be credited with several technological breakthroughs. If by primitive Kretschmer means contemporary tribal societies, their hallucinatory experiences which Kretschmer offers as the basis of their magic and sorcery, are better explained in medical and anthropological terms.
[23] B. Malinowski, *Myth in Primitive Psychology* (London: Kegan Paul, 1926).

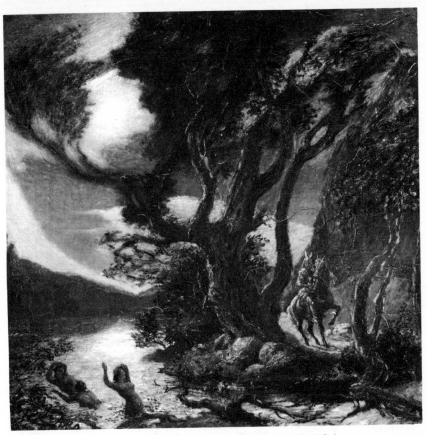

45. *Albert Pinkham Ryder,* Siegfried and the Rhine Maidens. *National Gallery of Art, Washington, D.C.; Mellon Collection.*

« The sources of the ethos. »

criterion fails to distinguish between a myth and a literary work of art it is because the former is at times just that—all art. Does this mean that, conversely, to the extent that works of literary art fail of self-generated intelligibility they fall into the category of myth? It would seem not, unless they achieve the social acceptance which is characteristically enjoyed by myths whether works of art or not. This is not the less true because in modern societies no myth or set of myths achieves universal acceptance within them.

It does less than justice to the nature of art, however, not to distinguish it, among the sources of a culture's ethos, as a peculiarly effective but unofficial (and even unnoticed) cause of moral change, that is, of change in attitude to the mores. There is also the feature

in art which makes it the most powerful expression of a culture's mind and mood, one which transcends and comprehends all the evidence of the succession of its fashions and which transcends and comprehends all the conflicts and crosscurrents in the culture's thought. In this book we have given some reasons why this is so. We may note here that as it functions in the discipline of intellectual history, art is actually made to serve as a symbolic summary and reminder of a myriad diverse items in a cultural period. It would seem that a work of art, though not itself a concept or primarily conceptual, is yet so intelligible to the intellectual historian as to be capable of generating and resuming concepts almost indefinitely. This may be because art is a psychological polarizer; but it also confirms our basic claim about the continuity between feeling and thinking.

The function of art

To the question "what is the function of art," we will first of all give the answers of some other thinkers. Here is W. J. Turner's answer to the question, which he raised in his book on Mozart. "I would say at bottom it is nothing more or less than the expression of the relationship between the individual and the universe." [24] Arnold Hauser reminds us, in his *Philosophy of Art History*, that "art . . . necessarily involves a wrestling with the problems of life and an effort to capture the meaning of human existence." [25] Boris Pasternak has Dr. Zhivago tell us that "Primitive art, the art of Egypt, Greece, our own—it is all, I think, one and the same art through thousands of years. You cal call it an idea, a statement about life so all-embracing that it cannot be split up into separate words . . ." [26]

[24] W. J. Turner, *Mozart, The Man and His Works* (Garden City, N.Y.: Doubleday & Company, Inc., 1954).
[25] A. Hauser, *The Philosophy of Art History* (New York: Alfred A. Knopf, Inc., 1959).
[26] *Dr. Zhivago* (New York: Pantheon Books, Inc., 1958), p. 281. It is worth noting, because it confirms a point made in this book, that Yuri Zhivago had been claiming earlier that art "is a principle that is present in every work of art, a force applied to it and a truth worked out in it. I have never seen art as form but rather as a hidden, secret part of content. . . . A literary creation . . . appeals to us above all by the presence in it of art. It is the presence of art in

It is to be noticed that these are not attempts at a formal defini-
tion of what art is, but statements of the most important thing that
art does, as will appear in the sequel. A formal definition, of course,
is only the summary of a hypothesis, and hypotheses must be based
on observation of innumerable instances of the phenomenon in all
kinds of different contexts. That there has not been enough of this
kind of observation was a point made in Chapter II. Even among
philosophical observers of the arts those at ease with the spirit of
creativity have been the exception; here, the philosopher's habit of
never assuming anything has stood in the way of sympathy with the
artist's operating assumptions. So among the lay commentators on
the arts and the ordinary man of our times there has been no con-
sciousness of the pervasiveness of art in their lives and little of its
relationship to what they prize most, their happiness.

The implicit and extended definition of art given by this book
is aimed at facilitating just this awareness of art's pervasiveness. Crea-
tive or aesthetic motivations are not peculiar to poets, composers, and
painters. We must understand what emerges on closer observation,
that such motivations operate in the everyday life of mankind. We
have noted that, for both artist and appreciator, working through a
creative experience is a self-rewarding activity.[27] Another way of
saying this same thing, and it is what is meant when this is said, is
that the quality of works of art is intrinsically and expressively de-
termined. This characteristic is often latent in, or acquired by, all
sorts of human activities which are not, at first sight, aesthetic or
expressive. This aesthetic and expressive, or self-rewarding, quality
may supervene upon an action so common and practical as walking

Crime and Punishment that moves us deeply rather than the story of Ras-
kolnikov's crime." Ibid., p. 281.
[27] From D. Morris's Biology of Art (Alfred A. Knopf, Inc., New York: 1952)
we learn that the quasi-patterns produced by chimpanzee scribblers develop
gradually from exploratory pencil or brush strokes. One or two patterns, e.g.,
the "fan" pattern, are recurrent among different subjects. While these scribbles
show some development, they never reach a symbolic level. When "cued" by
pre-existing patterns on the white paper the chimpanzee responds by clumsily
following the lead of the patterns. And, most important of all, scribbling, brush
and finger painting are found to be utterly absorbing, and are observed to be
self-rewarding in the sense that the chimpanzee resists interruption of the
activity for any reason and that he persists in returning repeatedly to the activity
in spite of his limited attention span.

« 46 »

or driving through a cityscape to an appointment on a particular morning. Conversely, think how much the poorer and duller life would be if aesthetic quality did *not*, continually and unexpectedly, threaten to suffuse as with a sudden blush the most instrumental of activities and observations. Sheer practicality or pure emotivity, if they had their way, would either of them wholly reduce and boil the world down to nothing but themselves—by counting as nothing what is nothing to them. Activity is not only blind but painful when its ends are arbitrarily and externally given; an end that is not immanent in an activity can hardly be its motive, and unmotivated activity (as every teacher and executive knows) requires coercion to be sustained. Because art is self-rewarding, that is, self-propulsive, it is the model upon which all human productive activity must be based if it is to be free, or uncoerced. Usefulness, we must realize, is more often the byproduct of creativeness than the child of necessity.

I am not only saying that where there is no art now in people's lives there ought to be—in the classroom, in the home, in entertainment. I am also saying that to closer observation there is more art, of whatever grade, than most people have suspected in their lives—though ordinary language hints at this in such locutions as "the art of teaching," "the art of loving," "how to" win friends, "how to" do it yourself. I am also proposing that the over-all quality of people's lives would be raised, spiritually and materially, if they would realize this and deliberately give more scope to "art" (in this sense) in their customary activities. The ubiquitous aesthetic thread which runs through the industrial, religious, and civic activities of mankind is most frequently unnoticed by those engaged in the activities. But, because it is what survives of these activities when their specific purposes have long since passed, the aesthetic component in all of them is what is most noticed by others in the industrial products, religious artefacts, and public ceremonials of other times and cultures. The question is, does this mean that the aesthetic component is the most important component in any human activity?

Now, we have already said that because something is political, religious, or technological it is not therefore non-aesthetic. Conversely, because something realizes an aesthetic intent, and is thus primarily aesthetic, that does not mean that it cannot also be political, religious, or in general instrumental. When we recognize that a thing or performance is primarily political, religious, or technological—

210

46. *Honoré Daumier*, The Laundress. *The Metropolitan Museum of Art. Bequest of Lizzie P. Bliss, 1931.*

« Aesthetic quality unexpectedly suffuses the most utilitarian of activities. »

though we know that with the passage of time it will look more and more like an expressive object—we are implicitly admitting that to the agents involved the aesthetic aspects of their activity were not consciously the most important. On the other hand, however, and in the case of the intellectual component, we also have to admit that the politician, religionist, and technologist as such are not trying to be, and do not conceive themselves as trying to be, intelligent before all else. Just as this does not imply that the intellectual thread is not basic to their concerns, and just as it is probable that, on second thoughts, the politician, religionist, or technologist *would* admit that he was trying to be as intelligent as possible, so the recognition that he does not think of himself as primarily or consciously trying to be expressive or creative does not imply that the aesthetic component in his activity is in fact minimal or minimized by him.[28]

Thus we can answer the question raised by saying that the creative component in political, religious, and industrial activity is important to all participants in these activities in the sense that the style which these activities develop for themselves may make or break them—in the sense, that is, that upon the way a thing is done or claimed may depend whether it gets done or is accepted.

The metaphorical hunger of the organism for satisfaction through the eye is, as Dewey said, hardly less than its literal need for food. And it is not just sight but all our sensory powers that naturally crave to find satisfaction in the material of experience, and which work upon this material in order to obtain that satisfaction from it. Such is the human organism that it can seldom be kept from getting a little aesthetic satisfaction from any activity it undertakes. Yet such is the human condition, on the other hand, that, with relatively small bribes to appease the expressive needs of men, the perverted intelligence of a few has, in the past, led whole peoples in the name of various illusions into anti-human destruction and waste.

[28] The fashionable talk of the "images" which politicians project is, amongst other things, an unwittingly aesthetic approach to the evaluation of office-seekers. Perhaps it is not too far-fetched to see, in the fashion which allows for "sidewalk superintendents" to observe the progress of major building constructions, a kind of aesthetic compensation for temporary inconveniences. And just as the Western religionist's desire to have the most coherent theology, by the test of rational criteria, is grounded in the human need to be as intelligent as possible, so his attraction to ritual, and the use of the arts in ritual, is grounded in the latent but ever-present human need for some kind of aesthetic satisfaction.

Where this occurred it was, of course, a case of the many *not* using *their* intelligence. It was a case of the masses being aroused, not in their rational and social sensibilities, but in their brute passions and unexamined prejudices. The art of government, in this case, was perverted to being the virtually physical manipulation of the social organism by an appeal to instincts whose automatism could be counted on to convert developing societies (and every society is a developing society) into fanatical, malleable, or affrighted mobs. Here, as in general, the perversion of art was a failure of intelligence; and the failure of intelligence was at once and inevitably reflected in some institutional ugliness in the body politic as a whole, or in some outrage to the humanity of the relations among its members; for incompletion and excess are criteria of prudential as well as aesthetic failures.

Art and intelligence are, it would seem, inseparable in their operation. How are they, then, distinguishable in their operation?

Intelligence is a symbolic and instrumental process; art is a symbolic and consummatory process. While intelligence seeks to control what it understands, art seeks to dramatize what it is giving shape to. Ideas and relations, modifiable plans of action based on observed correlations are the subject matter of intelligence. Qualities dramatically related in the interests of expression are the subject matter of art. Intelligence thus comes to emphasize and abstract the general features of things where art is concerned to exhibit their particularity. Of course, in grasping general traits intelligence relies implicitly upon the particular nature of the images associated with conceptual or ideal constructs. Just so, to achieve his effect the artist implicitly relies, in emphasizing and selecting particular qualities, on the human impulse to generalize and extrapolate.

But intelligence and art are, both, creative and communicative processes. Intelligence is creative in the sense that it invents, or is said to discover, an order in the world which allows the human being to intervene decisively in the course of affairs. Art is creative in the sense that it is expressive and, if it produces change, it is only indirectly and in moral matters. Art is communication in the sense of communion, it is a shared celebration or consecration of a value, perception, or experience. The development or achievement of this value requires intelligence, as does the process which is barely distinguishable from it of giving form to this value in some medium. In-

telligence is communicative in the sense that it institutes cooperation in activities which, however, are guided by mediate or even remote ends in view. Intelligence attempts to be a perception of how things function, not just in the experience of others, but of how they function in physical, or non-human, contexts. Understanding the manipulatability of things even in this dimension also requires art, however, as we have seen. Successful and assured manipulations are, in fact, based upon the arts of experimentation and verification. Just as the intelligent ordering of experience for any purpose has its consummatory aspects, so the artistic or consummatory ordering of experience has instrumental and intellectual ones.

Where intelligence seeks to exhaust the manipulatability of a thing, art seeks to make interest in it inexhaustible. The end result of the persistent exercise of intelligence is knowledge which, sooner or later, will be put into practice and may lead to an increase in human welfare. The behavioral habit which is the end result of art is a knowledgeable and simultaneously enjoyable practice. The enjoyment of art and its product may, indeed, become contemplative but it is an active contemplation. Intelligence becomes contemplative when it withdraws from action, making its knowledge useless; paradoxically, intelligence here becomes purely aesthetic and passive.

Though the practice of intelligence looks ever toward system, systematic finality is never achieved by it, nor could intelligence long rest in it. But the expressive finality of a work of art is hard to appeal from and may, in fact, be appealed from effectively only by another work of art. Art works, once created, stimulate further creation; intelligence, however, once exercised, most often requires the further challenge of some frustration or example to keep from lapsing into routine. The "rightness" of works of art is based on their congruence with human sensory processes, not on systematic consistency like the theoretical products of intelligence. Works of art are constructed to provide a maximum of surprise, or information (in the cybernetic sense), as they are enjoyed; though amenability to cybernetic analysis after the fact does not make original artistic construction mechanically possible. If they could be so constructed they would be products of deductive intelligence alone, not of artistic intelligence. So theories, which are the result of the art of inquiry, do not seek so much to be original as to be comprehensive and powerful in the application, that is, directive of fruitful practice. Thus both works of art and theories

214

are the result of the simultaneous exercise, in varying degrees, of art and intelligence.

Because intelligence is success in overcoming the egocentric standpoint of the animal, and art the practice of bringing natural necessities into relation with human concerns and cares, they, together, constitute the operating humanity of man. They are, together, the dynamism in technology, language, ritual or ceremonial, and myth. They continue to operate in the religions and ideologies which are developments of the last two and in the many special sciences and particular arts which have been the offshoots of the first two. Undifferentiated art and intelligence have often been and are well called imagination, the imaging, probing, relating, and sympathetic power or "organ" which creates the "realm" of possibility. With this power reflex action becomes reflective and deliberate conduct—and animal becomes man by the suspension and ordering of images which make judgment possible and the inhibition and anticipation, or control, of actions which makes human conduct possible.

This explains, I think, what the quoted statements of Turner, Hauser, and Pasternak added together imply about the most important function of art and works of art. They imply what we have just said: that art is the intelligent contrivance of instruments and exhibits which relate man to natural necessity and to his destiny as he tries to bring these under control—and as he perennially and alternately damns and celebrates the partial and progressing adjustment to them which constitutes the venture into humanity.

BIBLIOGRAPHICAL NOTES

A useful source book of statements about art by painters and sculptors from the XIV to the XX centuries is *Artists on Art*, ed. by R. Goldwater and M. Treves, 2nd edition (Pantheon Books, Inc., N.Y., 1947). Katherine Kuh's *The Artist's Voice* (Harper & Row, Publishers, N.Y., 1960) documents statements by seventeen contemporaries. *The Journal of Delacroix*, ed. by H. Wellington, transl. by L. Norton, is available from Phaidon Publishers, Inc. (N.Y., 1951). The *Memoirs of Constable*, assembled from his letters by C. R. Leslie, is also in print from The Phaidon Press (London, 1951). I follow with an almost random selection of titles accessible without much difficulty. I hope the reader will be impressed by the seldom remarked abundance in the field of statements about art by artists. *Cézanne's Letters*, ed. by J. Rewald, 2nd ed. (Bruno Cassirer, Oxford, 1944). *Degas' Letters*, ed. by M. Guerin (Bruno Cassirer, Oxford, 1947). Pisarro's *Letters to Lucien*, ed. by J. Rewald (Pantheon Books, Inc., N.Y., 1943). *Paul Gauguin, Letters*, ed. by M. Malingue (World Publishing Co., N.Y., 1949). Van Gogh's letters exist in several editions, including one by W. H. Auden; the most complete is printed in three volumes by The New York Graphic Society Publishers, Ltd. (Greenwich, Connecticut, 1958). *Lettres d'Odilon Redon*, publiés par sa famille (G. Van Oest & Cie., Paris and Brussels, 1923). H. Matisse's "Notes of a Painter," reprinted in *The Problems of Aesthetics*, ed. by E. Vivas and M. Krieger (Holt, Rinehart, & Winston, Inc., N.Y., 1953) has obtained wide notice. About Matisse's essay these editors point out that "its author does not distinguish clearly between what

217

is objectively exhibited on the canvas and the subjective processes of his own creative activity." *Adventures in the Arts,* by the painter (and poet) Marsden Hartley (Boni and Liveright, N.Y., 1921) is a most literate book. Wassily Kandinsky's *The Art of Spiritual Harmony* (transl. by M. T. H. Sadler, Constable and Co., London, 1914) was a landmark of sorts. So was Piet Mondrian's *Plastic Art and Pure Plastic Art 1937, and Other Essays* (Wittenborn, N.Y., 1945). Paul Klee wrote several characteristic short pieces such as the *Pedagogical Sketch Book* (Nierendorf Gallery, N.Y., 1944) and *On Modern Art* (Faber & Faber, London, 1948). *Essay on Landscape Painting* (transl. by Shio Sakanishi, John Murray, London, 1935) is by the medieval Chinese painter Kuo Hsi. Earlier Chinese artists are represented in *The Spirit of the Brush*, Chinese Painters on Nature A.D. 317-960 (translated by Shio Sakanishi, John Murray, London, 1939). The gap in our own Middle Ages is perhaps filled by Villard de Honnecourt, of whom Malraux and Gombrich make use but without adequate bibliographical reference. His annotated sketchbooks are in the Bibliothèque Nationale, Paris, Manuscript No. 19093. A *Facsimile of the Sketch Book of Villard de Honnecourt* was edited by R. Willis in London, 1859, based on the translation of G. B. Lassus, its French editor.

Besides Henry James's "The Art of Fiction" (see reference on page 169) there is the valuable *The Art of the Novel, Critical Prefaces by Henry James,* ed. by R. P. Blackmur (Charles Scribner's Sons, N.Y., 1953). Joyce Cary's *Art and Reality* (Harper & Row, Publishers, N.Y., 1958) represents a conceptual ability inferior to his novelistic talent. E. M. Forster's *Aspects of the Novel* (Harcourt, Brace & World, Inc., N.Y., 1947) has been followed by other essays on the arts including music. Lionel Trilling's *E. M. Forster* (New Directions, N.Y., 1943) and Henry James's *Hawthorne* (reprint, Cornell University Press, Ithaca, N.Y., 1956) are books by working novelists on novelists in whom they had a special interest. *Journal*, André Gide (Librairie Gallimard, Paris, 1948). *The Common Reader* and *The Second Common Reader*, Virginia Woolf (Harcourt, Brace & World, Inc., 1925 and 1932).

Bertold Brecht's writings on theatre are available in *Brecht on Theatre,* ed. and transl. by J. Willett (Hill and Wang, Inc., N.Y., 1964). D. Watson has translated E. Ionesco's *Notes and Counter Notes: Writings on Theatre* (Grove Press, Inc., N.Y., 1964). B. H. Clark's *European Theories of the Drama* (with a Supplement on the American Drama, Crown Publishers, Inc., N.Y., 1947) includes Eugene O'Neill's "The Diary of a Play." The play in question was "Mourning Becomes Electra." The motion picture director S. M. Eisenstein's *Film Sense* and *Film Form* were published by Harcourt, Brace & World, Inc., in 1942 and 1949 respectively.

Easily available in the field of music are: *Letters of Composers*, ed. by G. Norman and M. L. Shrift (Grosset & Dunlap, Inc., N.Y., no date, reprinted from the edition of Alfred A. Knopf, Inc., 1946). Aaron Copland, *What to Listen for in Music*, Rev. ed. (McGraw-Hill Book Company, N.Y., 1957); and, *Music and Imagination* (Harvard University Press, Cambridge, Mass., 1952). Igor Stravinsky, *Poetics of Music* (Vintage Books, N.Y., 1956). Roger Sessions' *The Musical Experience of Composer, Performer, Listener* (Atheneum Publishers, N.Y., 1962). Paul Hindemith, *A Composer's World* (Princeton University Press, Princeton, N.J., 1952). *Conversations with Casals*, by J. M. Corredor (E. P. Dutton & Co., Inc., N.Y., 1956). Carlos Chávez, *Musical Thought* (Harvard University Press, Cambridge, Mass., 1961). Benny Green, *The Reluctant Art: The Growth of Jazz* (Horizon Press, Inc., N.Y., 1963).

Poets have written about poetry in poetry throughout the tradition. Here is a limited list of prose works by poets. S. T. Coleridge, *Biographia Literaria*, Everyman Library Edition (E. P. Dutton & Co., Inc., N.Y., 1947). Goethe's *Dichtung und Wahrheit* exists in an old translation as *Truth and Fiction Relating to My Life*, transl. by J. Oxonford, 2 vols. (F. A. Niccolls & Co., Boston, 1902). There is much about poetry and drama in *Wilhelm Meister* which has been reprinted many times in English. Finally, there is the *Correspondence, 1794–1805, by F. v. Schiller and J. W. v. Goethe*, transl. from the 3rd German ed. by L. D. Schmidt (G. Bell & Sons, 1879). *My Heart Laid Bare*, Charles Baudelaire, ed. by Peter Quennell (Vanguard Press, Inc., N.Y., 1951). *The Mirror of Art*, Critical Studies. Ed. and transl. by J. Mayne (The Phaidon Press, Ltd., Publishers, London, 1955). A convenient edition of G. M. Hopkins is *A Hopkins Reader*, ed. by John Pick (Oxford University Press, Inc., N.Y., 1953). *Essays* by W. B. Yeats (The Macmillan Company, N.Y., 1961) have been reprinted with additions and in other forms. *The Autobiography of William Butler Yeats* (The Macmillan Company, N.Y., 1953). T. Sturge Moore, *Art and Life* (Methuen & Co., London, 1910). Walter de la Mare, *Private View* (Faber & Faber, London, 1953). Here are several by Ezra Pound: *Make it New; Essays* (Faber & Faber, London, 1934); *Pavannes and Divisions* (New Directions, N.Y., no date); *The Spirit of Romance* (New Directions, N.Y., 1952); *The ABC of Reading* (New Directions, N.Y., no date). Wallace Stevens, *The Necessary Angel* (Alfred A. Knopf, Inc., N.Y., 1951). T. S. Eliot, *Selected Essays*, Rev. ed. (Harcourt, Brace & Co., N.Y., 1932), and *The Use of Poetry and the Use of Criticism* (Barnes & Noble, Inc., N.Y., 1955). More recent are *Poetry and Drama* (Harvard University Press, Cambridge, Mass., 1951), and *The Three Voices of Poetry* (Cambridge University Press, N.Y., 1954). Marianne Moore, *Predilections* (The Viking Press, N.Y., 1955).

219

Antonio Machado's *Juan de Mairena*, 2 vols. (Editorial Losada, Buenos Aires, 1958) is well worthwhile and should be better known. Paul Valéry may be read in *The Collected Works in English*, translated by many people and edited by J. Mathews (Bollingen Series XLV, Pantheon Books, Inc., N.Y.).

For the purpose of a dynamic or functional interpretation of Aristotle, the reader will find most useful Gerard Else's *Aristotle's Poetics: the Argument* (Harvard University Press, Cambridge, Mass., 1957), J. H. Randall, Jr.'s *Aristotle* (Columbia University Press, N.Y., 1960). A. Grant's *Aristotle's Ethics*, 2 vols. (Longmans, Green, & Co., London, 1866) is very clear and still useful. The Loeb Library edition of *The Poetics*, transl. by W. Hamilton Fyfe (Harvard University Press, Cambridge, Mass., reprint of 1953) translates *télos tēs tragōidías* as "the end at which tragedy aims," *tēs tragōidías érgon* as "the proper function of tragedy," and *psychagōgeî hē tragōidía* as "the emotional effect of tragedy," on pages 25 and 26. But at VI, 22 and VI, 28 *érgon* and *dýnamis* are translated respectively as "function" and "effect," with *tōn 'opseōn* translated as "spectacular effects." At IX, 1 *poiētoû érgon* is translated as "a poet's object." At XIII, 5, and XIII, 6, *hamartía* is translated as "flaw" rather than "error." At XIII, 8 *tēn téchnēn . . . tragōidía* is translated as "the theory (!) of the art."

An interesting example of an aesthetics derived from what has gone before and towards the end of the development of a philosophical system is Schopenhauer's. See "Supplements to the Third Book," Volume II, *The World as Will and Representation*, translated by E. F. J. Payne (The Falcon Wing's Press, Indian Hills, Colorado, 1958).

On the "aesthetic attitude," see H. S. Langfeld's *The Aesthetic Attitude* (Harcourt, Brace & Co., N.Y., 1920). *The Sense of Beauty* (Charles Scribner's Sons, N.Y., 1896) is the title of G. Santayana's early work on aesthetics. Though I bring them under stricture, these books are sympathetic to art in the authors' senses of the word.

Stephen Pepper's *The Work of Art* (Indiana University Press, Bloomington, Ind., 1955) should also be consulted. In view of the concern with language in the present book the reader may wish to be referred to John Herman Randall, Jr.'s "The Art of Language and the Linguistic Situation: A Naturalistic Analysis," *The Journal of Philosophy*, Vol. LX, No. 2, 1963.

A standard statement of the doctrine of "the aesthetic object" is E. Jordan's *The Aesthetic Object* (The Principia Press, Bloomington, Ind., 1937).

An earlier discussion of questions about meaning in the arts was John Hosper's *Meaning and Truth in the Arts* (University of North Carolina Press, Chapel Hill, N.C., 1946).

The following are some other references, of varying value, to the psychoanalytic literature on art. Herbert Read "Psychoanalysis and Criticism," in *Reason and Romanticism* (Faber and Gwyer, London, 1926), and "Psychoanalysis and the Problem of Aesthetic Value," in *The Form of Things Unknown* (Faber and Faber, London, 1960). F. J. Hoffman, *Freudianism and the Literary Mind* (Louisiana State University Press, Baton Rouge, La., 1945). S. O. Lesser, *Fiction and the Unconscious* (Beacon Press, Boston, 1957). C. Badouin, *Psychoanalysis and Aesthetics* (Dodd, Mead & Co., N.Y., 1924). J. M. Thorburn, *Art and the Unconscious* (K. Paul, Trench, Trubner, London, 1925). D. E. Schneider, *The Psychoanalyst and the Artist* (New American Library of World Literature, Inc., N.Y., no date). Hanns Sachs, *The Creative Unconscious* (Sci-Art Publications, Cambridge, Mass., 1951). Ernst Kris, *Psychoanalytic Explorations in Art* (International Universities Press, Inc., N.Y., 1952).

In connection with existentialism the reader may want to consult A. B. Fallico, *Art and Existentialism* (Prentice-Hall, Inc., Englewood Cliffs, N.J., 1962) and E. F. Kaelin, *An Existential Aesthetic* (University of Wisconsin Press, Madison, Wis., 1962), both of which appeared subsequent to the completion of chapter VI of this book. G. Morpurgo-Tagliabue's *L'Esthétique Contemporaine* (Marzorati-Editeur, Milan, 1960), which also reached me too late to consult, contains a long chapter on "L'Existencialisme et l'esthétique."

An organicist aesthetics which seeks to do justice to the formalist emphasis of Bell and Fry is Morris Weitz, *Philosophy of the Arts* (Harvard University Press, Cambridge, Mass., 1950).

Here is a selection of other works in aesthetics which a systematic reader will want listed. Many of these are more or less indirectly alluded to, or more or less remotely presupposed by, the text of this work—though not cited previously.

V. Aldrich, *Philosophy of Art* (Prentice-Hall, Inc., Englewood Cliffs, N.J., 1963).

S. Alexander, *Beauty and Other Forms of Value* (Macmillan & Co., London, 1933).

E. Arteaga, *La Belleza Ideal* (Espasa-Calpe, Madrid, 1943).

A. G. Baumgarten, *Reflections on Poetry*, ed. & transl. K. Aschenbrenner & W. B. Holther (University of California Press, Berkeley, 1954).

M. Beardsley, *Aesthetics*, Problems in the Philosophy of Criticism (Harcourt, Brace & World, Inc., N.Y., 1958).

J. Bennett, *Four Metaphysical Poets*, 2nd ed. (Cambridge University Press, N.Y., 1953).

E. Bentley, *The Importance of Scrutiny* (G. W. Stewart, N.Y., 1948).

R. P. Blackmur, *The Double Agent* (Arrow Editions, N.Y., 1935).

————, *The Expense of Greatness* (Arrow Editions, N.Y., 1940).

————, "A Burden for Critics," *Lectures in Criticism* (Pantheon Books, N.Y., 1949).

V. Blake, *Relation in Art* (Oxford University Press, N.Y., 1925).

F. Boas, *Primitive Art* (Dover Publications, Inc., N.Y., 1955).

G. Boas, *A Primer for Critics* (The Johns Hopkins Press, Baltimore, Md., 1937).

M. Bodkin, *Archetypal Patterns in Poetry* (Oxford University Press, N.Y., 1934).

B. Bosanquet, *Three Lectures on Aesthetic* (Macmillan & Co., London, 1923).

M. Bowra, *Primitive Song* (World Publishing Co., Cleveland, Ohio, 1962).

————, *Heroic Poetry* (Macmillan & Co., London, 1952).

C. Brooks, *Modern Poetry and the Tradition* (University of North Carolina Press, Chapel Hill, N.C., 1939).

————, "The Poem as Organism," *English Institute Annual*, 1940 (Columbia University Press, N.Y., 1941).

————, *The Well Wrought Urn* (Harcourt, Brace & World, Inc., 1956).

S. Brown, *The World of Imagery* (Harcourt, Brace & Co., N.Y., 1927).

J. Buchler, *Toward a General Theory of Human Judgment* (Columbia University Press, N.Y., 1951).

P. C. Buck, *The Scope of Music*, 2nd ed. (Oxford University Press, N.Y., 1927).

E. Bullough, *Aesthetics* (Stanford University Press, Stanford, Calif., 1951).

K. Burke, *The Philosophy of Literary Form* (Louisiana State University Press, Baton Rouge, La., 1941).

E. F. Carritt, *The Theory of Beauty*, 5th ed. (Methuen & Co., London, 1949).

G. A. Carver, *Aesthetics and the Problem of Meaning* (Yale University Press, New Haven, Conn., 1952).

E. Cassirer, *Language and Myth*, transl. by S. K. Langer (Harper & Brothers, N.Y., 1946).

A. R. Chandler, *Beauty and Human Nature* (Appleton-Century-Crofts, N.Y., 1934).

A. K. Coomeraswamy, *Christian and Oriental Philosophy of Art* (Dover Publications, N.Y., 1956).

————, *History of Indian & Indonesian Art* (Edward Goldston, London, 1927).

G. W. Cooper & L. B. Meyer, *The Rhythmic Structure of Music* (The University of Chicago Press, Chicago, 1960).

F. M. Cornford, *The Origin of Attic Comedy* (Cambridgé University Press, N.Y., 1934).

R. S. Crane, *The Languages of Criticism & the Structure of Poetry* (University of Toronto Press, 1954).

B. Croce, *Estética*, 2a. ed. española con prólogo de M. de Unamuno (Francisco Beltrán, Madrid, 1926).

C. Debussy, F. Busoni, C. E. Ives, *Three Classics in the Aesthetics of Music* (Dover Publications, N.Y., 1962).

J. Dewey, *Philosophy and Civilization* (G. P. Putnam's Sons, N.Y., 1963).

I. Edman, *Arts and the Man* (W. W. Norton & Co., N.Y., 1928).

W. Elton, ed. *Aesthetics and Language* (Basil Blackwell, Oxford, 1954).

W. Empson, "A Doctrine of Aesthetics," *The Hudson Review*, Vol. 2, No. 1.

————, *Seven Types of Ambiguity*, Rev. ed. (New Directions, N.Y., 1947).

————, *The Structure of Complex Words* (New Directions, N.Y., 1951).

J. T. Farrell, *Literature and Morality* (Vanguard Press, Inc., N.Y., 1947).

————, *A Note on Literary Criticism* (Vanguard Press, Inc., N.Y., 1936).

C. Fiedler, *On Judging Works of Visual Art*, transl. H. Schaefer-Simmern & F. Mood (University of California Press, Berkeley, Calif., 1949).

H. Focillon, *The Life of Forms in Art*, transl. C. B. Beecher & G. Kubler (Yale University Press, New Haven, Conn., 1942).

P. Frankl, *Das System der Kunstwissenschaft* (Rohrer Co., Leipzig, 1938).

D. Fraser, *Primitive Art* (Doubleday & Co., Inc., N.Y., 1962).

R. Fry, *Transformations*, Reprint of 1956 (Doubleday & Co., Inc., N.Y.).

————, *Vision and Design* (Meridian Books, N.Y., 1956).

T. H. Gaster, *Thespis*, new rev. ed. (Doubleday & Co., Inc., N.Y., 1961).

E. Gilson, *Painting and Reality* (Meridian Books, N.Y., 1959).

R. Gomez de la Serna, *Ismos* (Editorial Poseidon, Buenos Aires, 1943).

P. Goodman, *The Structure of Literature* (University of Chicago Press, 1954).

K. Gordon, *Esthetics* (Henry Holt & Co., N.Y., 1909).

D. W. Gotshalk, *Art and the Social Order*, 2nd ed. (Dover Publications, Inc., N.Y., 1962).

B. Gracián, *Agudeza y Arte de Ingenio* (Espasa-Calpe, Argentina, ed. 1942).

R. Graves, *On English Poetry* (Heinemann, London, 1922).

————, *Poetic Unreason* (Cecil Palmer, London, 1925).

————, *The Common Asphodel* (Hamish Hamilton, London, 1959).

————, *The Crowning Privilege* (Cassell & Co., London, 1955).

T. M. Greene, *The Arts and the Arts of Criticism* (Princeton University Press, Princeton, N.J., 1940).

E. Gurney, *The Power of Sound* (Smith, Elder & Co., London, 1880).

——, *Tertium Quid*, 2 vols. (K. Paul, Trench & Co., London, 1887).

E. Hanslick, *The Beautiful in Music*, ed. M. Weitz, transl. G. Cohen (The Liberal Arts Press, N.Y., 1957).

J. Harrison, *Ancient Art and Ritual* (Henry Holt & Co., N.Y., 1913).

——, *Themis*. With an Excursus on the Ritual Forms Preserved in Greek Tragedy, by G. Murray, and a Chapter on the Origin of the Olympic Games, by F. M. Cornford (Cambridge University Press, N.Y., 1927).

C. Hartshorne, *The Philosophy and Psychology of Sensation* (University of Chicago Press, 1934).

——, *Reality as Social Process* (Free Press of Glencoe, Inc., N.Y., 1953).

H. G. Henderson, *An Introduction to Haiku* (Doubleday & Company, Inc., N.Y., 1958).

B. Heyl, *New Bearings in Esthetics and Art Criticism* (Yale University Press, New Haven, Conn., 1943).

Y. Hirn, *The Origins of Art* (Macmillan & Co., London, 1900).

A. Hodier, *Jazz: Its Evolution and Essence*, transl. D. Noakes (Grove Press, Inc., N.Y., 1956).

J. Huizinga, *Homo Ludens* (Roy Publishers, Inc., N.Y., 1950).

B. Hunningher, *The Origin of the Theater* (Hill & Wang, Inc., N.Y., 1961).

R. Huyghe, *Dialogue avec le visible* (Flammarion, Paris, 1955).

S. E. Hyman, *The Armed Vision* (Vintage Books, N.Y., 1955).

K. Bharatha Iyer, ed. *Art and Thought* (Luzac & Co., London, 1947).

H. Janis & R. Blesh, *Collage* (Chilton Co., Philadelphia, Pa., 1962).

J. L. Jarrett, *The Quest for Beauty* (Prentice-Hall, Inc., Englewood Cliffs, N.J., 1957).

I. Jenkins, *Art and the Human Enterprise* (Harvard University Press, 1958).

I. Kant, *Critique of Aesthetic Judgment*, ed. & transl. J. C. Meredith (Oxford University Press, N.Y., 1911).

H. Kallen, *Art and Freedom*, 2 vols. (Duell, Sloan & Pearce, N.Y., 1942).

H. D. F. Kitto, *Greek Tragedy*, 2nd ed. (Methuen, London, 1950).

S. K. Langer, *Feeling and Form* (Charles Scribner's Sons, N.Y., 1953).

——, *Philosophy in a New Key* (Harvard University Press, 1942).

——, *Problems of Art* (Charles Scribner's Sons, N.Y., 1957).

F. R. Leavis, *Revaluation* (G. W. Stewart, N.Y., 1947).

R. Lechner, *The Aesthetic Experience* (Henry Regnery Co., Chicago, 1953).

V. Lee, *The Beautiful* (Cambridge University Press, N.Y., 1913).

G. E. Lessing, *Laokoon*, transl. E. C. Beasley (G. Bell & Sons, London, 1914).

A. B. Lord, *The Singer of Tales* (Harvard University Press, Cambridge, Mass., 1960).

P. Lubock, *The Craft of Fiction* (Peter Smith, N.Y., 1947).

A. Malraux, *The Voices of Silence* (Doubleday & Co., Inc., N.Y., 1953).

K. Mannheim, *Essays on the Sociology of Knowledge* (Routledge, K. Paul, London, 1952).

J. A. M. Meerloo, *The Dance* (Chilton Co., Philadelphia, 1960).

L. B. Meyer, *Emotion and Meaning in Music* (The University of Chicago Press, 1956).

J. A. Michener, *The Floating World* (Random House, Inc., N.Y., 1954).

J. Miles, *The Continuity of Poetic Language* (University of California Press, Berkeley, 1951).

R. Mukerjee, *The Social Function of Art* (Philosophical Library, Inc., N.Y., 1954).

T. Munro, *Towards Science in Aesthetics* (The Liberal Arts Press, N.Y., 1956).

J. Middleton Murry, *The Problem of Style* (Oxford University Press, N.Y., reprint of 1960).

C. K. Ogden & I. A. Richards, *The Meaning of Meaning* (Harcourt, Brace & Co., N.Y., 1923).

H. Osborne, *Aesthetics and Criticism* (Routledge, K. Paul, London, 1955).

———, *Theory of Beauty* (Routledge, K. Paul, London, 1952).

E. Panofsky, *Meaning in the Visual Arts* (Doubleday & Co., Inc., N.Y., 1955).

D. H. Parker, *The Analysis of Art* (Yale University Press, New Haven, Conn., 1926).

———, *The Principles of Aesthetics*, 2nd ed. (Appleton-Century-Crofts, N.Y., 1946).

S. C. Pepper, *The Basis of Criticism in the Arts* (Harvard University Press, Cambridge, Mass., 1945).

M. Praz, *The Romantic Agony*, transl. A. Davidson (Oxford University Press, N.Y., 1933).

J. C. Ransom, *The New Criticism* (New Directions, Norfolk, Conn., 1941).

H. Read, *Art and Society*, rev. ed. (Faber & Faber, London, 1945).

I. A. Richards, "The Interactions of Words," in *The Language of Poetry*, ed. A. Tate (Princeton University Press, Princeton, N.J., 1942).

———, *The Philosophy of Rhetoric* (Oxford University Press, N.Y., 1936).

W. Ridgeway, *The Origin of Tragedy* (Cambridge University Press, N.Y., 1910).

225

H. Rosenberg, *The Tradition of the New* (Horizon Press, Inc., N.Y., 1959).

G. Santayana, *The Life of Reason*, Triton ed. (Charles Scribner's Sons, N.Y., 1936).

F. Schiller, *On the Aesthetic Education of Man*, transl. R. Snell (Yale University Press, New Haven, Conn., 1954).

M. Schorer, J. Miles, G. McKenzie, eds. *Criticism. The Foundations of Modern Literary Judgment* (Harcourt, Brace & Co., 1948).

W. C. Seitz, *The Art of Assemblage* (Museum of Modern Art, N.Y., 1961).

E. Sewell, *The Structure of Poetry* (Routledge, K. Paul, London, 1951).

M. W. Smith, ed. *The Artist in Tribal Society* (Free Press of Glencoe, Inc., N.Y., 1961).

B. Snell, *Poetry and Society* (Indiana University Press, Bloomington, Ind., 1961).

D. Stauffer, ed. *The Intent of the Critic* (Princeton University Press, Princeton, N.J., 1941).

J. Stolnitz, *Aesthetics and the Philosophy of Art Criticism* (Houghton Mifflin Co., Boston, 1960).

J. Sully, *Sensation and Intuition* (H. S. King & Co., London, 1874).

W. Sypher, *Rococo to Cubism in Art & Literature* (Random House, Inc., N.Y., 1960).

L. Tolstoy, *What is Art and Essays on Art*, transl. A. Maude (Oxford University Press, N.Y., 1930).

R. Tuve, *Elizabethan & Metaphysical Imagery* (The University of Chicago Press, 1947).

P. Tyler, *The Three Faces of the Film* (Thomas Yoseloff, Publisher, N.Y., 1960).

A. P. Ushenko, *Dynamics of Art* (Indiana University Press, Bloomington, Ind., 1953).

C. W. Valentine, *The Experimental Psychology of Beauty* (Nelson & Sons, London, 1919).

E. Vivas, *Creation and Discovery* (The Noonday Press, N.Y., 1955).

——, "The Neo-Aristotelians of Chicago," *Sewanee Review*, Vol. LXI, No. 1, 1953.

L. Warner, *The Enduring Art of Japan* (Harvard University Press, Cambridge, Mass., 1952).

R. Wellek & A. Warren, *The Theory of Literature* (Harcourt, Brace & World, Inc., N.Y., 1956).

A. N. Whitehead, *Symbolism, Its Meaning and Effect* (The Macmillan Company, N.Y., 1927).

E. Wilson, *Axel's Castle* (Charles Scribner's Sons, N.Y., 1931).

————, *The Wound and the Bow* (Oxford University Press, N.Y., 1947).
W. K. Wimsatt & M. Beardsley, "The Intentional Fallacy," *Sewanee Review*, Vol. LIV, No. 3, 1946.
————, "The Affective Fallacy," *Sewanee Review*, Vol. LVII, No. 1, 1949.
P. S. Wingert, *Primitive Art* (Oxford University Press, N.Y., 1962).
H. Wölfflin, *Principles of Art History*, transl. M. D. Hottinger, 7th ed. (Dover Publications reprint, N.Y., no date).
F. J. E. Woodbridge, *The Realm of Mind* (Columbia University Press, N.Y., 1926).

All but the first of the following anthologies which I have not cited in this book are in print:

E. F. Carritt, ed. *Philosophies of Beauty* (Oxford University Press, N.Y., 1931).
B. Ghiselin, ed. *The Creative Process* (University of California Press, Berkeley, 1952).
W. E. Kennick, ed. *Art and Philosophy* (St. Martin's Press, N.Y., 1964).
S. K. Langer, ed. *Reflections on Art* (Johns Hopkins University Press, Baltimore, Md., 1958).
M. Levich, ed. *Aesthetics and the Philosophy of Criticism* (Random House, Inc., N.Y., 1963).
J. Margolis, ed. *Philosophy Looks at the Arts* (Charles Scribner's Sons, N.Y., 1962).
M. Philipson, ed. *Aesthetics Today* (Meridian Books, N.Y., 1961).
M. Rader, ed. *A Modern Book of Esthetics*, 3rd ed. (Holt, Rinehart, & Winston, Inc., N.Y., 1960).
V. Tomas, ed. *Creativity in the Arts* (Prentice-Hall, Inc., Englewood Cliffs, N.J., 1964).
M. Weitz, ed. *Problems of Aesthetics* (The Macmillan Company, N.Y., 1959).

M. L. Stein and H. S. Heinze have done an abundant and analytic bibliography of work in psychological aesthetics called *Creativity and the Individual* (Free Press of Glencoe, Inc., N.Y., 1960) which is concerned with the creative process in mathematics, natural science, and the social sciences as well as in the arts in the traditional sense.

PHOTO CREDITS

229

INDEX

Index

232

Index

236